# PORTRAITS OF AMERICA

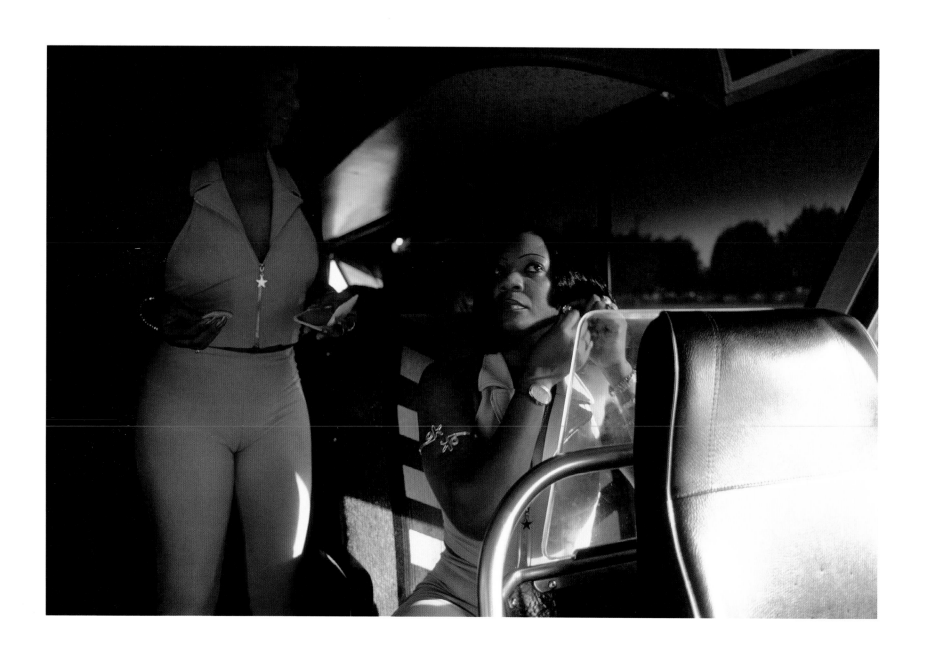

*Diann and Scandalicious, dancers for Bobby Rush, on the bus, Greenville, Mississippi* 1997

# WILLIAM ALBERT ALLARD

# PORTRAITS OF AMERICA

## FOREWORD BY RICHARD FORD

NATIONAL GEOGRAPHIC

WASHINGTON, D.C.

This book is dedicated with love to my children,
Scott, Chris, Terri, David, and Anthony

*Milwaukee Brewers spring training, Arizona* 1990

# CONTENTS

# FOREWORD *by Richard Ford*

IT WOULD BE NICE (FOR ME) TO INTRODUCE YOU TO WILLIAM ALBERT ALLARD'S WON-
derful photographs equipped with something interesting you don't already have: a useful word or
two that directs your attention where it might not have lingered, or that replenishes your diction for
pleasures that could go unvoiced; do something, at least, to sharpen your readiness for the sensa-
tions of looking.

Allard's photographs typically obviate the commentator's need to comment. One of their stead-
fast qualities—beyond a rich palate and an amiable intensity—is their effect of being complete-as-
seen. They are subtle and nuanced, but subtle and nuanced in ways the viewer can get to on his
own. This isn't to say Allard's photographs are uncomplicated in their appeals, or obvious. They
surely aren't. Stop right now and look at the photograph on pages 166-67 entitled "Madsen Grove
Resort...1995." It is an *almost* shocking photograph: the blue and windless Minnesota lake, the

children cavorting in the background with their little insub-
stantial plastic tubes, the shoreline green and inert. An idyll of
Midwestern summer pleasures.

But what do we make of the other child? The one up to her
knees in the watery foreground, shivering, her fingers clutched,
her smooth girl's features apparently in the grip of something
unstated, possibly profound, something the picture's composi-
tion and other formalities imply by being so remote from?
What is it? The unwelcome apprehension of childhood's end?
The arrival of this child's own isolating nubility? Or even dark-
er thoughts about the deep waters awaiting?

It is one of my favorite Allard photographs—favorite for
being not at all obvious. And yet, by viewing it in the company
of other of his images, one becomes reasonably certain what
this worried-looking little girl suffers from: she's simply cold.
Her face and posture may suggest darker possibilites. And the
photograph may in fact musingly collude in the implication.
But ultimately the measured, nicely-constructed whole of
the picture deflates a darker view. This pleasurably blue water
can't really be *menacing*. These other children in the balancing
background aren't endangered—they're *playing*. The shoreline

isn't hopeless and inert, it's only placid. Indeed, the more we
look at the picture, the more we sense our first thought was the
right one. The photograph may summon up a complex and
affecting mystery which invites an ambiguous, even a fore-
boding thought. But ultimately it confirms a plainer, more
affectionate one.

THIS QUALITY OF FULLY REALIZED SELF-EVIDENCE IS NOWHERE
more apparent than in the single-subject human portraits, of
which there are 34 here. Allard calls this book, representing his
four decades of a photographer's life, *Portraits of America*; and
its portraits of people—mostly straight-on, close-up, highly
detailed head shots—often making *un*ambiguous eye contact
with us and the camera, which gives this collection its core, its
cohesive claim to its theme, and its spirit.

Allard has made a long and studious life out of looking
closely at and representing *people*. Only 12 of these photographs
have no persons at all in them. And while these few uninhab-
ited ones seem to me attractively "arty" and pensive about the
lives absent from their frames, they are clearly subjects apart
from the photographer's chief interest, which is us folks.

Allard's life portraits are resolutely un-uniform in their stagings, their tone and mood, and in their degree of particularity. (Look at the cowboy photos on pages 39, 45, 74, and 245). But they are all four-square unironic about the human subject, whether in his or her natural surroundings, or abstracted by the camera's close notice. Circumstance, if the picture reveals it, is never stronger than man, never makes a dupe of him. Subjects hold the camera's interest (and ours) intently, complexly, even prettily. Faces seem chosen for their capacity to appear amiable and memorably authentic—not eccentric—noticeable and inviting in their details. They address us forcefully without actually confronting us with what they are.

Though what they are, plainly enough, are solitary-seeming individuals facially testifying to the artist's faith that man is the fundamental moral integer of life. Indeed, simply to *look* through this collection of human studies is to grasp such a conclusion without needing to be told. Allard's grand view of late 20th-century American man had admittedly required him to search for his subjects in remote and far-flung pockets of the American culture (blues clubs, minor league baseball parks, rodeos, Hutterite colonies, even, for God's sake, Minnesota), as though such faces and people weren't as available as once they were. Yet his take on humankind is hardly obscure, inasmuch as his portraits do not elicit responses which their human subjects wouldn't corroborate, were we to know them. We, of course, can't look at these portraits without realizing that just outside their frames lies a murkier, much less affirming world where we likely wouldn't see these people in the precise way Allard shows them to us. And sometimes they may seem glamorous and romantically selective in their depiction of the American cowboy or the slightly overbred Southern belle. But we must concede that we've encountered not a falsehood or an illusion (they *do* look this way, or can), but the answers to Allard's moral catechism: Man is essentially beautiful; his work ennobles him; photography is virtuous when it can give testimony of such things using the forces of composition, style, choice, generosity, and memory. If you care to see man differently, you may by looking elsewhere. But you must know, when you look here, that man *is* this way, too.

By pointing out straightaway what seems to be the core of this book, I hope I've freed myself now to hunt and peck around among its particulars and to take note of things I merely like.

*Portraits of America* is a virtual feast, in that it offers us enough that we can relax our critical principles, and in an almost carnal way browse.

Allard's formal strengths as a technical photographer are many and extremely various. He is, for instance, a superb action photographer; which is to say that the actions he photographs (look at the intense rodeo picture, "Wild horse race, Wolf Point, Montana," on pages 242-43) are *full* of energy and unexpected, dramatically operative details, many of which we don't even register at first, we're so seized by the action. "Wild horse race" seems powerfully authentic; that is, it reinforces in a muscular way what we already know and think and feel to be true about the rodeo. Yet it also situates us to see something we could never have seen, and thus reveals (or invents, if you please) the action anew, widening and refreshing the rodeo's importance to us.

So much is simply *in* this photograph that the sheer act of composing it becomes a small miracle, and for us a great pleasure as we try to take it all in. First, the straining Bellows-like cowboys in yellow and blue, pulling on a horse we almost don't see, so affected are we by the men's transfixing effort. Then our eyes, in relief, seek the space to the right and the less distinct horse, and the men holding it; and then are the blurry lights and the dust and the ropes—all seeming interconnected but somehow autonomous, too—brought into a defining organization as the fierce character of the rodeo. And only *then*, and unexpectedly, do our eyes find those men in the upper left corner who seem to be watching something else entirely! They are like the ploughman in Auden's poem "Musée des Beaux Arts," who goes about his homely business as Icarus falls rather calamitously into the sea.

"Wild horse race" is a wonderful photograph—alerting, stirring, savage-seeming yet distilled, intensely narrative and (to me, anyway) poignant for its view of great human effort expelled in behalf of, really, so very little at all.

As noted, Allard seems to be a born composer of photographs. His frames are unstintingly, minutely, attended to in ways that can often create a painterly effect. The most obvious, and to me most striking, instance of this is the photograph entitled "Paula Kimbrough in her Easter dress, Junior Kimbrough's House, near Holly Springs," on pages 110-11. In

addition to looking like a cast still from a production of *Porgy and Bess,* this photograph is composed of no fewer than five distinct, if narratively enigmatic, structural elements (not the least interesting being the burnished plank wall), as well any number of late-blooming details and textures (the *Star Wars* blanket, the Miller High-Life can under the man's semi-kneeling knee, the blue bedspread mimicking the gold skirt material, and the beseeched woman's improbably but demurely crossed ankles). This rash of vivid details causes the photograph to give us almost too much to take in, and causes life to seem almost too complex—that is, if the picture weren't so beautiful. Though it is typical of Allard the photographer that we are often so thoroughly *positioned* by the architecture of structures that we only gradually locate the picture's full complement of details—any one of which may have inspired the arrangement, and whose measured disclosure contributes to the photograph's complex effect, while making us feel satisfyingly anticipated as we move through them.

"Paula Kimbrough in her Easter dress" is not, I should say, utterly characteristic of Allard's compositional habits, if only because the human subjects essentially "line up" across the frame, and the whole picture contains little depth of field to invite us in. In this way, it has the almost casual qualities of a family portrait from a century ago. Nonetheless it is a wonderfully ordered photograph, ordered indeed to the point of being stylized and objectified, yet still immensely likable for its shadowy hues, its amused self-awareness, and the exotic narrative undertones it manages so moodily to incorporate.

A much more characteristic Allard composition, found here with its structural terms stationed widely across the frame as if to make them unmistakable, is the photograph on pages 44-45, entitled "George Stahl, in the horse barn, Surprise Creek Colony, Stanford." As usual, little needs to be said. The photograph *is*, in essence, its balanced and dual-focused composition made animate by color, texture (the hay, the box), the dramatic play of light and dark (including the hats and the stabled horse's white fetlocks, the mediating red of young George's face), and the boy's eyes, which may be closed or may be innocently lowered regarding an ant crawling up his shirtsleeve. One can easily imagine this Hutterite boy's face as the subject of one of the close-up portraits. But here, his appearance and existence are placed in a larger, more complicated and engrossing context, so that no single element is as interesting or vibrant as the whole composition, which draws our eyes first deeply to the lighted doorway, the blurred horse and the seated figure, and only then gives up the musing-dozing George Stahl, as though he were an afterthought—albeit an important one. After this, the rest of the photograph comes to notice—the shadowy horse in the shadowy middle, and the extraordinarily long left leg of the man seated in the lighted door frame. The photograph, in large measure, succeeds because Allard takes command of our apprehension of its homely parts, and engages us in their lively articulation, which makes the fitting-together of parts a source of subtle, if not overbearingly important, pleasure.

A remarkable companion image to "George Stahl" is the photograph, "Pioneer Rookie League, Great Falls, Montana," pages 134-35, which is a compositional fraternal twin of the two horsemen in the barn, with everything else—tone, narrative subtext, light values, even the ordinal sequence by which we take in the picture's parts—being quite different. Here, largely because there's nothing very interesting at the top of the lighted stairs, and because the man holding the bat is evidently departing, and finally because the border between the blue and beige wall surface leads to and through the embracing couple, our eye simply cannot resist the two lovers kissing, which becomes the anecdotal subject of the photograph against which the other elements play a small, ironic role. As with the barn image, no single element is nearly as involving, as dramatic, provoking, pleasing, or testing to the eye as all the elements shaped and delimited by the photographer's instinct. Though, of course, one might argue that to say so is only to assert the obvious about any good photograph, poem, novel, story, play, movie....

It should be said that Allard's native sense of how to compose a remarkable photograph out of seemingly unpromising materials at hand in no way *defines* his "style." Such observations about composition only identify one technical-aesthetic solution to the photographer's imperative to make a good picture. Successful solutions, if repeated, may produce something *like* a style. But regarding any art that's good, declarations about style are usually accurate for only a small portion of a small portion of an artist's production, may in fact trivialize the work, and be motivated by limiting forces extrinsic to it. Indeed, over a lifetime, most artists develop and exhaust several complex and

hard-to-encapsulate "styles," in an effort to keep their contributions fresh, their minds engaged, their grasps widening. And while it can become a public liability not to produce work which can be easily, "stylistically" pigeon-holed, one might bear in mind the words of the architect Renzo Piano, who wrote that "Having a style is not bad. But it can be a golden cage."

Moving through this sumptuous collection you will, in fact, see all manner of styles: the heroic, bravura style of "Ed Cantrell, Sweet Water County, Wyoming, 1983" (pages 72-73); the assorted, manly compositions of minor league baseball, in which muscles and various sites and rites of passage preoccupy attention. Again, there are the stirring portraits, the action photographs, the few but atmospheric landscapes. My favorite and the most personal and autobiographical idiom is the brief "Time at the Lake, Minnesota" series (pages 152-171), in which Allard (a native Minnesotan) throttles back on thematics and on his customary intensity in favor of a more relaxed, sometimes amused lyricism sponsored, it would seem, by familiarity and the expressiveness of the past. Nothing in these 12 memorable and utterly distinct images seems illustrative of anything but experience itself. Remember the shivering little girl in Madsen Grove. As was true there, the subjects feel accessible to the photographer, yet not as immediately containable or composable as the presumably less familiar Hutterites, venerable bluesmen, and rodeo cowboys. Images such as "Grand View Resort, Gull Lake, 1991" (pages 158-159) and "Kee-Nee-Moo-Sha Resort, 1995" (page 165) originate from the complexly idiosyncratic part of Allard's compositional and tonal repertoire, and seem to represent the photographer (forgive me) sharing Minnesota like a memory, more than examining it like a subject.

I realize I've sought, in various ways, to say that *Portraits of America* is not a paticularly idiosyncratic collection. It is various, expressive, and intense. Its pictorial effects are extraordinarily rich, even lush. It is romantic, patient, affectionate, comprehensive, technically astute, and unapologetically narrative. Yet ultimately it is quite formal in its technical acumen and artistic vocabulary, and in its rather stately attitude toward the lives and stories it represents. If Allard were a poet he would probably write sonnets.

Therefore, any odd bits of idiosyncrasy stand out. Just as the moody, depopulated pictures serve this populous book as counterpoint, so the compositionally unusual ones amplify, and give us respite from its rigors, while enhancing our appreciation of Allard as a photographic artist with much to show us.

Not that he ever completely breaks rank; just now and then ventures slightly aslant of his formalities and gives in to impulse. The quietly disturbing portrait entitled "Ricky Murphree, North Mississippi Retardation Center, Oxford" (page 101), and the arresting "Ole Miss fraternity Christmas party, Oxford" (page 107), are two cases in point: dissimilar images which transmute the human form and dramatize the human story by representing life as an arrangement (on the one hand) of parallel vertical lines, and (on the other) of acute, congested angles. Nothing human is lost. The poignance of young Ricky's all-too-determined life, and the smug, self-occupied remoteness of the frat kids are, if anything, made more palpable by the blunted framing, the bodies left partial, the subjects' indifference to the camera. The route to what's human has simply, briefly changed away from the sturdier compositional reliances of the rodeo horses and rugged cowboy faces. It's as if these few unexpected and seemingly complexer subjects required a less pictorial and more pointedly abstract eye for their truths to be seen.

That's hardly all one would like to say about William Albert Allard's photographs. And this from an admirer who started by claiming not much needed to be said. If you're still here, this is all you have time for before the photographs themselves. Avedon wrote that "A portrait is not a likeness. The moment an emotion or fact is transformed into a photograph it no longer is a fact but an opinion. All photographs are accurate. None of them is the truth." Portraits, he ultimately argued, are performances. And that's not a bad way to think about William Albert Allard's photographs—as wonderful performances. They don't suffer from being called that. They gain in our esteem—given their particularity, their luminance, the high finish they give to human existence—if we think of them not as facts but as art, made things, opinions, as brightly informative and indispensable mediators between the world and we who would see it, like it, live in it more fully. □

RICHARD FORD
2001

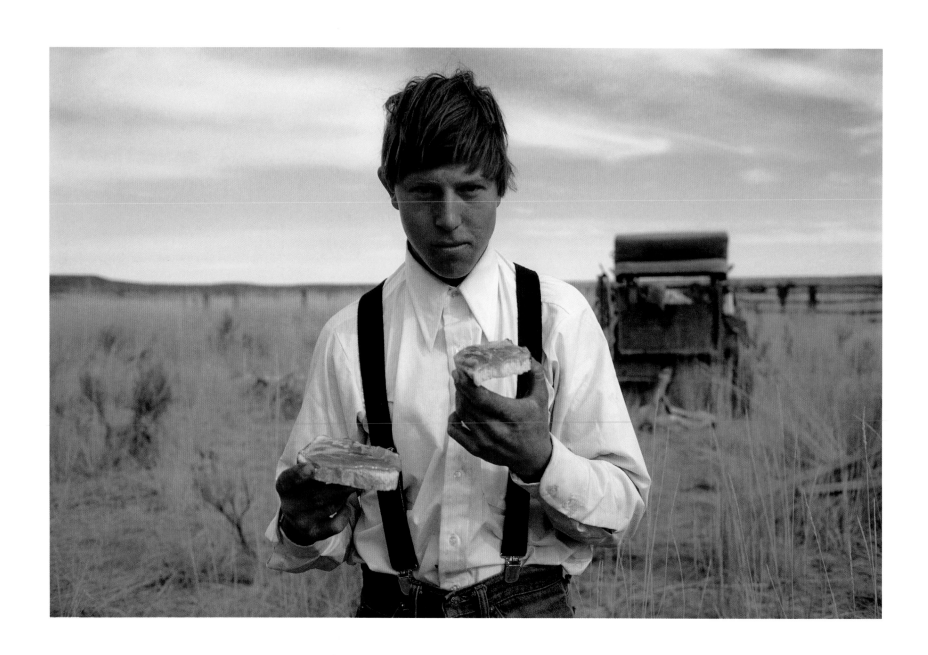

*T.J. Symonds, IL Ranch, Nevada* 1979

# INTRODUCTION

A FEW YEARS AGO I HEARD MYSELF REFERRED TO as "a photographer who specializes in America." Hmmm, I thought, at the time. What does *that* mean? I felt almost slighted. After all, I've worked in about 25 different countries. That's not nearly as many as some of my friends in the profession, but my passports have been stamped a few times over the years. I've traveled. I've been around.

On the other hand, I admit there have been moments when I've questioned whether, in fact, I am missing a gene that photographers who work for NATIONAL GEOGRAPHIC are supposed to have. In my 37-year career—photographing for a variety of magazines but mostly GEOGRAPHIC—I *have* stayed at home a lot in the sense of working in my native country. But for good reason: I keep falling in love with the place. There is a lot to love about America, and as a photographer and writer I've been able to find as much as I could possibly ask for, or fully handle, with places and people here in the United States, particularly within the rural landscape. There is no examination of inner cities or American suburbs here, no Baltimore neighborhoods, no tract housing social mores, no mean streets; I didn't gravitate in those directions.

In some ways this book is a kind of self-portrait. It represents both a retrospective of my work in America over the years and a reflection of a good part of my life up to now in the sense of what I have found appealing as an artist and a person. Looking at the subjects in the Table of Contents, I can't help but think back on how I came to be involved with them.

In June of 1964 I was asked to photograph the Amish people of Lancaster County, Pennsylvania, for my first assignment as a summer photographic intern for NATIONAL GEOGRAPHIC. My first profesional job out of the University of Minnesota, this was my first opportunity to photograph in color, and my first chance to take those youthful hopes and ambitions built up during five years of school, with all the accompanying naïveté, to try to convince someone to let me photograph their way of

life despite the fact that their way of life rejected mine. To be the subject of photographs at all was forbidden by the Amish religion. It would not be the last time I'd be faced with that kind of challenge. It was a critical starting point to the direction I would take in my pictures.

Starting in the late 1960s, when I was in my early 30s and in the spring of my career, I was drawn to the American West and it would become a large part of my life and work for more than a decade. Because I had photographed the Amish of Pennsylvania with success, I was asked by NATIONAL GEOGRAPHIC in 1969 to explore the possibilities of doing a story on Hutterite colonies and their communal way of living. I visited colonies in three Canadian provinces, and several in the Dakotas and Montana, and decided to concentrate on two colonies in Montana. I was asked to photograph and also write the story. Besides building the foundation for a friendship with Hutterite families that has lasted to this day, my time in central Montana that year was the real beginning of my love affair with Montana in particular and the American West in general.

For the next ten years I concentrated on developing ideas for stories I could do in the West. I worked abroad, as well, but tried to go west whenever possible. During that decade I did a book on the American cowboy for National Geographic, and magazine stories about ranch life and about Chief Joseph and the Nez Perce Indian War of 1877. Then, in 1980, I decided my photographic vision was not growing and I needed to say good-bye to the West as a major resource for my work. So I took a leave of absence from it for the better part of 15 years, working often outside the United States. I did stories for NATIONAL GEOGRAPHIC on Peru, Provence, Cyprus, and Sicily. I did just a little work out West in the early 1980s and not again until I returned to photograph Montana's Missouri Breaks in 1996. Then, in 1998, I photographed professional rodeos in seven western states. Although I don't have the desire to photograph out West as much now as I did before, that vast country

continues to draw me to its mountains and plains and to spend time there with old friends. And there are times when I simply need to go to Montana, just to be there, to feel whatever it is about that place that draws me to it.

In 1996, for example. I'd been expecting to go to India for NATIONAL GEOGRAPHIC. It would have been my first time working there, and I was looking forward to what I knew would be a tremendous visual experience. But that didn't happen. Instead, I was asked if I'd like to do a story about perfume or one on Naples, Italy. I didn't feel a great desire to do either one, I was so disappointed about not going to India.

Disappointment can inspire you or it can put you into a funk. I was not inspired. But I told the magazine I'd take the Naples assignment. I'd worked in Sicily a couple years earlier and that had been wonderful. Naples has got to be a good place to see, I thought. But before leaving for Europe I realized that the intensity I need to feel for a subject was missing, and I decided I somehow had to go to Montana. I needed to find work there that would clear my mind. I wrote a quick proposal for a story about the Missouri Breaks country of north-central Montana, and it was accepted. I cancelled my plans for Naples, got into a three-quarter-ton diesel pickup truck with a camper top, and headed west. I spent the spring and fall roaming the Breaks country searching for images, seeing old friends and making new ones. Getting in some Montana time.

My first attempt to read William Faulkner was his novel *As I Lay Dying*. A small book, if such can be said about any Faulkner work, it was an intriguing and difficult, elusive piece of writing for me. I was around 22 years old, and reading was as necessary to me as eating. I was devouring books, kind of catching up on what I should have been doing in high school. I was a student at an art school, but I thought maybe I wanted to be a writer; I hadn't yet fallen in love with photography. At the same time I was attempting to navigate Faulkner, I was also reading John Steinbeck, F. Scott Fitzgerald, and a lot of Ernest Hemingway, especially his short stories. Hemingway was so straight to the point. Declarative. Faulkner was all puzzles with a zillion pieces. There's a lot to that first Faulkner book I read that I didn't comprehend at the time, and there's some doubt as to just how fully I have grasped much of that man's art. He is an adventure for the mind, if, at times, a struggle. It would be almost ten years after cracking open that Faulkner book before

I would first see his Mississippi, in 1968, on an assignment for *LIFE* magazine to photograph blacks leaving the Mississippi Delta to take part in the Poor Peoples' March on Washington. It would be close to another two decades before I'd return to Mississippi, this time to work on a NATIONAL GEOGRAPHIC story I'd proposed on William Faulkner, to take on the challenge of bringing my cameras into the shadows of Faulkner's genius.

In the spring of 1990 NATIONAL GEOGRAPHIC offered me a choice of two available assignments: Russia or minor league baseball. I don't think it's possible to conjure up two more radically different subjects, and I chose—after lengthy consideration of perhaps five minutes—to go to baseball games that summer. Russia will always be there, I thought, and we'll always be doing something about Russia in the magazine. But we'll never, ever again do a story about baseball, a game that was part of me as a kid, just as it was part of most American boys in the mid-20th century, those years when baseball was still the national pastime. I couldn't resist the chance to photograph what once was a dream.

The first minor league baseball game I ever saw was on television. The Minneapolis Millers was a Triple A team—that's just short of major league quality baseball, playing in the American Association—a farm, or franchise, club of the New York Giants. We'd listen to the Millers' games on the kitchen radio in the early years of television, before we had a set. Sometimes my father would send me over to the home of a friend who had one, so I could watch the team play. My father's friend kept the living room dark so that the TV, with its ghostly blue-gray light, was the only illumination in the room. I always felt a little awkward because I didn't really know the people; they didn't have any children, and I'd sit silent and alone in their living room watching the game, with its small flickering figures on a black-and-white field of play.

Baseball has traditionally put drama into the everyday lives of millions of ordinary people. On a Sunday afternoon in early October 1951, a bunch of the kids in my neighborhood were out on Aldrich Avenue, throwing around a football and periodically checking in on the score of the third and deciding game of the National League playoffs between the New York Giants and the Brooklyn Dodgers, which was being broadcast on the radio. I can't recall what kind of day it was, cloudy or sunny. That was a long time ago. I had just turned 14. What I can clearly recall, however, is one of my friends suddenly

tearing out his front door as if the house were on fire. He was wide-eyed and screaming like a teenage maniac, a redundancy, I suppose, but that's how I remember it.

"The Giants win the pennant! The Giants win the pennant! The Giants win the pennant!"

My friend was echoing words that would become legendary, words spoken moments earlier when New York radio announcer Russ Hodges described the dramatic end to one of the most famous baseball games ever played, the Giants defeating the Dodgers on a Bobby Thomson ninth inning, game-winning home run, a blow that made some hearts soar while others were shattered. It put the Giants into the World Series and Dodger fans into deep despair. Playing for the Giants that day was a young man who'd started the season in a Millers uniform but had quickly been sent up to the Giants, to try to make it in the big leagues. He did. His name was Willie Mays.

Because I was born and raised in Minnesota, that land of more than 10,000 lakes, the lake country was in my blood long before I ever approached it with a camera. For 60 summers my family visited the same small lake, staying at one of the rustic mom-and-pop resorts now dwindling in number. In my mid-20s, I moved from Minnesota to the Southeast. You get spoiled when you grow up in the middle of something like the lake country and maybe you don't really appreciate it until you move away and it's not so easy to get there anymore; it's not just a matter of "goin' to the lake." So in 1991 when I went back home (although I've lived in Virginia almost half my life, Minnesota will always be *home*, I suppose) to work specifically on a photo essay about the northern lake country, I found even deeper personal waters than I had consciously realized or expected would be there. It was kind of like digging through a junk drawer and finding a box of stuff that's been transferred who knows how many times to how many different houses. In it you come across an old dog collar and tag with the name of a beloved friend long dead. It brings up lots of old images and feelings. Going back to Minnesota to do that work in 1991 was like that. I have tried in years since to return as often as I can.

I am frequently asked: "What was your favorite assignment?" and "Do you have a favorite picture?" Impossible questions to answer, I say, or, at least I *used* to say. I still cannot select a favorite picture. That's like being asked to pick a favorite child. But my favorite assignment, as of right now? Blues music. Hands down, blues music. Even more than all the pleasure I got from chasing around out West for so many years, the pleasure I took in 1997 while making the photographs in "A View of the Blues" was simply the best experience of my career, thus far. Music has always been a major force in my life, a daily need. I've never enjoyed photographing more than I did while hanging out at blues festivals and in clubs and joints late at night just listening to good music being made and trying to show how it felt to be there, to hear it and feel it. It was an absolute labor of love.

In truth, all these subjects were serious love affairs, first loves, some of them. You can have more than one of those in a photographic life. First loves tend to die hard. They may not— and often don't—last, but when they are over they leave something of themselves within you forever. And I have the photographs to prove it. □

WILLIAM ALBERT ALLARD
*Afton, Virginia* 2001

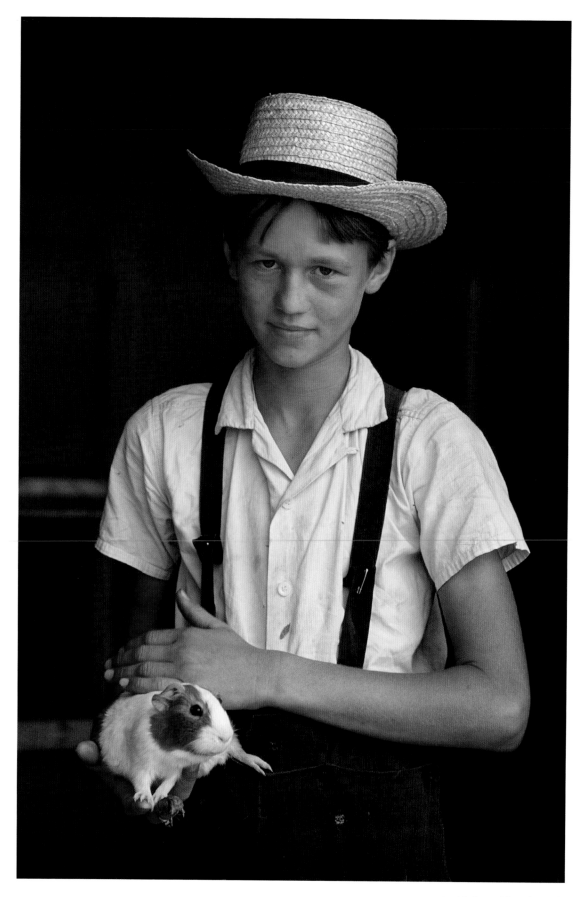

*Amish boy with guinea pig*

# THE AMISH

### [ LANCASTER COUNTY, PENNSYLVANIA 1964 ]

IN THE SUMMER OF 1964 I WAS LIVING IN WHAT I THOUGHT HAD TO BE THE smallest hotel room in North America, or at least in Washington, D.C. The Alturas on 16TH and P Sts. N.W., was a small residential hotel just a couple blocks from the headquarters of National Geographic where I was newly employed as a summer photographic intern. In my hotel room was a narrow bed, a small dresser, a tiny table, and a single hardback chair. With five large steps you could travel the length of the room; less than that would cover the width. The positive side was that the room was cheap and close to the Geographic. The negative side was that the room had cell-like dimensions and lacked air-conditioning in a town just slightly less tropical in the summer than, say, New Orleans, or maybe Hong Kong. Of course I didn't actually know that when I arrived from my home in Minneapolis because I hadn't really been much of anywhere outside Minnesota before, certainly not to New Orleans or Hong Kong.

Anyway, there I was in June, and with the first hot, humid day I found myself wondering just how bad it would be by August. Fortunately I was soon given an assignment that took me out of that room and that town for a good part of the summer, although, not, as I recall, in August.

I had two major breaks that summer. The first was being selected by Bob Gilka, then the director of photography for National Geographic, for an internship at the magazine—an opportunity to prove myself without having to go the usual route of starting at a small newspaper, then struggling to get noticed and maybe move up in the profession. It was a long shot—a temporary, low-paying summer job; but it was a chance. The second break came with my first assignment as an intern: to photograph the Old Order Amish of Lancaster County, Pennsylvania, people notorious for not wanting to be photographed.

In some ways I was prepared for that challenge. It was less than a month since my graduation from the University of Minnesota with a degree in journalism, specialization in photojournalism. I didn't want to work for a newspaper. My primary interest was to document people and their lives as a mag-

azine photographer; the chances for doing extended stories with well-reproduced pictures were better. In the years after high school and while studying at art school and then the University of Minnesota, I had worked a lot of different jobs that allowed me to observe people: I'd been a telephone construction lineman, a cab driver, a beer truck driver; I'd sold pots and pans to brides- to-be; and I'd managed a nightclub.

When I started at National Geographic I was 26 and married, with four children ages one through four. Because of my age and family situation, I sometimes felt much older than I was. I had a lot of ground to cover to reach my goal, no time to waste. It simply didn't occur to me that I might not have whatever it takes to do that. And I liked people. If you want to photograph people it's better if you feel comfortable around them and are curious about their lives. I was.

There was a lot to be curious about with the Old Order Amish. They shun modern conveniences the rest of America takes for granted. No cars or trucks, no electricity in the houses or barns, and, for the most part, no gasoline-driven farm implements; they work their fields with mules and draft horses. They travel by horse-drawn buggies. They believe that to

pose for a photograph is sinful, "a graven image," and adults, especially, refuse requests to have their pictures taken. Children, being children, are allowed to be a bit less wary.

Through a young non-Amish friend I'd met my first day in Lancaster County I started trying to meet the Amish. My new friend's father owned a gravel quarry and sold to Amish farmers. He gave me names of a couple of people, and I went out looking for them. I'd tell them who I was and the magazine I represented. The first man turned me down. So did the second. I think it may have been the third man I approached who, after also declining, suggested I might speak to his son Melvin Stoltzfus, who, with his wife Barbara and four children, farmed nearby. I talked to Melvin and Barbara, and after I described what I wanted to do—simply be around to make a few photographs—they agreed. I'm not sure why they said yes to me.

I visited their farm, not every day, but often enough for them to become accustomed to my presence. Melvin and Barbara were about my age, maybe a couple of years older. They were very hospitable, sometimes inviting me to join them for lunch or dinner. I photographed them at work and in their home, but I never asked them to pose.

My identity soon became known as I drove the back roads of the county in my sky blue 1960 Ford sedan from the National Geographic garage. I'd show up here and there, at a barn raising, maybe a mule auction, sometimes at the edges of fields ripe for harvest.

My photographs from the six weeks I spent in Lancaster County that summer and fall are simple pictures of quiet people. I photographed Amish kids being taught in a one-room school, where a real dunce cap waited to be donned by some unfortunate child; round-face toddlers looking out the back windows of buggies; kids meandering along the roads; Amish buggies passing in the rain.

Sometimes while photographing landscapes along the edge of a field by one of the covered wooden bridges then still standing in the county, I would hear the rumble of steel-rimmed carriage wheels and the hollow clop of pacing hooves long before I sighted the approaching buggy.

An afternoon I remember better than most came on a gray, rainy kind of day that I was tempted to spend in my motel room reading; instead, I went out looking for pictures. Driving the roads, I saw an Amish farmer stringing a wire fence from a flatbed wagon drawn by two draft horses. On the wagon were two children, a young boy and a little girl. I stopped my car on the shoulder of the road, left my cameras on the seat, and walked down the bank and out into the field. I think they recognized my car. I think they knew who I was. I introduced myself and asked if I could ride on the wagon and take some pictures of them building the fence. He said he thought that would be okay.

I spent a couple of hours with them. I took some portraits of the little wisp of a girl standing beneath the heads of the huge horses. The kids played with their dog and picked clover they said was to feed a pet guinea pig. The father stopped once to remove a sliver from the toe of his barefoot son, and at the end of the afternoon the boy asked me if I would like to take some pictures of his guinea pig. We walked up to the barn and as the father unharnessed the horses, I photographed the boy and his pet. Looking at the picture now, it is a simple portrait but it seems to say so much about those people and their ways. It says a lot, but very quietly.

The published photographic essay about the Amish had an intimacy to it that was uncommon in National Geographic at the time. Some have said that my Amish pictures represented a landmark, the beginning of change in the way the magazine depicted people. If that's true, I was lucky to have had the chance to contribute to that change. □

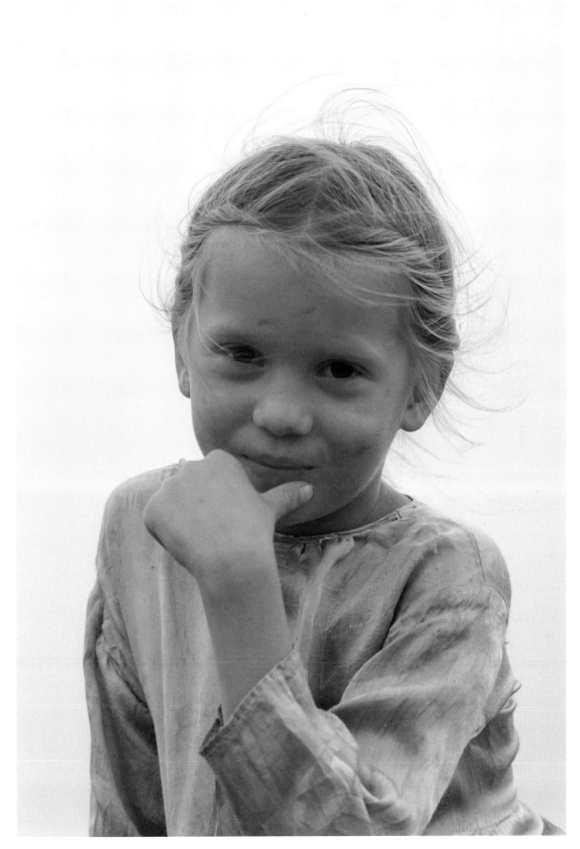

*Girl in a blue dress*

*Amish fields*

*Harvesting grain*

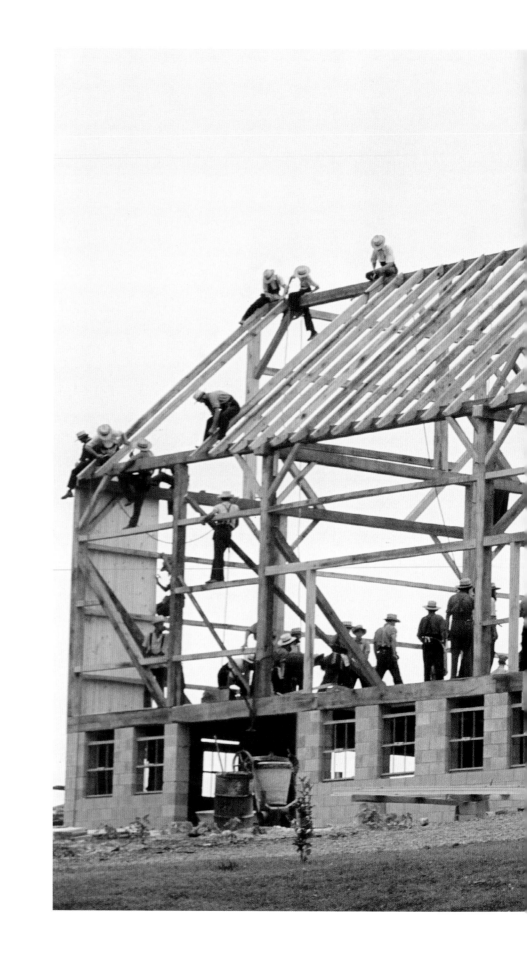

*Barn raising*

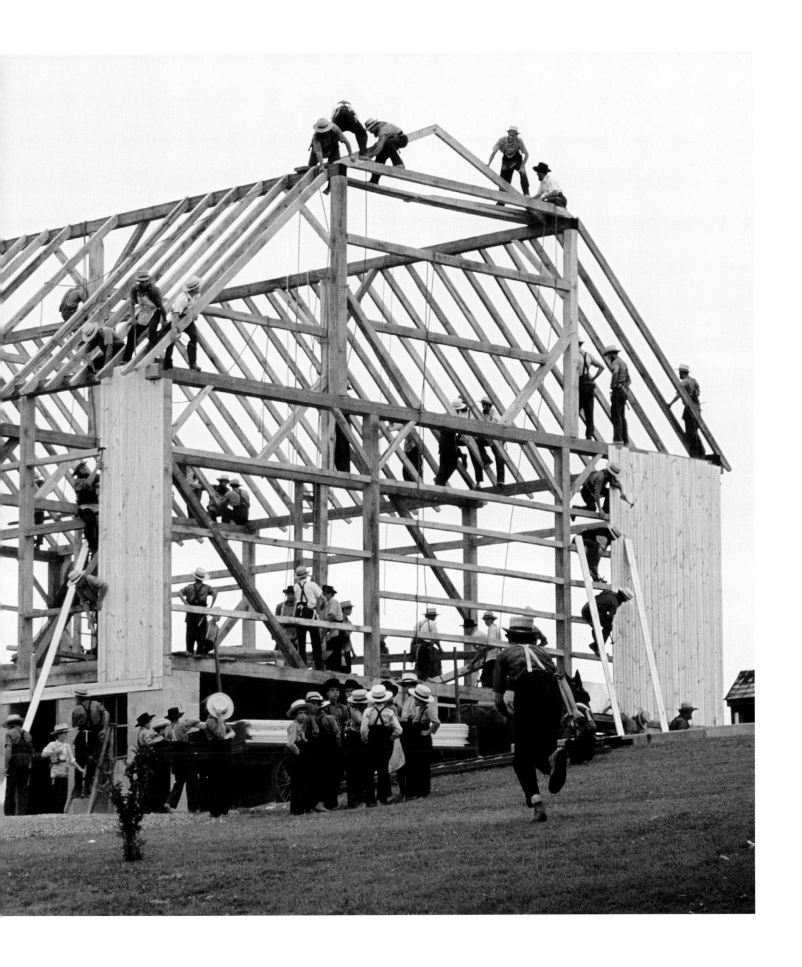

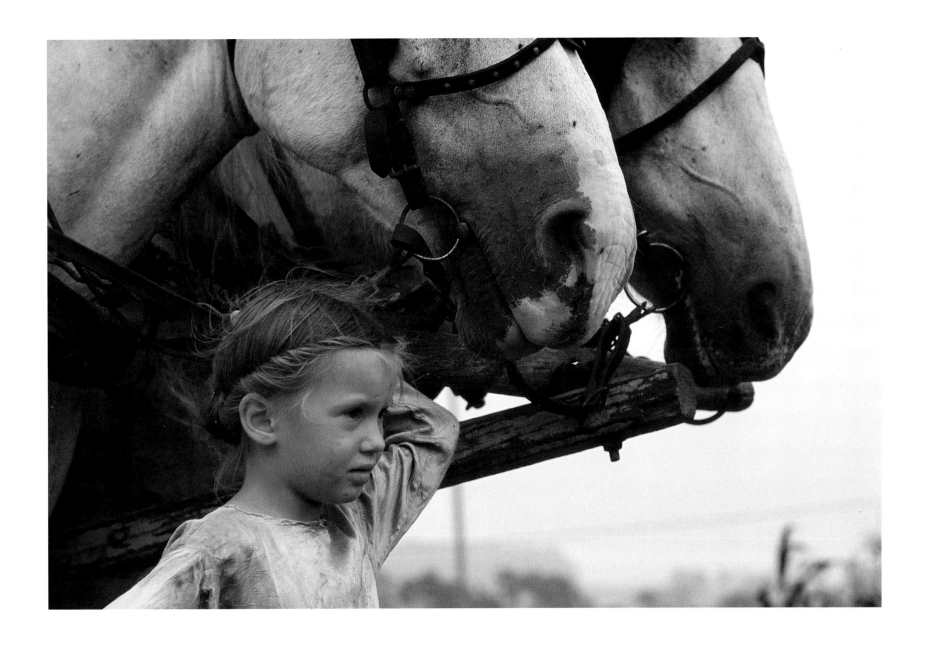

*Girl with horses*

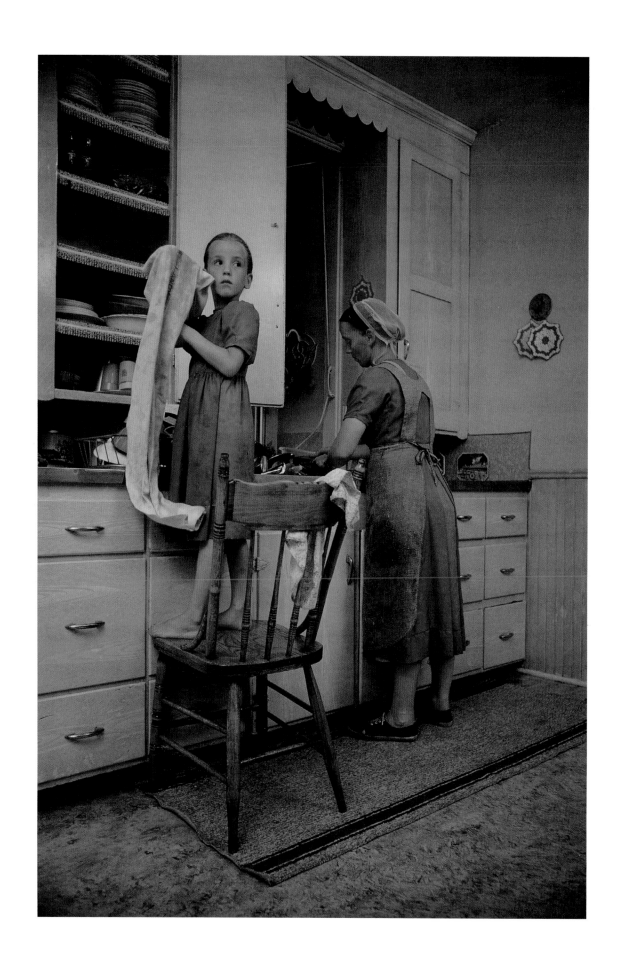

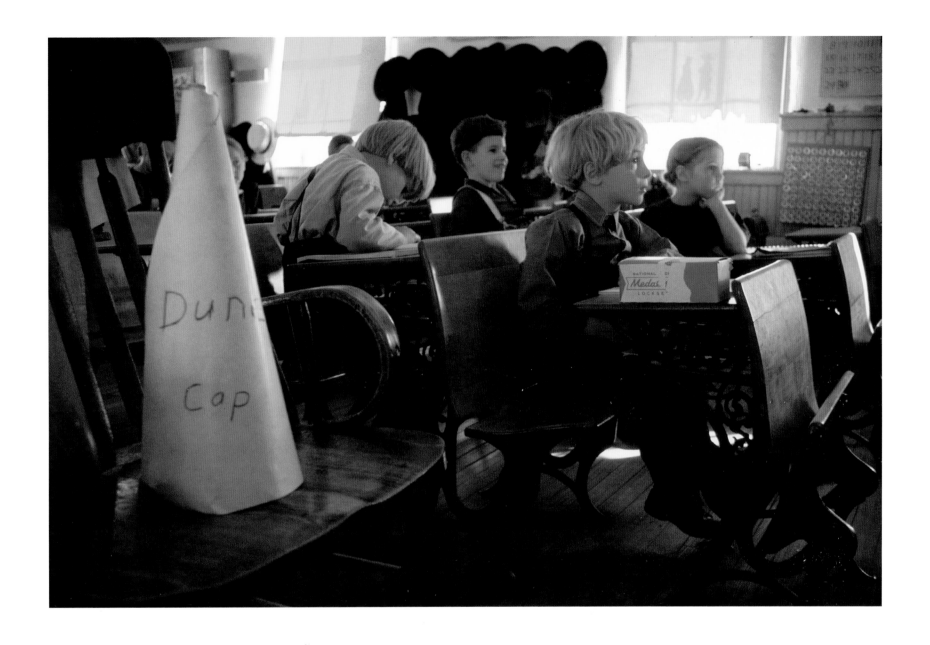

One-room school

LEFT: *Barbara Stoltzfus and her daughter*

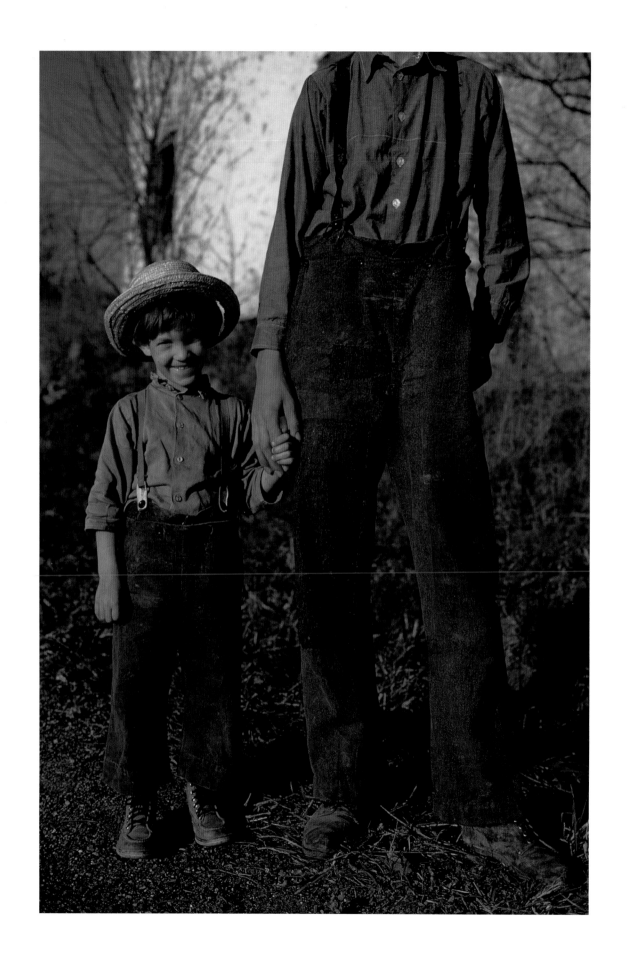

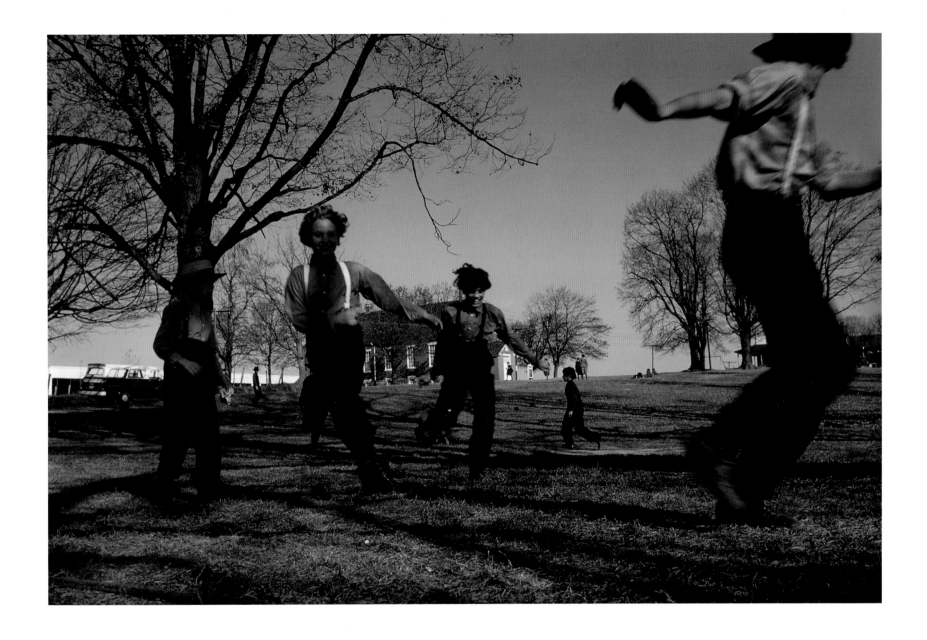

*School recess*

LEFT: *Brothers*

27

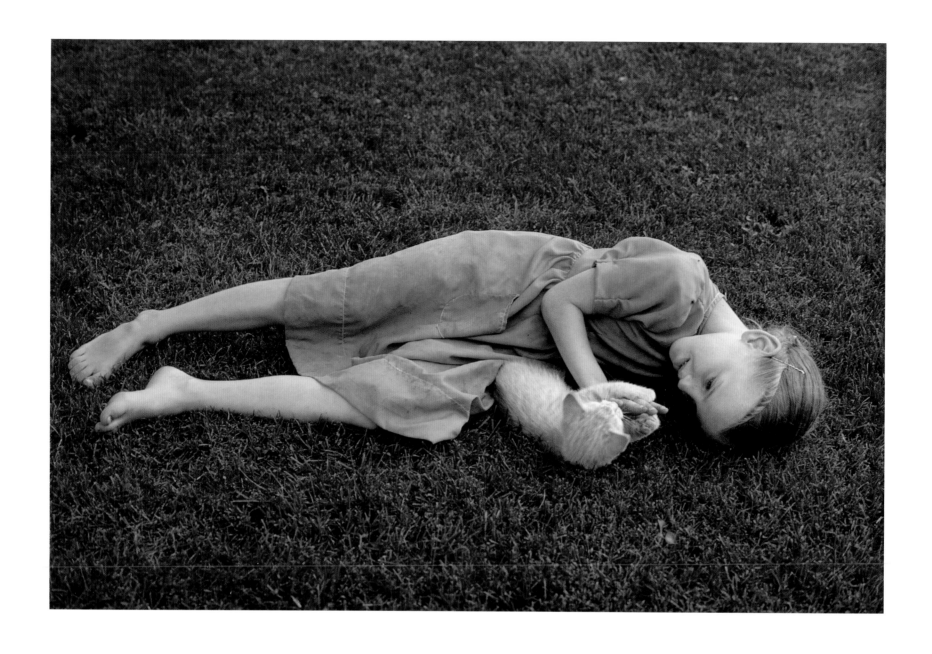

*The Stoltzfus girl with kitten*

RIGHT: *Boy at an auction*

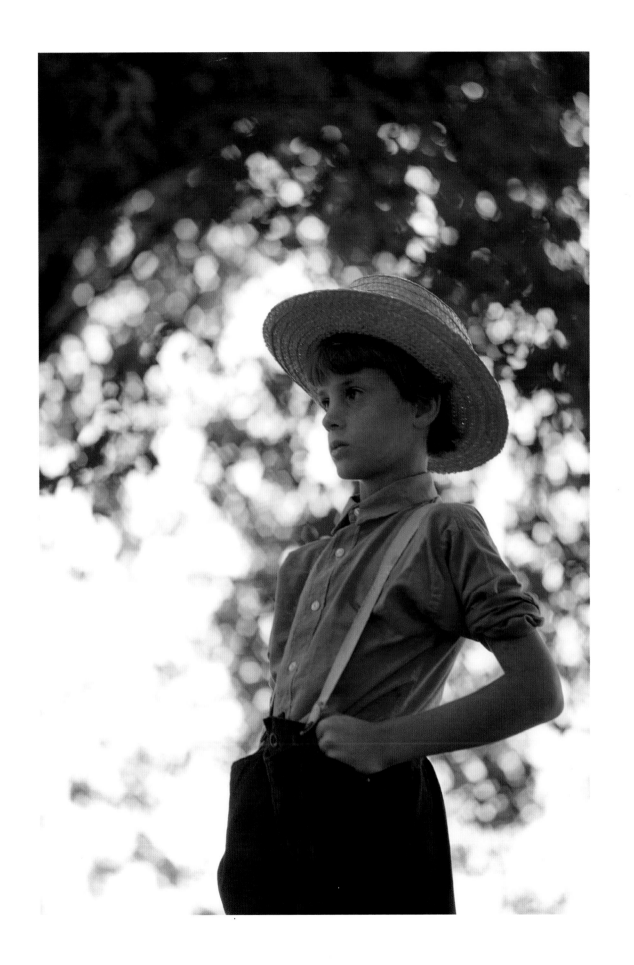

*Amish buggy in the rain*

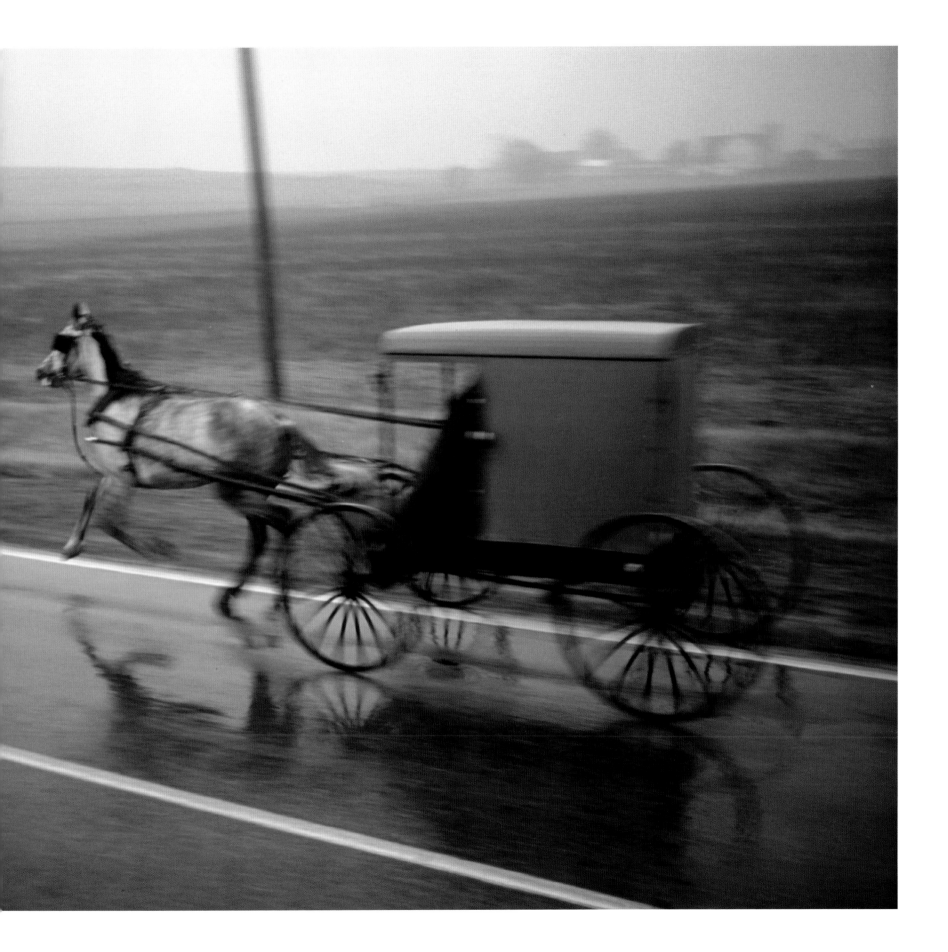

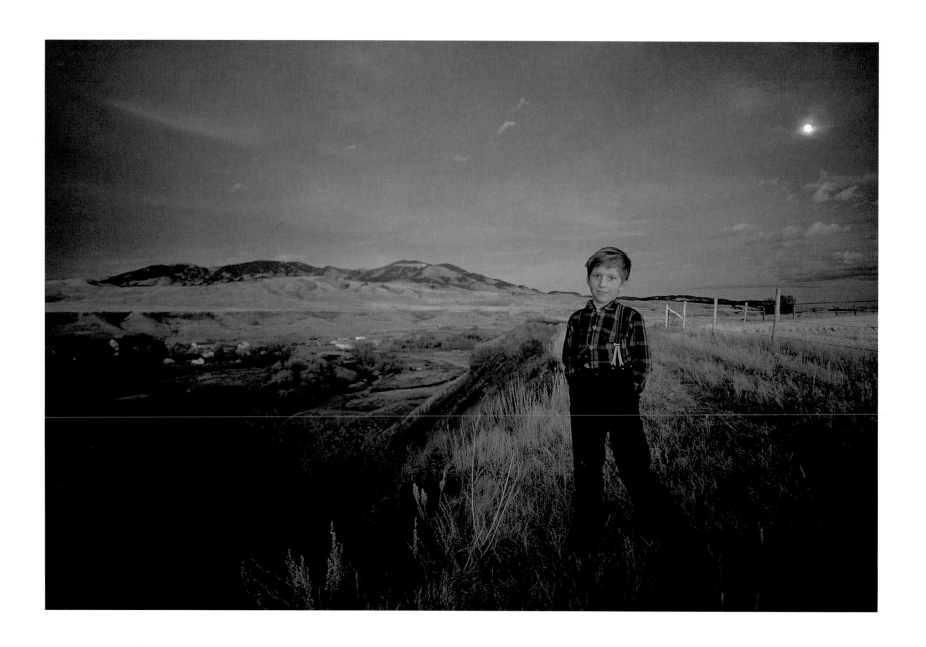

*Herb Walter in the fields above Spring Creek Colony, Lewistown, Montana*

# THE HUTTERITES

## [ MONTANA 1969 ]

DRIVING 87 EAST OUT OF GREAT FALLS ON A LATE WINTRY NIGHT, THE WIPERS slapping snow from the windshield, I sped by tiny central Montana communities spaced out over 90 miles of two-lane highway. Belt, Geyser, Stanford, Windham and Moccasin, Hobson and Moore. I couldn't really see much of them. Had it been daylight, I'd have spotted the distant water towers and grain elevators, those landmarks of the American West that often bear the name of the place you're coming to or leaving. I'd have slowed some to see the catch pens and loading chutes at the edges of the towns; the wooden bleachers of the arenas where they have once-a-year rodeos; the solitary gas station liquor-and-grocery store and the occasional low-slung, no-frills motel. But at night, between slashes of the wiper blades, all I saw was a scattering of lights like low-lying stars, and then quickly they were behind me and I was heading into a vast darkness once again.

Along the way I crossed over Surprise Creek, Wolf Creek, and the Judith, a narrow ribbon of a river flowing northward, where in less than a hundred miles it will empty into the Missouri. The Judith River once gave up its beaver to mountain men of legendary times just a few decades after explorers Lewis and Clark came up the Missouri on their epic journey. They were headed for the Pacific Coast and a monumental place in American history. I was headed for Lewistown hoping to find a good motel and a story about some people called Hutterites.

In Lewistown the sidewalks of Main Street were softly bathed in lights from store windows and the neon signs of bars and restaurants, all seeming to beckon travelers to come in off the road and stay awhile, or at least stop and have a drink and something to eat. I swung around a side street and passed the Mint bar (I sometimes wonder if it's mandatory for every town in the West to have a place called the Mint), then pulled back onto Main Street, parked, and went inside another place called the Midway, and into a miasma of aromas with the staleness of yesterday's beer and cigarettes, the heady edge of whiskey, and in the restaurant attached to the bar, the homemade fragrance of the evening's specials. Men with bronzed faces and crisp

white shirts sat at cloth-covered tables eating and drinking. The Midway was a ranchers' and cattle buyers' bar and restaurant. I stayed late there more often than I probably should have starting with that very first night in 1969. I thought the lamb chops were the best I'd ever had and I'd gnaw the bones clean. Today the bar has become a casino and the restaurant, although still there, has changed some and the lamb chops are gone.

That first wintry night in Lewistown—actually it was around the end of March, but that can still be winter out there—was kind of a travel epiphany for me, one of those times that leads to a lifelong affection for a place. Of course, it wasn't just Lewistown or the Midway, the whiskey or the lamb chops I was falling in love with, although, like a first kiss, that may have been all of it that first night. Ultimately, it would prove to be Montana.

Montana. It feels good just to say it. I'd been there before, initially about three years earlier, but I'd spent most of my time then down on the southern edge of the state, just outside Yellowstone National Park. There I'd concentrated on photographing the park's animals instead of people, with occasional forays into Livingston looking for books to read. This

time I was looking for people who would let me enter their lives and their world, a world far different from mine.

Distinguished by their German dialect and Old World clothing, the Hutterites are one of three surviving Anabaptist groups in North America that originated in Europe during the 16th-century Protestant Reformation. The other two are the Mennonites and the Old Order Amish. Unlike the Mennonites and the Amish, the Hutterites live communally.

The first Hutterites came to America in the late 1870s, and three different and yet basically similar Hutterite sects can now be found in some 200 colonies scattered about in Montana, the Dakotas, Minnesota, Washington, and the Canadian provinces of Alberta, Saskatchewan, and Manitoba.

At a Hutterite colony most of the dining is communal: men sit at long wooden tables on one side of the room; the women sit on the other. There is very little talk among the men at their tables, and almost none among the women, at least none that I could hear. Children eat earlier than the adults. Hutterites observe strict religious practices and are devout pacifists. Like the Amish, the Hutterites dress in simple, Old World fashion; the women always cover their heads in scarves and wear long dresses. Like the Amish, a married Hutterite man will wear a beard. And, like the Amish, photographs are forbidden by church elders, although most Hutterite families have some photographs tucked away, if not on prominent display.

There are a number of important differences between the the two. Unlike the Amish, Hutterites welcome modern conveniences such as telephones, electricity, and automobiles and trucks, although according to church edict, television sets and radios are not allowed. There will be only one or two telephones on most colonies: one in the home of the colony boss and maybe one at the preacher's. Computers and fax machines are now used by the Hutterites, as well as the latest in farming and ranching equipment and technology.

The Amish live on individual farms and have increasing difficulty finding available land for young Amish men who want to continue the farming tradition. Hutterites' communal structure, on the other hand, gives them an advantage: through thrift and virtually no labor costs, they can purchase large tracts of land unaffordable to many individual ranchers.

Every colony has two leaders: a preacher and a boss. The preacher tends to the spiritual needs of the colonies' inhabitants. The boss assigns jobs to the men and sees that the colony's work gets done efficiently and profitably. In order for me to photograph on a Hutterite colony I had to get permission from both the colony boss and the preacher.

It was not an easy decision for the leaders of the colonies to permit me to work among them as a journalist. For allowing me to photograph some of the intimacies of their way of life, they could be harshly criticized by the elders of their sect. But I have never to this day heard of any serious problem created among my Hutterite friends because of my presence.

Hutterites raise most of what they eat except for some staples such as flour and coffee, sugar and fruit. They make most of their clothing. When there is a major job to be done, like sheep shearing, chicken or geese butchering, almost anything that requires lots of help, the entire colony pitches in, sometimes including most of the children. It was lambing time at Surprise Creek Colony near Stanford when I arrived there the first day, ready to photograph, or so I thought.

Joe Stahl, then 51, a solidly built man with eyes that seemed to look through you instead of at you, the father of a dozen children and one of the toughest men I've met along the way in my career, was the boss of Surprise Creek Colony. Joe had been a colony boss for 26 years. The colony was then running approximately 1,300 sheep and 300 cattle on 14,000 acres. About 50 people including children lived at Surprise Creek in 1969. Today that number has doubled and they will soon need to "branch out," to divide the membership and form another colony elsewhere on newly purchased land. As in other Hutterite colonies, the names Stahl, Hofer, and Walter predominate.

The first afternoon I was there I requested permission to photograph, and Joe Stahl asked me, "What are you—some kind of hippie?"

"No," I laughed, "I'm just a little overdue for a haircut."

He didn't laugh at all.

"Well," he said, looking me straight in the eyes, "how often you get a haircut is no business of mine. But if you're gonna be around here doing whatever you do...let's get one thing straight right now. We don't tell lies around here. We don't raise a lot of hell. All we do is try to mind our own business and get on with our work. If you've got anything else in mind, you'd better get back on the road. If not—let's go look at the sheep."

We looked at the sheep. And from that afternoon on, throughout my visits to the colony that year and in later years when I came just as a friend, Joe Stahl was never less than direct and to the point. A colony boss—voted in by the members of the colony—has a tough job, and I guess he never felt he had the time to be talking just for the sake of talking. Joe died of cancer seven years ago at age 75, the boss to the end. His two oldest sons run the cattle and sheep operation. Another son is the assistant preacher.

The preacher when I first came to Surprise Creek Colony was 60-year-old Eli Walter, a gray-haired and bearded handsome man with an ever present twinkle in his eyes. Eli had no formal religious training, but he had been elected to the position. While I always felt as though I were walking on eggshells around boss Joe Stahl, with Eli I kind of knew his bluster had a smile behind it.

"Hey, you!" he would shout, finding me in the kitchen photographing the women as they canned strawberries. "What are you doing! No pictures of the women!" Standing in the doorway, dressed all in black, there was often such sternness in his voice that I would wince and look quickly for the laughter in his eyes. It was always there. Eli died at 80, six years after giving up his role as colony preacher.

Although I photographed and made friends at three different colonies in Montana back in 1969, I probably spent more time at Surprise Creek than at the others. Preacher Eli's son Darius was my best friend in the colony more than three decades ago when we were both young men. Today Darius is the boss of Surprise Creek, and now when I go to Montana each fall with my dog, Sarah, to hunt and to visit my Hutterite friends, we live at his house.

The Hutterite way of life is greatly restrictive, and converts are rare and not sought out by the colonies. One is born a Hutterite. With everyone living so close, there are few secrets. Like any other community there are problems within. Small feuds sometimes arise within or between families. Beer is distributed to the members, and just about every family makes its own wine out of anything from berries to rhubarb to dandelions. There are sometimes drinking problems.

Now and then a Hutterite man or woman leaves for a life outside the colony. Often they come back, sometimes they don't. It must be very tempting to a young person, thinking about all the attractions out in the big world.

I was in the hills on horseback one day with a Hutterite boy of 17, the son of a preacher. Like other Hutterite boys his age, he sometimes got caught smoking behind the corral, or coming out of the movie house in town when he was supposed to be checking the horses.

The Hutterites have their own way of disciplining their people, young and old. He probably had to kneel in front of the entire congregation in church and confess what he had done. And then he probably had to sit with the little children.

There had been no rain for weeks, and though we walked our horses, the sun brought sweat to their withers, and the 17-year-old told me that you can tell it's really dry when a single rider can kick up a dust trail.

We stopped at a stream, and the water we drank had come down from the mountains and it was cool and tasted of the earth. In the thick heat of midday we drank carelessly, splashing our faces until our shirt fronts hung wet and the falling droplets made pockmarks in the dust.

"Do you ever feel like going away?" I asked.

"What do you mean?" he said.

"You know, do you ever feel like leaving the colony?"

"No," he said. "I've never felt a temptation to leave here. It must be a pretty rough life on the outside, all alone, trying to make a living. Don't you think?"

We let the horses drink and then rode on.

"Yes," I told him. "It can be all of that." □

*Prayer meeting, Spring Creek Colony, Lewistown*

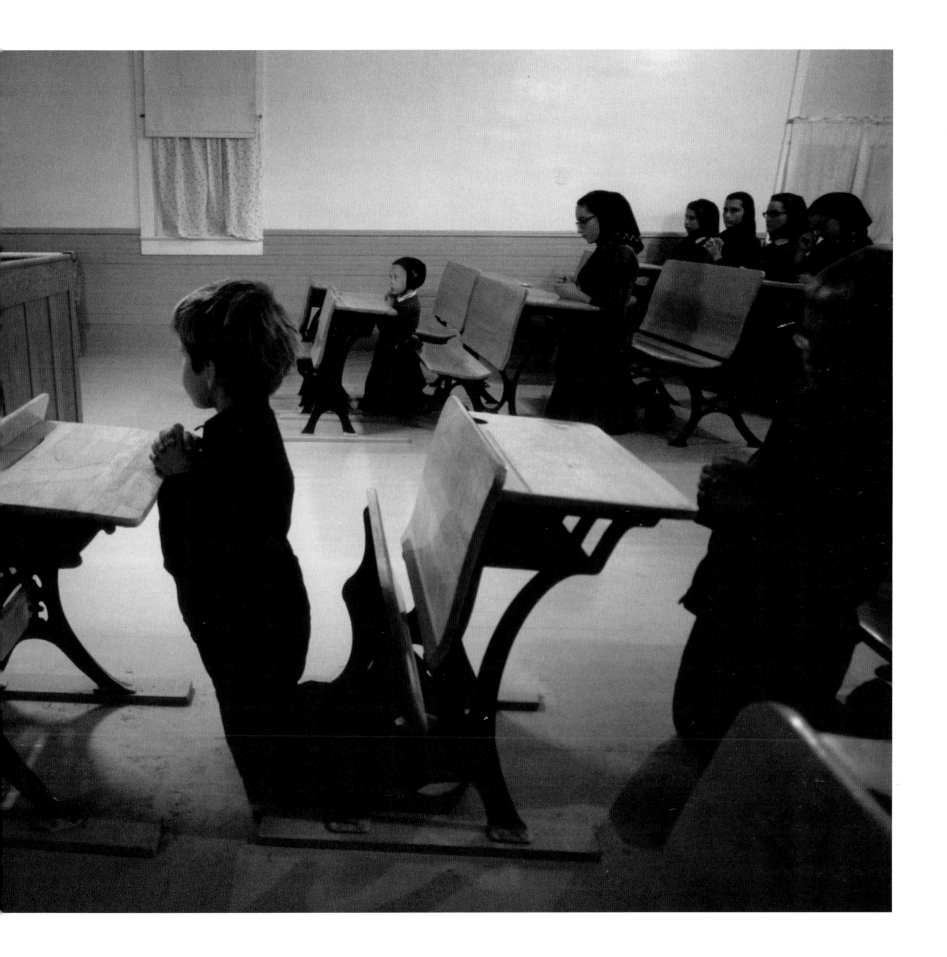

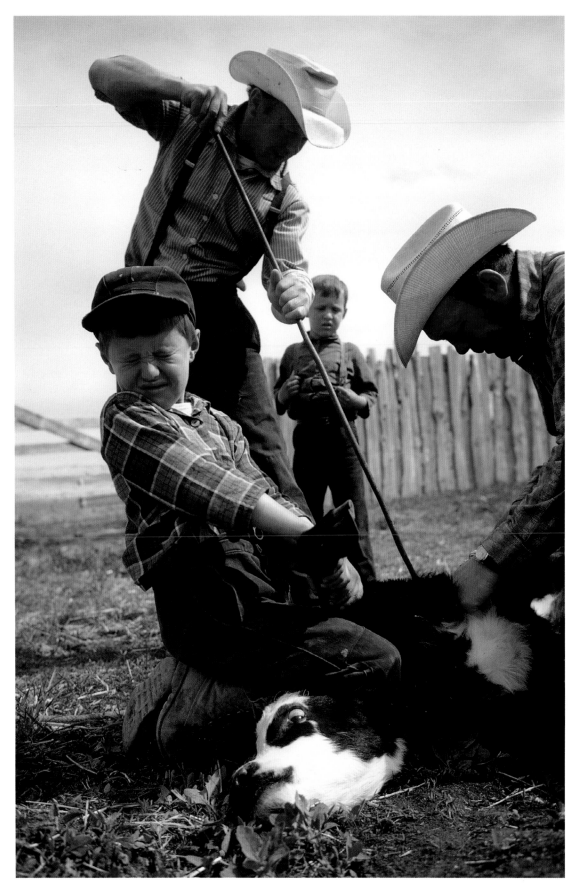

*Calf branding, Surprise Creek Colony, Stanford*

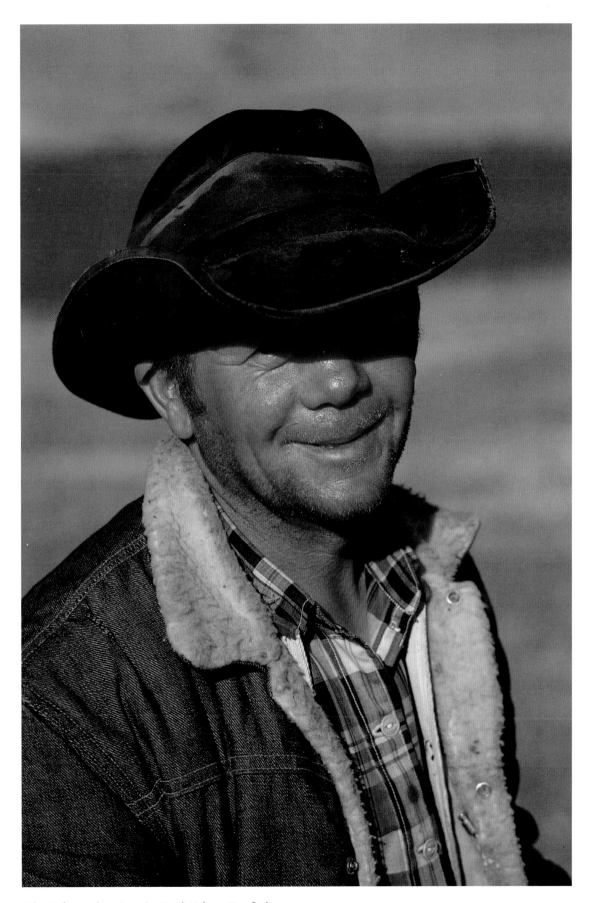

*Jake Hofer, cowboy, Surprise Creek Colony, Stanford*

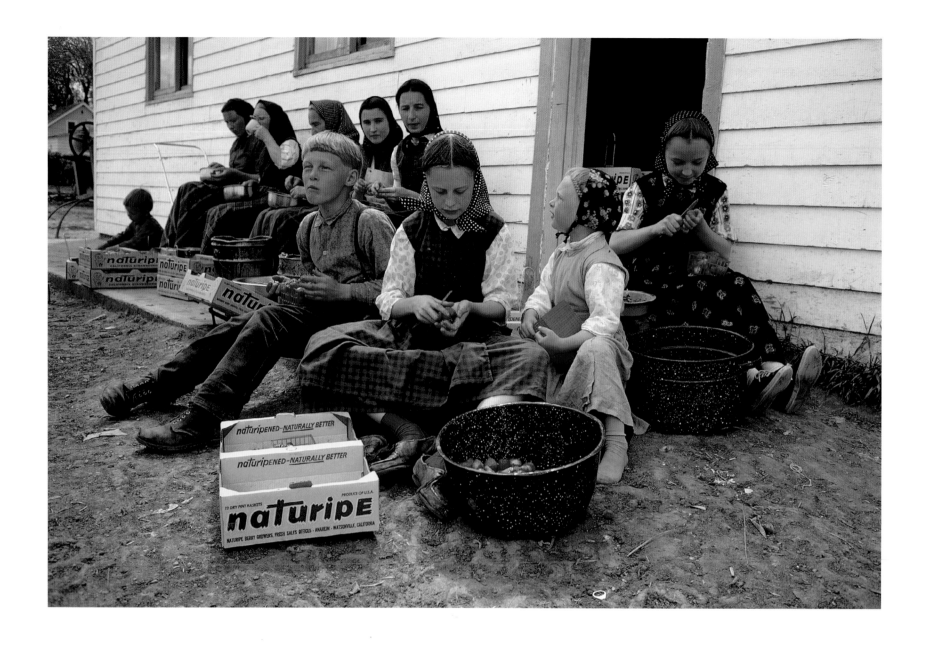

*Canning strawberries, Surprise Creek Colony, Stanford*

RIGHT: *Susanna Hofer with duckling, Surprise Creek Colony, Stanford*

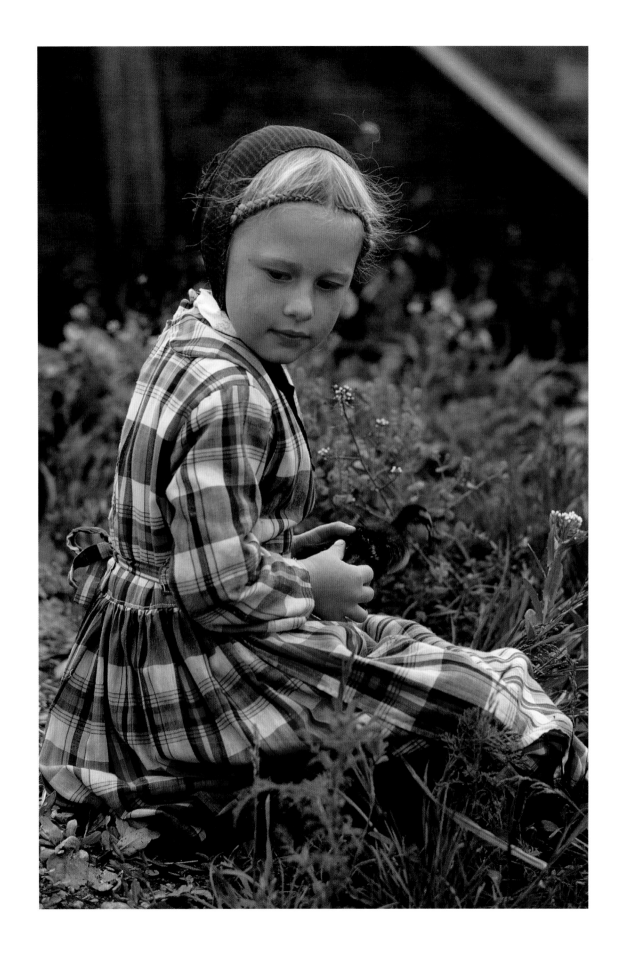

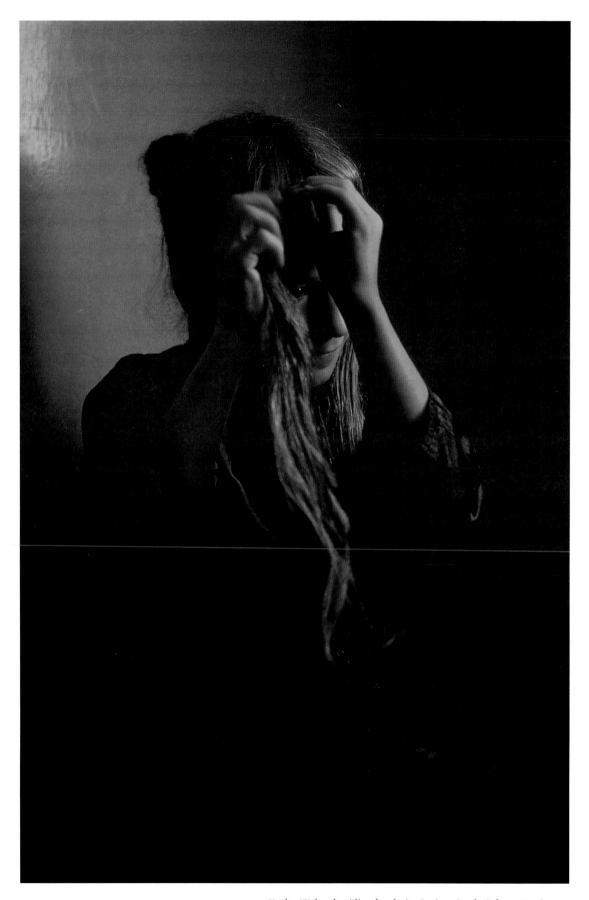

*Kathy Walter braiding her hair, Spring Creek Colony, Lewistown*

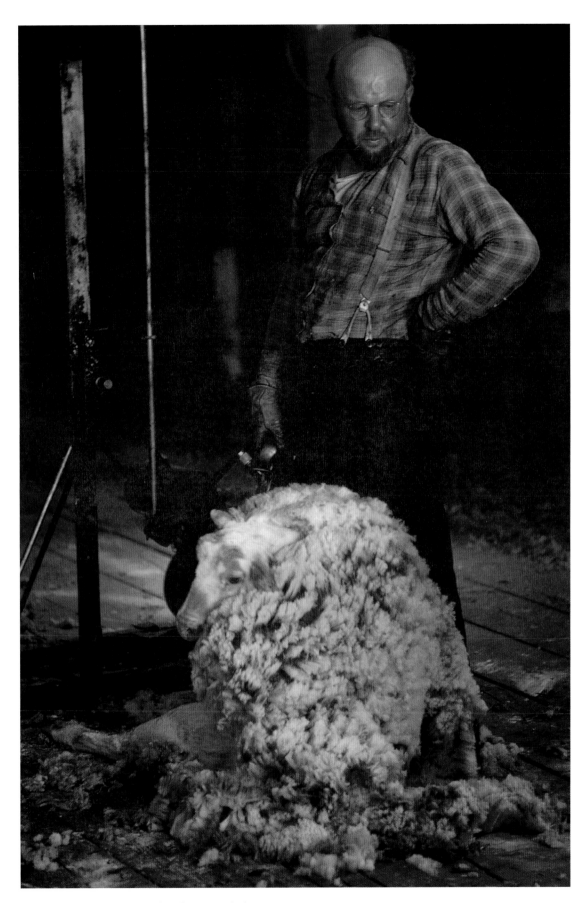

*Joe Stahl, boss, Surprise Creek Colony, Stanford*

*George Stahl, in the horse barn, Surprise Creek Colony, Stanford*

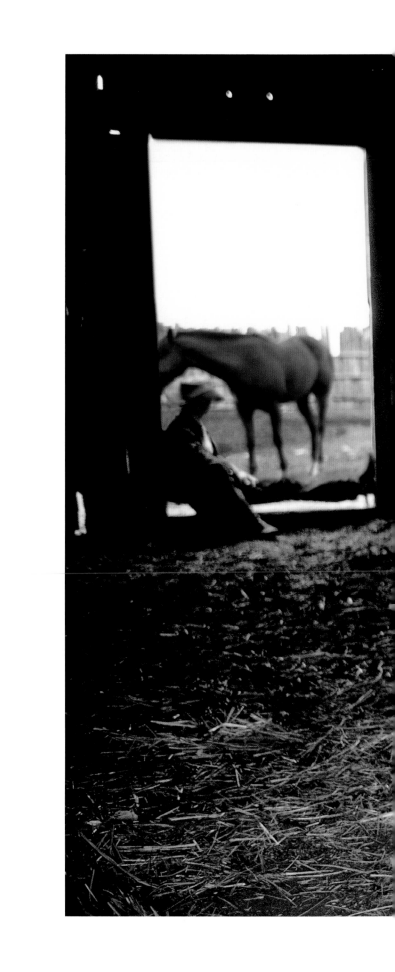

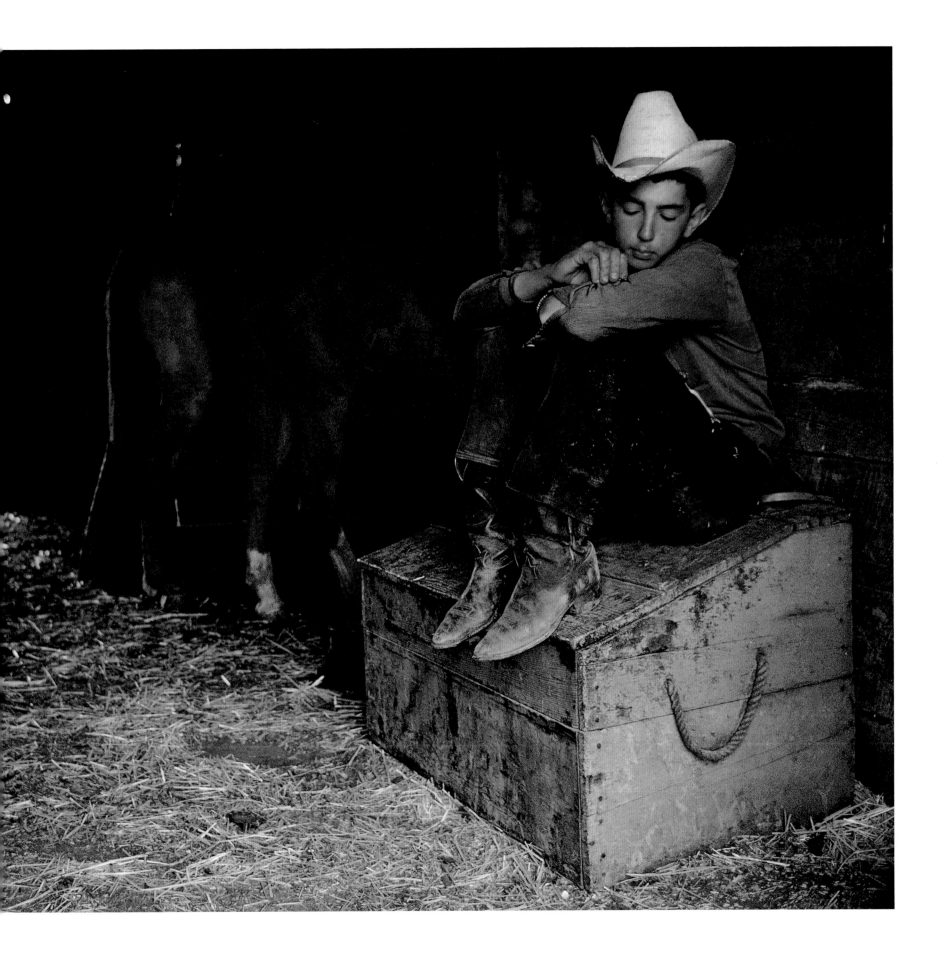

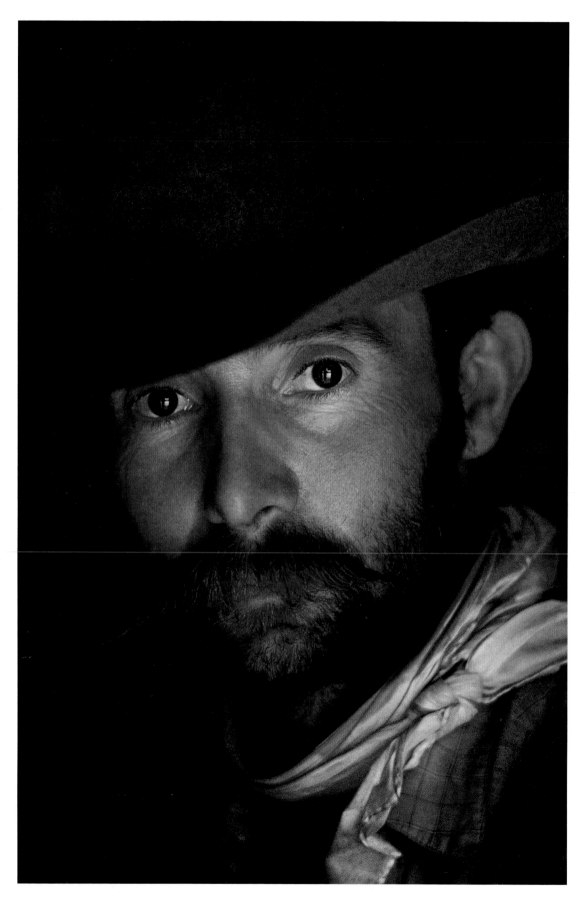

*Brian Morris, buckaroo boss, Quarter Circle A Ranch, Paradise Valley, Nevada* 1970

# OUT WEST

[ 1970–1983 ]

I HAD A SADDLE; WHAT I LACKED WAS A HORSE.

I'd come by plane and car from my home in Virginia to a small ranch house on the Little Humboldt River in northern Nevada where I was told I could find Nate Morris. Old Nate, they said, could give me directions to the Circle A cow camp. Somewhere out there below the Santa Rosa Range was a cluster of canvas tents occupied by Nate's son, Circle A buckaroo boss Brian Morris, and his crew of a half dozen buckaroos. That's what they call cowboys in Nevada and Oregon. They were moving cattle to summer ranges. I wanted to photograph them for a National Geographic book about the American cowboy I'd started the year before, in late 1970.

I'd been with Brian and the Circle A bunch before, and I knew their camp would include a chuck wagon truck, a camp cook, a cavvy of about a hundred saddle horses, and probably one dog. Spaced out over two million acres of Owyhee Desert range were ten thousand head of cattle carrying the Circle A brand on the left hip.

When I reached Nate's place he said the country was way too rough for my car and offered me the loan of a horse. He said he would throw my extra gear in a truck due to go out to camp the next day. He couldn't go with me now but he would draw me a map. It would be a good four-hour ride, but I should be able to make it before dark. I was still young enough to think it would be just the thing to ride into Brian's camp at dusk and surprise him.

So I took Nate up on his offer of a horse. I think it was a blue roan. That's a nice color in a horse.

I had a saddle. I had a bridle and bit and a *mecate*—a headstall with a length of hand-braided horsehair lead rope you could tuck into your belt and grab onto in case you were suddenly unhorsed. I'd found that, used, in Capriola's saddle shop in Elko, Nevada. I had my new shotgun chaps I'd bought recently in Lubbock, Texas, trading off my old bat-wings. And I had a pair of ropers' spurs I'd bought a year earlier from my friend, Darius Walter, at the Surprise Creek Hutterite Colony in Montana. I'd been carrying all these things around with me through airports and car rentals since starting work on the book.

It's a shame, I suppose, that I wasn't really a horseman.

I could stay aboard a decent horse and I enjoyed riding, but I certainly wasn't a *horseman*. Enjoying something and being skilled at it are not necessarily the same. I guess you can have one without the other, but it would be nice to have both. I didn't grow up around horses except for the pair of heavy-footed draft animals on my uncle's farm in Minnesota. As a pre-teenaged kid I'd spend parts of my summers there. Those horses pulled farm wagons, harrows, and hay mowers. We didn't ride them. I'd carry ice water in sweat-beaded mason jars out to my uncle as he worked the team in sweltering fields. I'd go barefoot most of the time, side stepping chicken droppings that littered the sandy farmyard. I don't think anybody used the term "free range" back then. They were just chickens.

Even though I wasn't a horseman, as a photographer I'd discovered that the best way for me to get close to any subject was to immerse myself. I expected to spend a lot of time around cowboys and buckaroos working cattle in open and often rough country. I could do a certain amount from a four-wheel-drive vehicle, but the best way to get close to my subjects was on horseback. I might not be a horseman, but I would ride. And, I think like being in a foreign country and trying to speak the

local language, any effort is appreciated. I saddled the horse, tied my sleeping bag to the cantle, and set out for the camp.

In my saddlebags I had some film, a couple of extra lenses, and a bottle of Kentucky sour mash whiskey, a gift for Brian and the crew. I favor a Tennessee brand, but I found it wasn't stocked locally when I drove through the bright lights of Winnemucca and then the much dimmer environs of Paradise Valley, a small one-bar ranching community on the Little Humboldt where the corporate-owned Circle A Ranch was headquartered.

The official name for the ranch was actually the Quarter Circle A. But all its buckaroos and all the locals called it the Circle A. Who knows why? I guess it doesn't matter. Everybody knew what they meant.

I knew Brian would appreciate the whiskey and would probably have some of his own when and if we ran out of mine. I figured his brother, Clark, might be in camp also. Brian and Clark were considered two of the best horse breakers around Nevada. Brian was becoming a local legend. This was when they could still run and rope mustangs out on the desert, breaking the good ones and selling them to cow outfits looking for rough-broke horses for their saddle strings. These were not so much direct throwbacks to the Spanish mustangs as remnants and offspring of horses turned loose or lost over the years. There were a lot of wild horses out in that country then. I nudged my blue roan ahead and we cantered along the desert trail, the low-riding sun casting slanted shadows twice our size.

I DON'T KNOW IF THOSE SUMMER DAYS ON THE FARM in Minnesota had anything to do with it, but as a kid I was always enamored with the thought of going out West. I wanted to see the mountains and the plains I'd read about in books from the library and seen in illustrations in the *Saturday Evening Post* magazines stacked next to the summer glider on the screened front porch of our house in Minneapolis. It took me a while, but I got there.

From my Montana days with the Hutterites in 1969, on through the following decade and a bit longer, I found myself seeking just about any reason to get back out West. In 1970 I wrote and photographed a story on the U.S./Mexican border by motorcycle for NATIONAL GEOGRAPHIC magazine. After that, their book division asked me to do the photographs for a book about the American cowboy. That's what brought me to Nevada the first

time. Later, the magazine asked me to photograph and write about a working cattle ranch of my choice. So I went to the Padlock, a ranch that operates in both Wyoming and Montana. That was in '72. I kept heading west on through the '70s.

Over that decade of the '70s, I spent time on a number of big cattle ranches: the Pitchfork in Texas; the Padlock and Snake River Ranches in Montana and Wyoming; the Circle A and the IL in Nevada. I was around some small outfits, too. All were places where I was made to feel welcome, and I tried to return the favor by making photographs that showed the reality of the ranchers' world and their work. I saw a lot of the West and met a lot of interesting people during those years, and I keep their memories alive in my pictures.

Henry Gray lived and ran cattle for 50 years out on the Organ Pipe Cactus National Monument country in Arizona's Sonoran Desert. He was 72 when I met him in 1970 while I was working on the story about the U.S./Mexican border. In the oven-like heat of that country, Henry wore his shirt buttoned up to the top, his sleeves buttoned at the cuffs. The head of a long-horned steer, its hide dried and cracked, loomed out from the wall of his bedroom. Next to it was an American flag. A 48-star American flag.

The government was asking him to take his cattle off the desert. "I've lived here such a long time," he said. "All I know is cattle. Guess I'd have to quit ranching. I've never lived in town. I go in for supplies about every two weeks or so, but I never seem to do no good there. Sitting around gets the best of me. I don't believe I'd last long in town."

Later in my life I would appreciate Henry's thoughts about living in town. I've lived in rural Virginia for more than 30 years, and a few years ago we moved to a place that was damn near in the suburbs. When the leaves were off the trees I could see neighbors. We don't live there anymore.

Tom Roberson lived up in the Big Hole country in Montana. He was 88 when I met him in 1976 while I was going through Montana tracing the story of Chief Joseph and the Nez Perce Indian War of 1877 for a GEOGRAPHIC article. Tom had cowboyed around the Musselshell as a kid and once shared his bedroll with a train robber. That would have been in the first decade of the 20th century.

"Two men came into our camp riding the best saddle horses I'd ever seen," Tom told me. "I guess I was the only one in camp that didn't know them. One of 'em came over to me and

said, 'Hey, kid, I'm out of a bed, but I'm clean. How's chances of bunkin' with you?' I had a new bedroll and I said, 'Sure—but you take those spurs off, because if you tear my new blankets I'll never forgive you.' He took his boots off and laid down with his six-shooter right next to him.

"Come morning, he gave me a gold ring. 'Here, kid,' he said, 'keep this to remember the night you slept with a train robber.' The cook gave 'em a sack of biscuits, boiled meat, and some coffee, and they rode off without another word. It was Kid Curry and his brother. They'd robbed a train and were getting out of the country as fast as they could, leaving as few tracks as possible. You know, if the law had come along, they wouldn't have learned a thing from our bunch. That was the custom of the country.

"It was raw country then. I've taken horses that weren't mine and used 'em as long as I wanted to. But I never did steal a horse. Always turned it loose when I got done with it."

T. J. Symonds was a 17-year-old buckaroo when I met him on the IL Ranch in northeastern Nevada in 1979. I was out there on a commission from the Polaroid Corporation, making pictures with their cameras and film as well as my own 35-mm cameras. The day before I pulled into the IL cow camp, T.J. had suffered a "heart attack" while out riding circle, gathering cattle. He felt dizzy and managed to get off his horse before falling off. Hank Brackenbury, the 21-year-old buckaroo boss, convinced that T. J. had suffered a heart attack, rushed him by pickup truck to Elko, 45 miles to the south. Not until reaching the emergency room did T. J. fully regain consciousness, and in doing so, he looked up at the faces of strangers clad in hospital white.

"Goddammit," he said, in despair, "I'm dead, ain't I? Dammit, I'm dead."

Well, he wasn't. Evidently T.J. had had some kind of heart flutter out there on his horse, panicked, and as a result, hyperventilated—nothing more serious than that. He was released and advised to rest for a day or so. Hank walked T.J. out.

But you just can't turn loose a couple of young buckaroos in town—especially when one of them is convinced he's just returned from the dead—and expect them to go directly back to the job. After all, buckarooing isn't like a "real job." So, in traditional fashion, they made the rounds: first stop was Capriola's Saddle Shop for some new shirts and hats, then on to the Commercial Hotel and the Stockmen's Bar for some drinks, and as dark closed on Elko, the final stop was at the Mona Lisa, where the hours pass easy and the girls show a definite preference for buckaroos over truck drivers and salesmen.

Then there was Ed Cantrell.

I met Cantrell in Wyoming in 1983. I was trying to give up the West as a major source for my work and find a new inspiration, but the truth was I'd had a falling out with NATIONAL GEOGRAPHIC and I was making a living doing mostly commercial photography, which paid well when I got work, but I seldom found it interesting. I wasn't doing as much magazine work as I was used to and I missed it greatly. I'd read somewhere about Cantrell and convinced LIFE magazine to do a story on him.

Ed Cantrell had been director of public safety in Rock Springs, Wyoming, when it was an oil boomtown, doubling in population, with prostitution, drugs, all the vices that often accompany that kind of prosperity. Late one night in 1979, while sitting in the front passenger seat of a police car parked outside the Silver Dollar Saloon, Cantrell shot and killed one of his own undercover narcotics agents sitting in the back seat. Shot him between the eyes, just a little off center. They'd been arguing and Cantrell claimed it was self-defense, said he thought the man was going to draw on him.

Cantrell was charged with murder and jailed for three weeks until he was released on a $350,000 bond posted by some eastern Wyoming ranchers who also hired Gerry Spence, a flamboyant and highly successful personal injury and criminal defense attorney out of Jackson Hole to defend Cantrell.

At his trial Cantrell demonstrated his speed with a gun, drawing three separate times to show the jury how quick he could have shot a man he thought was going to try to shoot him. He was acquitted, but his career as a public law officer was over. There were many who thought he should have been found guilty of murder. There were many who didn't like him. Still supported, however, by the local ranchers association, he was hired on by them as a range detective to combat cattle rustling. He'd been a range detective in earlier years. In 1983 cattle rustling was booming. With our modern interstate highway system and cattle pens often placed conveniently close to the highways, cattle rustling was a bigger problem then than it had been a century earlier.

Rinker Buck, a writer for LIFE, and I spent about three weeks with Ed Cantrell out in the country around Rock Springs. We went with him to investigate missing cattle and cattle vandalism. Western boomtowns attract workers who often come

from a different part of the country and maybe have a different attitude about certain values. They say that the first thing a lot of young guys do when they find themselves out West is to buy a four-wheel-drive vehicle that allows them to go pretty much where they want. Then they buy some high-powered firearms and shoot at pretty much what they want. I watched a ranch woman accompany Cantrell out to where one of her $2,000 Hereford bulls lay stiffened and fly-covered, bloated up and smelling bad from lying dead and simmering in the desert sun for days. Somebody had shot it. For target practice.

In his early 50s, Ed Cantrell was soft spoken and withdrawn in some ways. He was candidly open in others. Supposedly a tee-totaler before his murder trial, Cantrell maintained a reputation as a heavy drinker after it. Of medium height and wiry build, with a graying moustache and crew cut, physically he was not an imposing man until you got to his eyes. They were pale blue, occasionally bloodshot, and often seemed cold.

On several occasions Cantrell demonstrated to Buck and me his prowess with a handgun. I recall he favored a six-inch barreled .357 Magnum Smith and Wesson revolver in a hip holster. He could draw that gun and point it at you with amazing speed. I saw him do that to Buck once when we were sitting inside a ranch cabin. He was showing Buck how he had shot that undercover man. Cantrell sat in one chair, Buck sat in another, behind and just to the left of Cantrell, as if in the back seat of a car. I remember him unloading the gun before demonstrating. His draw was swift and fluid, and in a heartbeat just a couple of feet separated the muzzle of Cantrell's gun from Buck's startled face. I remember Cantrell pulling the trigger and hearing the snap of the hammer falling on the firing pin. I winced inside myself when he did that. He said that once he started the draw, pulling the trigger was automatic, irreversible.

One day Buck and I rode horseback with Cantrell while he was helping a rancher separate some cows and calves in the country around the Little Snake River down close to the Colorado border. Toward the end of the afternoon we noticed that Cantrell was no longer around. His white pickup truck was also gone from where we'd parked our vehicles. We finished helping the rancher, then unsaddled and turned out our horses and went looking for Cantrell. We checked out the nearby town where we were all staying, a little place called Baggs. He wasn't there.

As the sun descended, we drove down to the river. It was getting to be that time of day the French call "the time between dogs and wolves," when shapes and shadows seem to blend and change and the eyes cannot always perceive what is real or imagined. The river was almost metallic, reflecting the softly glancing silver light of dusk.

We saw his truck along the edge of the river. We drove down toward him as he came slowly up the dirt track. We would pass side by side if we continued. I told Buck to stop and I'd go over to speak to Cantrell. I got out and walked around the front of our vehicle to approach Cantrell in his pickup as he drew closer.

I didn't see it at first. It wasn't until I was within about five feet of him sitting there behind the wheel, his gray Stetson and his white shirt outlined within the cab of his truck. His left elbow was resting on the door frame of the open window, his left hand on the steering wheel. Then I saw the gun. The barrel was nestled in the crook of his left arm and the muzzle, a hard black hole, was pointed at my chest. His face was expressionless. His eyes were blue, cold, and distant.

My response was involuntary.

"Jesus Christ! Ed! What the hell are you doing?" I raised my arms as if in surrender.

I started to move slowly backward and to my left, thinking to get back to our car. As I did, he tracked me by easing his truck forward, the gun still steadied in the crook of his arm as he steered with one hand. I realized any kind of retreat was senseless. I probably wouldn't get but a few feet before feeling the bullet if, for some insane reason, he really wanted to take me out. So I stopped and then walked directly over to his truck and stood almost speechless in front of him. I didn't know what to say.

"Chilled your shit, didn't I?" he said flatly, at last.

"Oh...yes," I said, with some difficulty. "Yes. You did."

He lowered the gun.

Buck came over and we talked for a little while with Cantrell and then we left to return to our motel in Baggs. We spent a few more days with Cantrell in Wyoming, and then we returned to our homes in the East.

There are many things I'll remember from my years of traveling and meeting people in all parts of the world. That night on the Little Snake River will stand out, I suppose, but not for pleasant reasons. I've been around guns all my life. As a boy in Minnesota I learned that you never pointed a gun at anything

or anyone you didn't intend to shoot. You just didn't do that. And it wasn't a matter of whether the gun was loaded. You assume they always are; that's the only safe way to be with guns. And I know damn well Cantrell's gun was loaded. He had too many enemies for it not to be. I guess I still haven't forgiven him for that. Or maybe I have but I just can't forget it.

IT WAS MORE THAN FOUR HOURS BEFORE THE BLUE ROAN and I got to the Circle A Cow Camp that evening in Nevada. There were faint wisps of lavender clouds edging a darkening western horizon. It was getting hard to see. I may not have found the crew at all had I not seen a bit of glowing light that turned out to be a couple of gas lanterns hanging in their camp. I might just as easily have not seen those lights and continued to ride beyond them and into a long night in the dead center of nowhere.

I dismounted in front of Brian Morris's tent.

"Well, you crazy sonuvabitch," Brian said in that rolling drawl of his. He was in his long johns and ready to crawl into his bedroll. Some of the other buckaroos were still up, and we all sat by the fire for quite a while, passing around that bottle of Kentucky whiskey and telling stories before calling it a night.

One member of that crew, Claude Dallas, a 21-year-old man a couple of years out of Ohio, with an intense craving for the ways and legendary freedoms of the Old West, was still learning to buckaroo. The skills of a cowboy or buckaroo don't automatically come with the price of the boots and hat.

I'd met Claude late the previous year, not long after he'd hired on to the Circle A. He'd shown up in Paradise Valley one day, riding a buckskin and leading a pack horse, carrying a rifle and looking for a place to buckaroo. He did odd jobs around Paradise Valley until Brian Morris eventually hired him. Claude wore wire-rimmed glasses, a narrow-brimmed, round-crowned hat, and had a face with a kind of innocent tenderness about it. He was soft spoken and extremely polite. Claude Dallas was a diligent young man. He pushed himself hard learning to work cattle and getting to know the country. Claude cared a lot about his gear.

Good cowboys take great pride in using good gear, from their saddles and bridles and bits to the boots on their feet, the hats on their head, and their chaps. Chaps are leather leggings that protect a cowboy from brush and weather and just wear and tear from endless hours in the saddle. They come in different styles.

Shotgun chaps are snug fitting, usually zip-up, full-length leggings. The old style bat-wing chaps kind of flare out to the side, like a rodeo bronc rider's. In parts of Nevada and Oregon some buckaroos favor "chinks." Those are shorter, come down to just below the knee, and are sometimes fringed. And now and again, especially in cold country, you see "woollies"—chaps that are covered with sheep wool, often dyed to a requested color.

In 1972 I was in a Montana cow camp with the Padlock branding crew. My sons, David, 8, and Scott, 12, had come out to Montana to be with me for a couple of weeks. One night after supper we heard about a pair of exceptional woollies from a longtime cowboy named Smitty.

"A man I worked with on one outfit had a pair of bright orange wool chaps," Smitty recalled. "Orange woollies, they were. Another fella on the outfit took a likin' to those chaps. Decided he had to have 'em. Finally traded the man for 'em. Gave him his wife and $25. He sure liked them orange chaps."

My oldest son laughed at that story and probably thought Smitty had made it up. Of course, my son had never seen a pair of orange woollies. I saw a pair of green ones once, and they were beautiful.

Claude Dallas had a pair of woollies. During the time I spent in the Circle A Camp I watched Claude make a pair of spurs, hand-filing the Spanish-style rowels. I noticed that Claude almost always had a holstered Colt .22 automatic on his right hip. Clark Morris also sometimes carried a handgun. It wasn't uncommon in a cow camp to have a pistol for rattlesnakes or for other situations possibly more desperate, like getting caught beneath a fallen horse and having to shoot it or—as Brian said—yourself, if there's no way out.

I spent some days out on the high desert with Brian and the Circle A crew that summer as I photographed for the Geographic book. One day, after coming into ranch headquarters following a long cattle drive, we all headed into Winnemucca for a night on the town. Claude was not known to be big on raising hell in town. He rode in with me in my rented Blazer and we parked in front of the Gem bar and went in to have a beer. We stood side by side at the bar. After a while a police officer walked in, looked at Claude, and said, "Hey, you can't wear that in here." For the first time, I noticed Claude was still wearing the Colt on his right hip. The gun was partially covered beneath his denim jacket.

I looked at Claude. I remember the look in his eyes. He was very quiet, he didn't say anything, but I thought, maybe this could be a short-fuse situation. So I spoke right then and there. I said, "It's no problem, let's go stash it in my truck." We went out, he took off the holster and belt, wrapped it up, and stuck it under the front seat of the Blazer. We divided ways. I went to take pictures in the brothels, he went elsewhere. When I looked later, the gun was gone from under the seat, and I didn't see Claude again until a few days later back at the ranch.

After that summer I didn't see Brian Morris or Claude Dallas for quite a while. Then I saw both briefly eight years later, in 1979, when I was photographing on the IL Ranch outside Tuscarora for the Polaroid commission. I took a day to go looking for them just to say hello. About a year later I heard Claude had left buckarooing to become a fur trapper. He'd done that as a kid in Ohio and now he was putting his old skills to use again, living off the land in a camp by himself, killing deer for meat, and in charge of his own destiny, I guess. Claude was an anachronistic figure out there, so at home in the vastness of that country, living much as he might have had he been born into the 19th century frontier era. He probably would have preferred it, and may have been better suited to it.

In the spring of 1981 I got a call from a magazine in Denver asking me if I had any pictures of Claude Dallas. It took a minute for it to register. I have pictures of lots of cowboys and buckaroos from lots of places. Why, I wondered, did they want pictures of Claude? They told me.

Claude Dallas was wanted for the murders of two Idaho Fish and Game officers he'd shot and killed in January of '81 when they came into his camp on the Owyhee River just five miles north of the Nevada line. They'd found him with venison hanging and deer season two months past, and bobcat pelts in his tent with the season not yet open.

The officer in charge insisted that Claude leave his camp and a pair of mules to go face charges 150 miles away in Boise. Claude, reasonably enough, I think, made a plea not to have to abandon his camp and livestock. He was willing to accept a citation for a fine. An argument ensued, the two officers were shot and killed, and Claude was at large and being sought. A friend of Claude's visiting the camp at the time was the only witness. He heard the argument and turned at the sound of the first shot to see Claude firing a .357 Magnum at both officers; but he did not see the initial act, whether Claude, or an officer, drew first, as Claude later claimed.

A year later, Dallas was caught in the Paradise Valley area. He was tried and convicted of voluntary manslaughter and sentenced to 30 years. Within a year or so he broke out of his Idaho prison and was once again on the Wanted List. In about a year he was arrested coming out of a convenience store in Los Angeles. He is now back in prison in Idaho.

WHEN IT COMES RIGHT DOWN TO IT, THERE ISN'T MUCH that's really romantic about being a cowboy when you consider the hard work under baking or freezing conditions, the long days, and low pay. At calving and branding time you may work seven days a week for weeks on end. It can be boring. And it can be lonely if you don't like being alone. On the other hand, there is a certain independence and the chance to work out in the open and with luck and the right kind of ranch, on horseback more often than not. Nobody ever wanted to be a cowboy so they could fix fence or mow hay. There's another advantage of sorts, and that's being able to pick up your pay, gather your gear and bedroll, and head out somewhere else when it suits you to do so. If there's one thing the buckaroo or cowboy understands, it's the need, sometimes, to simply move on. Most of us can relate to that but damn few of us act on it.

Brian Morris and I were having a couple of drinks one afternoon in the bar they call Paradise Hill. Brian was sitting there in a shaft of afternoon sunlight cutting through the windows and skimming across the pool table. He wore his high-topped, handmade Bleutcher boots and a scruffy wild rag around his neck, and his face was burnished by the sun and wind of the high desert country he knew so well. We were to move out on a cattle drive the next morning and we were talking about the state of cowboying and how much was being taken over by modern technology of one sort or another. I asked him, "Brian, the way everything is going, with more trucks, more fences, more machines being brought in to do the job of a man with a rope and a horse, do you ever think you'll be replaced by a machine?"

He looked at me and in his marvelous soft drawl he said, "Bill, they just ain't come up with nothin' yet that'll take as much abuse as a cowboy."

That was 30 years ago now, but I imagine there'll always be young men out there somewhere hoping they never do. □

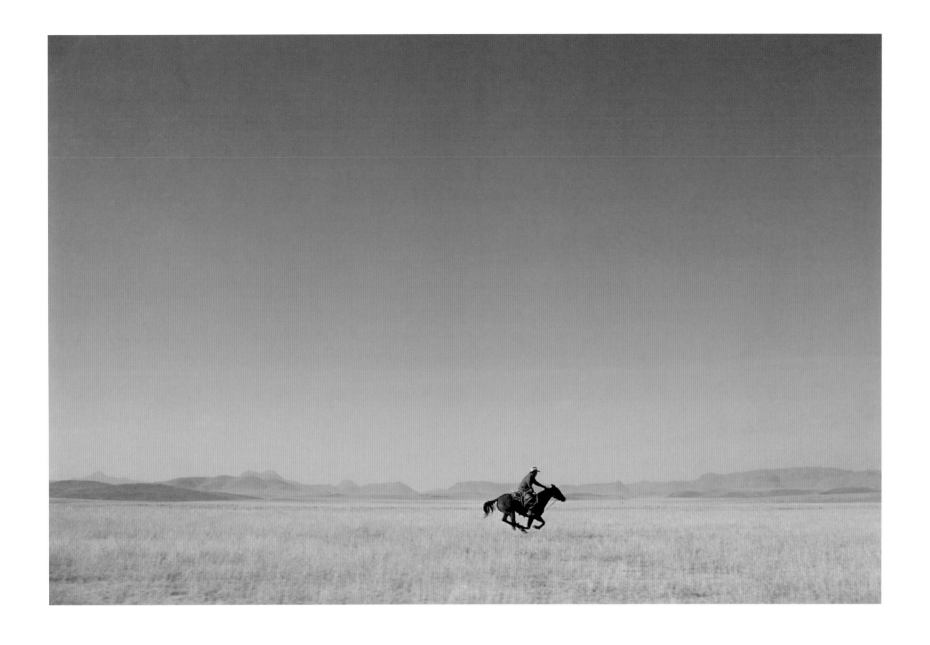

*Texas* 1974

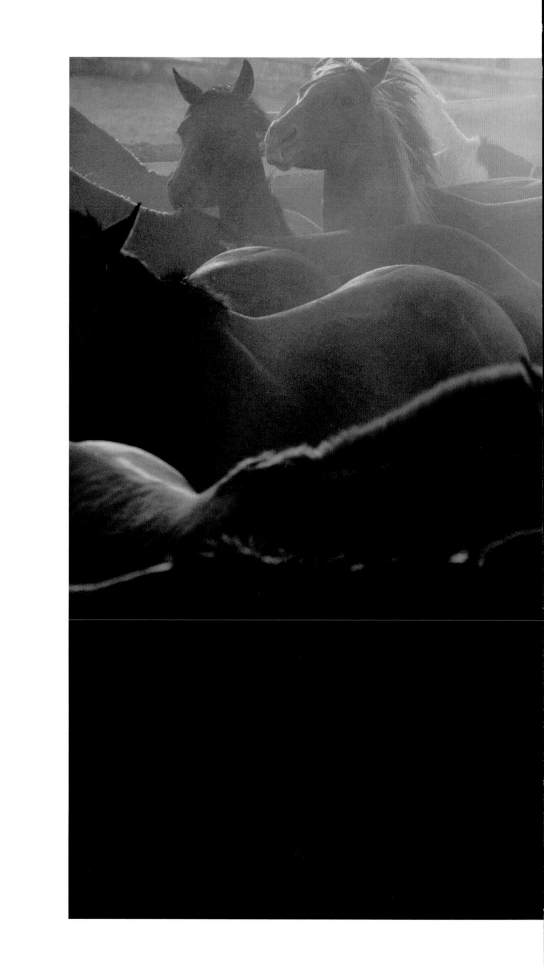

*Ricky Morris wrangling horses, IL Ranch, Nevada* 1979

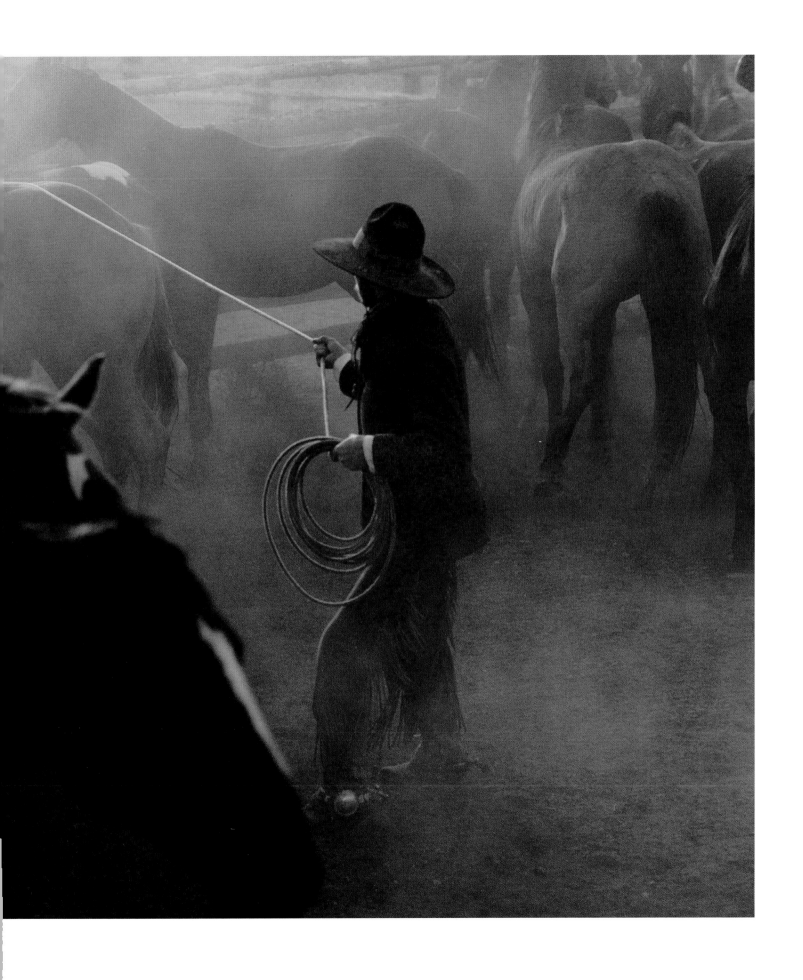

*Calf branding, Padlock Ranch, Montana* 1972

RIGHT: *Calf branding, Pitchfork Ranch, Texas* 1971

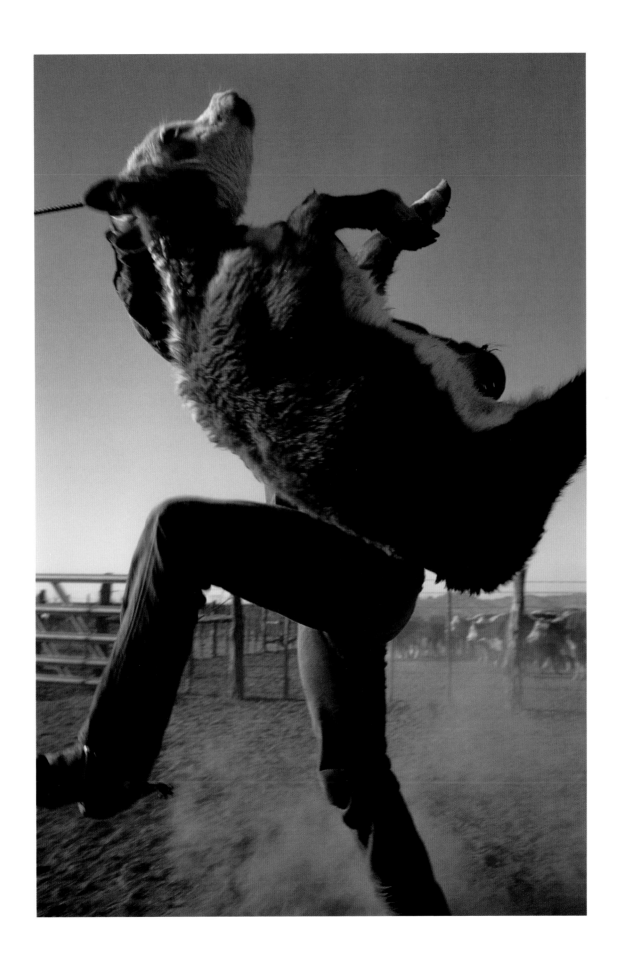

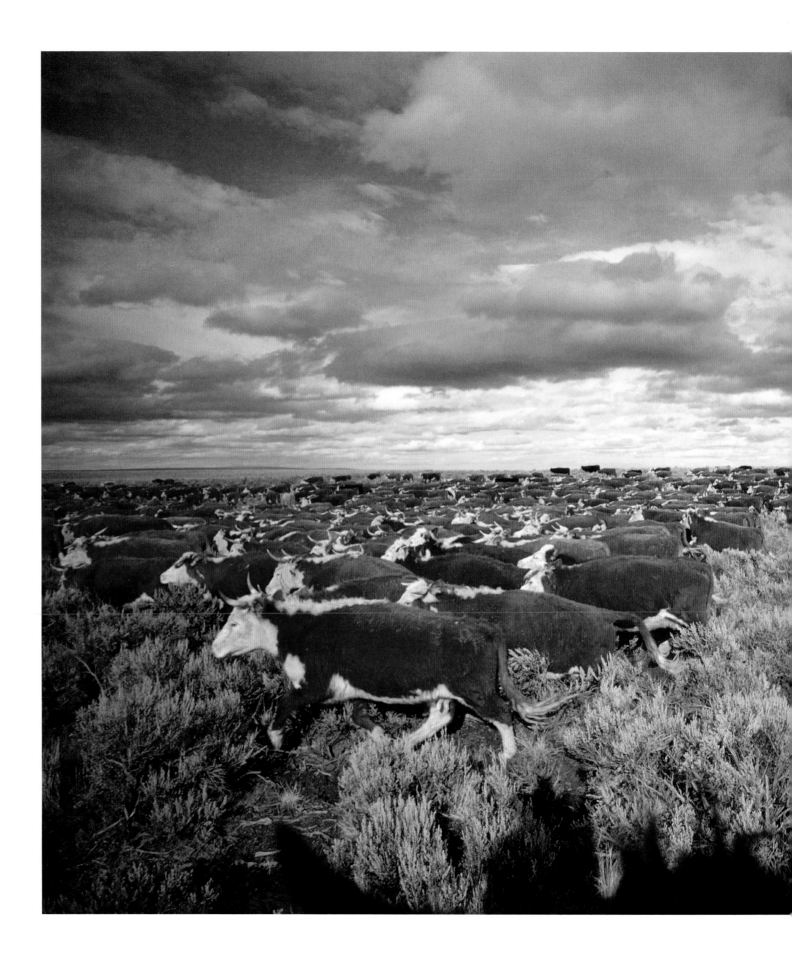

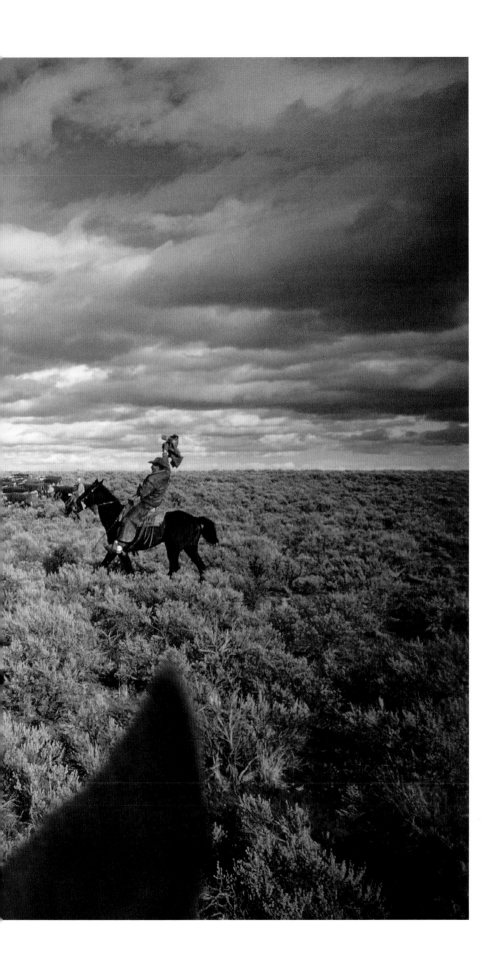

*Cattle drive, Quarter Circle A Ranch, Nevada* 1971

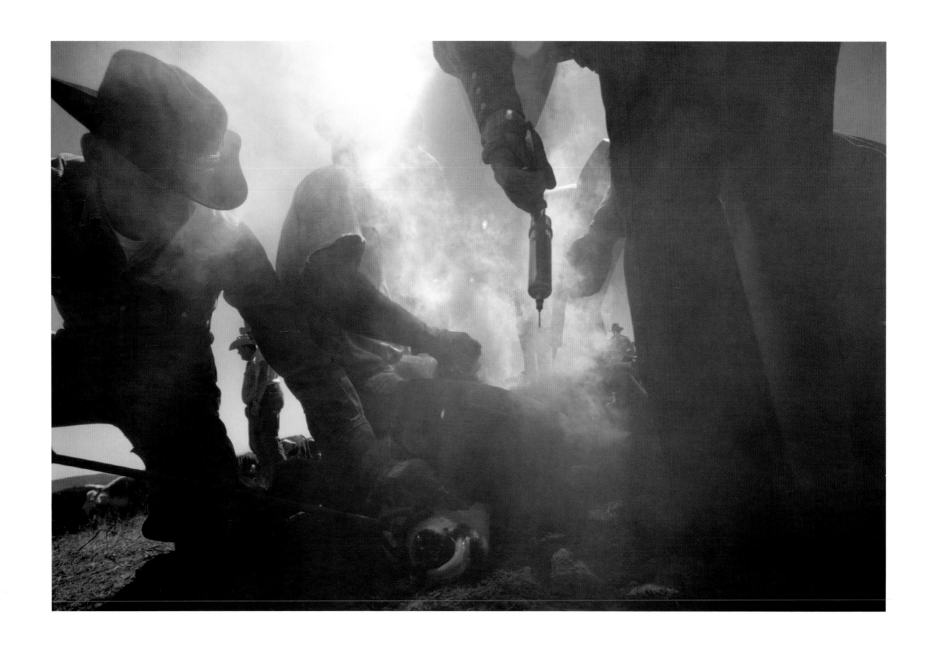

*Calf branding, Padlock Ranch, Wyoming* 1972

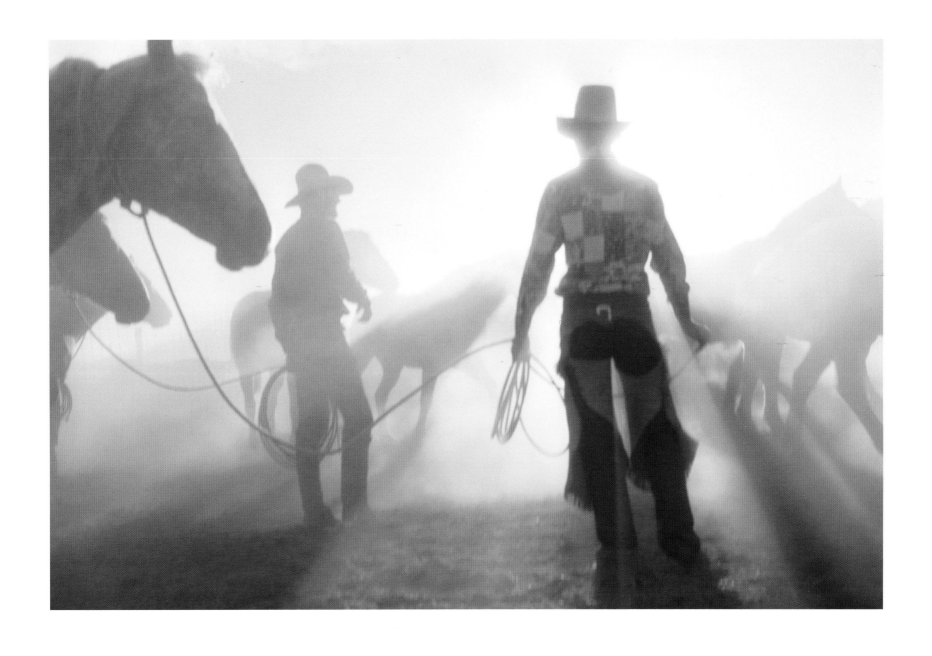

*Wrangling horses, Padlock Ranch, Montana* 1979

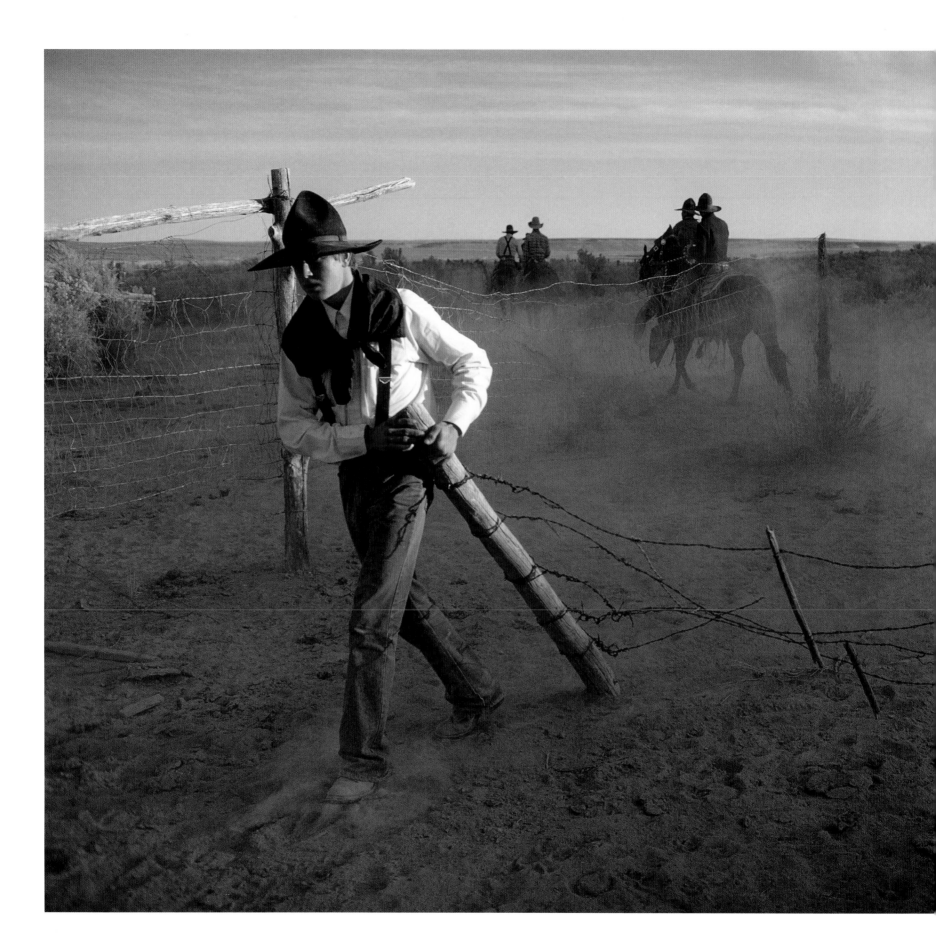

*T.J. Symonds closing the wire gate, IL Ranch, Nevada* 1979

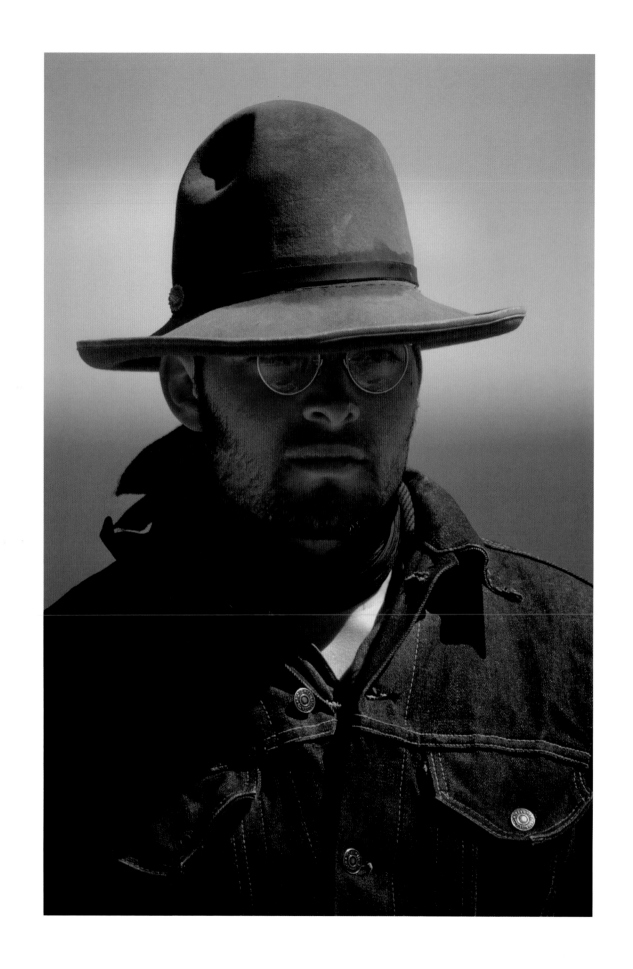

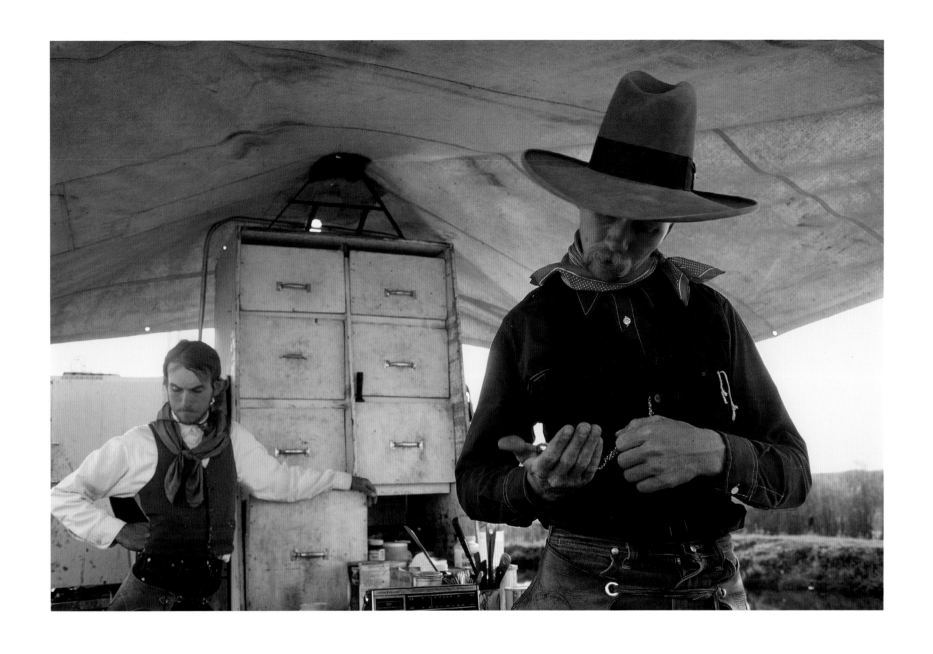

*Ricky Morris and buckaroo boss Hank Brackenbury (right), IL Ranch, Nevada* 1979

LEFT: *Claude Dallas, Quarter Circle A Ranch, Nevada* 1971

*Cow camp at dawn, IL Ranch, Nevada* 1979

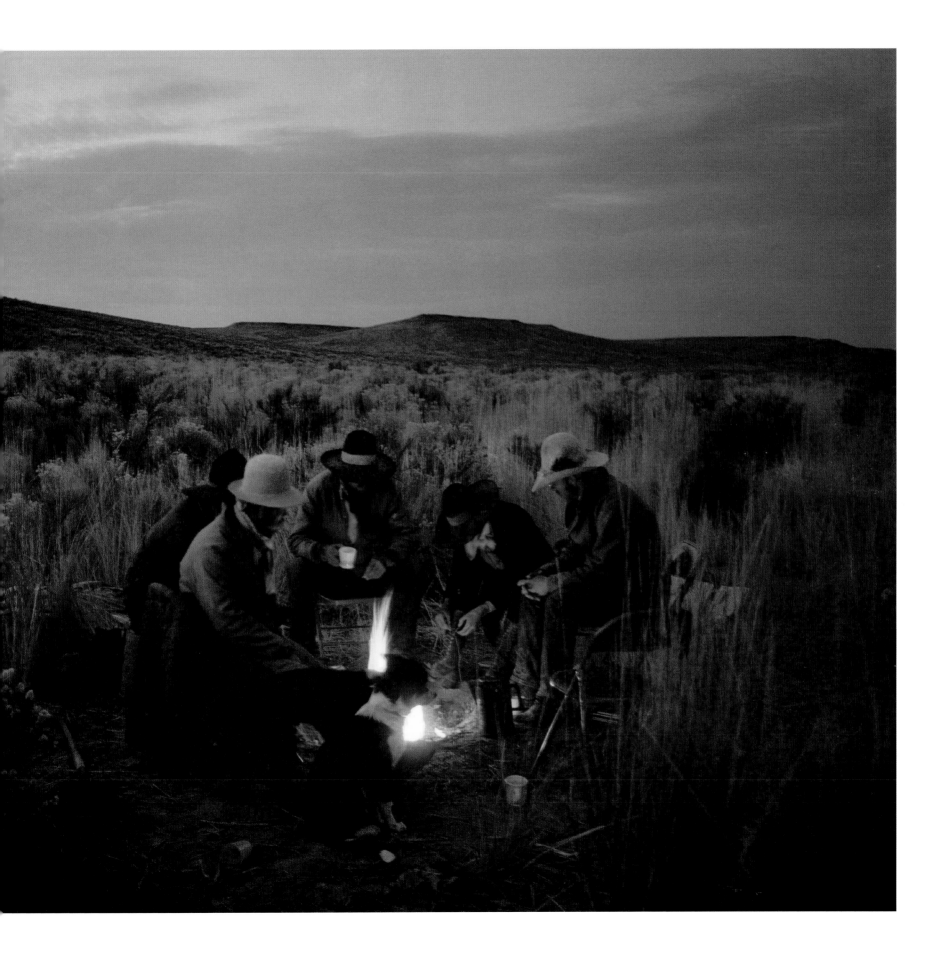

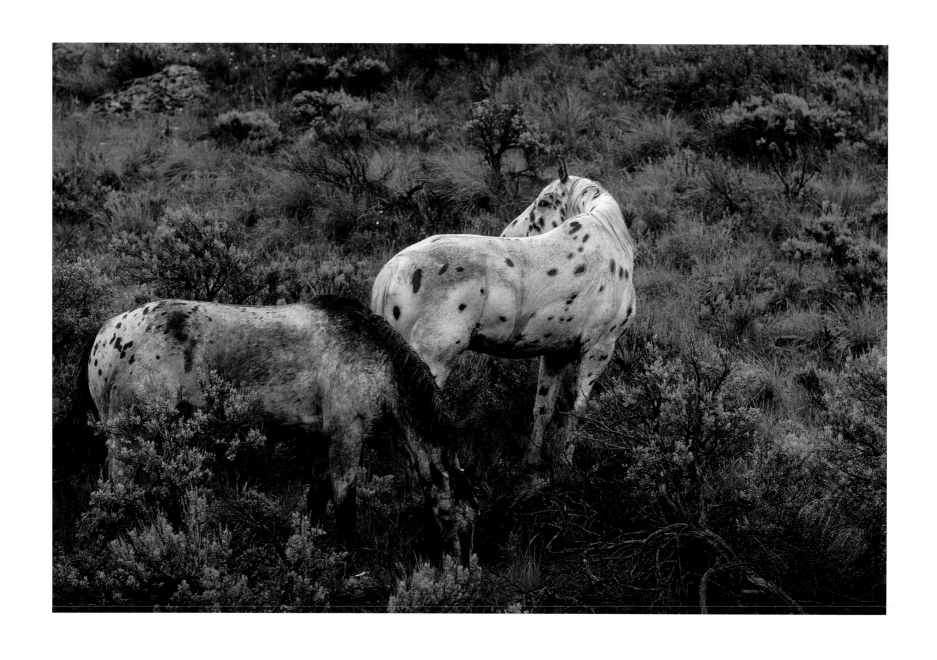

*Appaloosa horses, Idaho* 1975

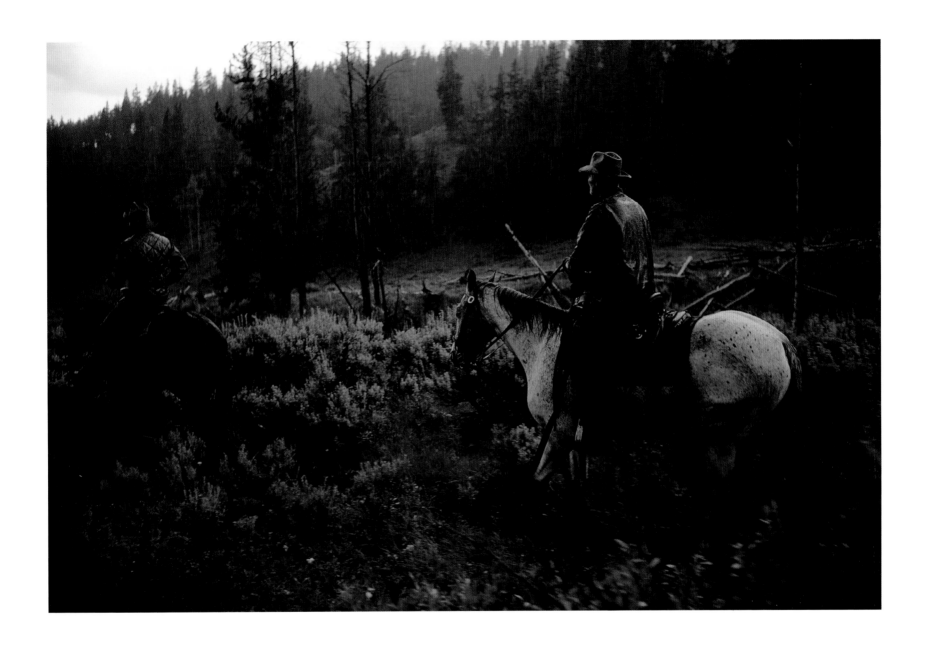

*In the Gros Ventre Mountains, Wyoming* 1971

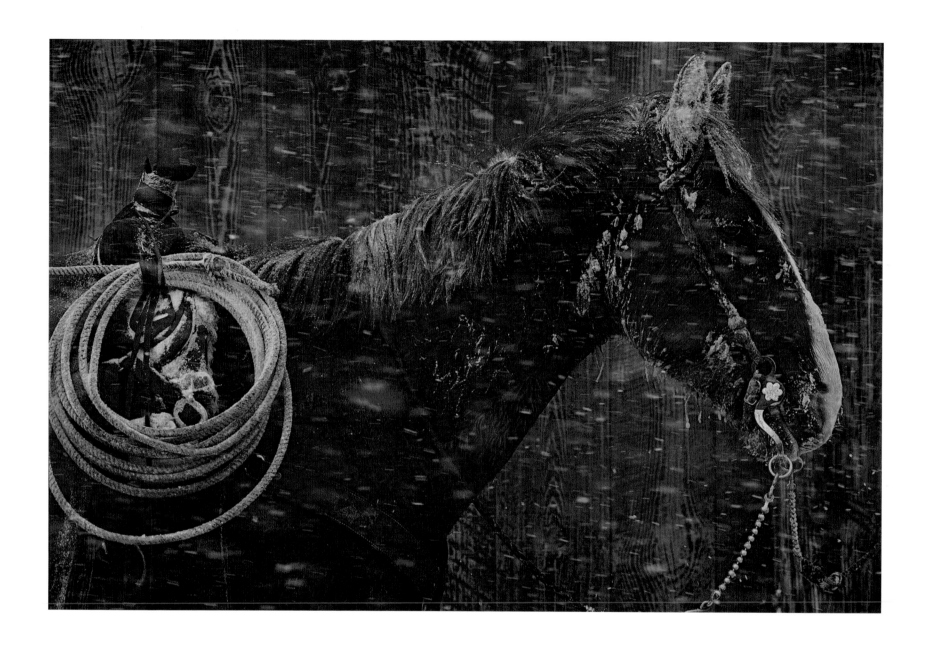

*Cow horse, Padlock Ranch, Montana* 1978

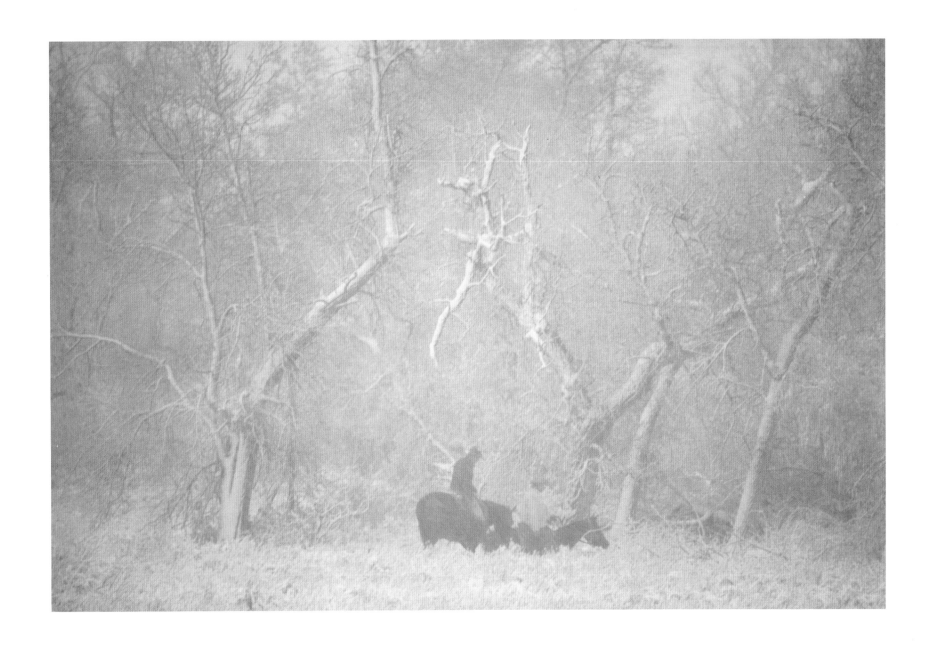

*Padlock Ranch, Montana* 1972

*Ed Cantrell, Sweet Water County, Wyoming* 1983

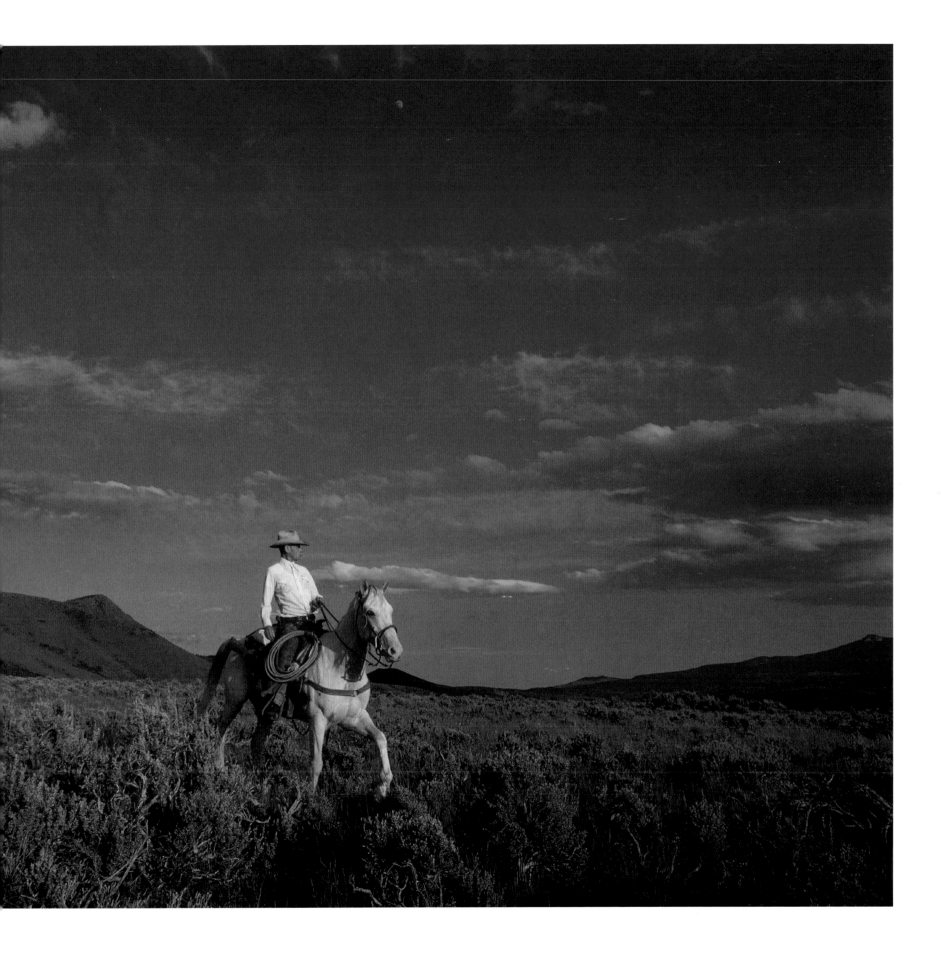

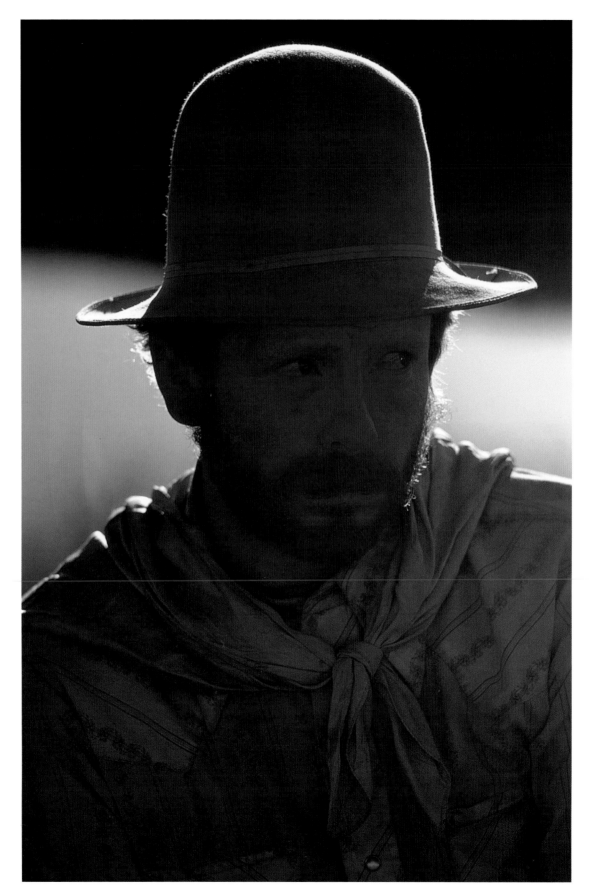

*Clay Bartram, IL Ranch, Nevada* 1979

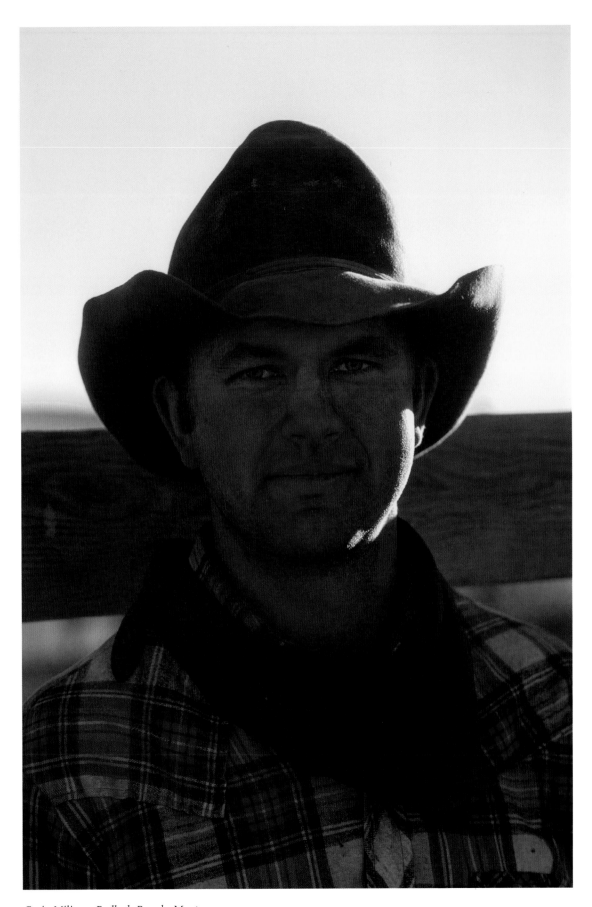

*Craig Milium, Padlock Ranch, Montana* 1979

*T.J. Symonds, IL Ranch, Nevada* 1979

*Stan Kendall, in the Miner's Club, Mountain City, Nevada* 1979

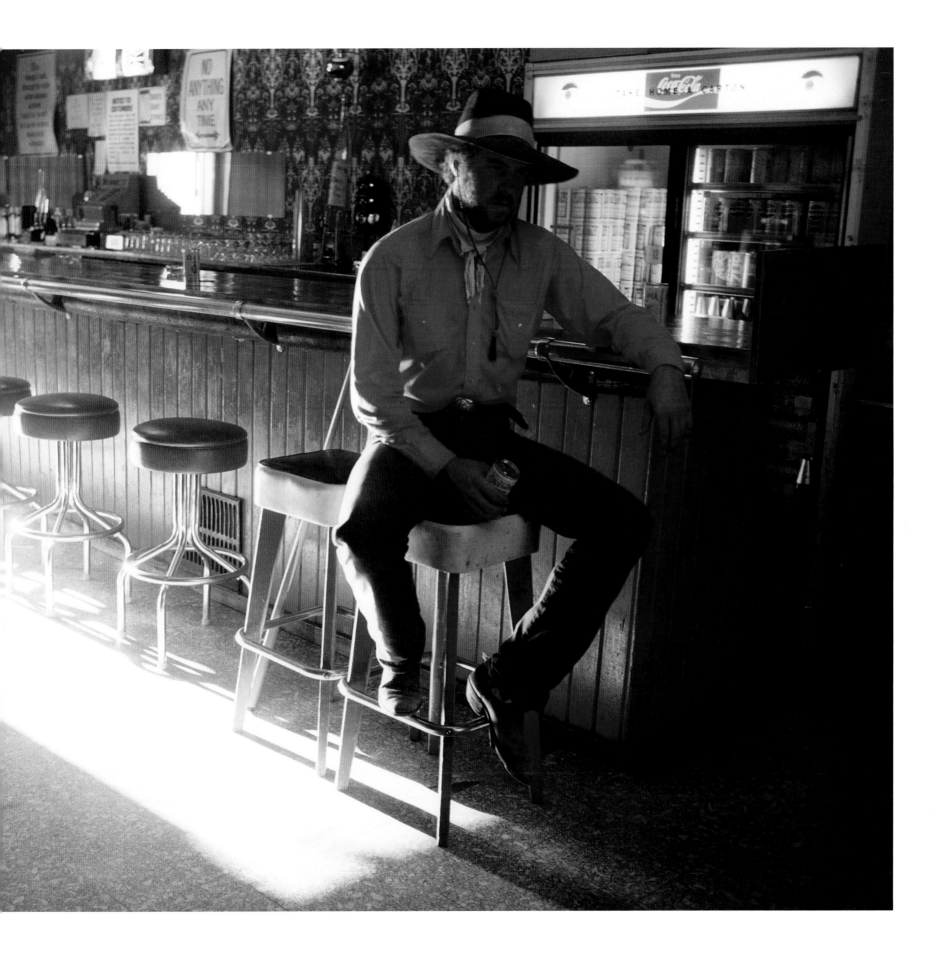

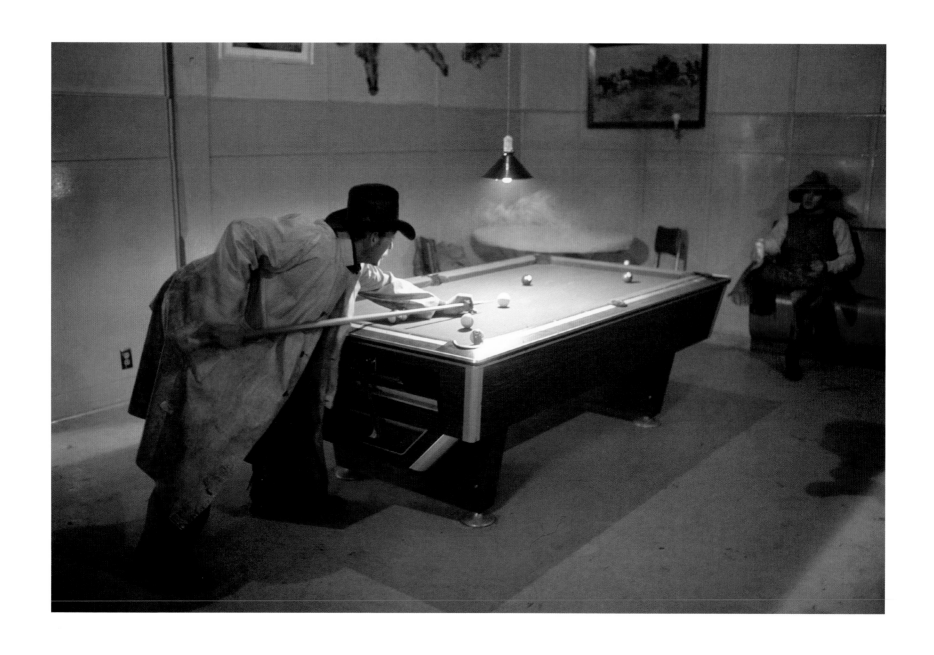

*Quarter Circle A buckaroos, Paradise Valley, Nevada* 1970

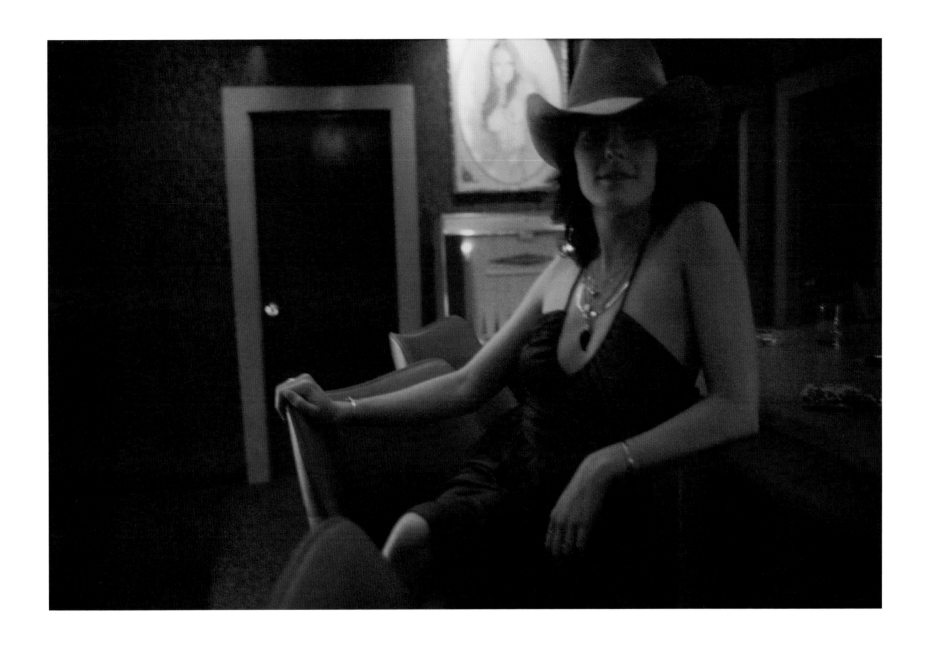

*Elko, Nevada* 1979

*Henry Gray, rancher, Arizona* 1970

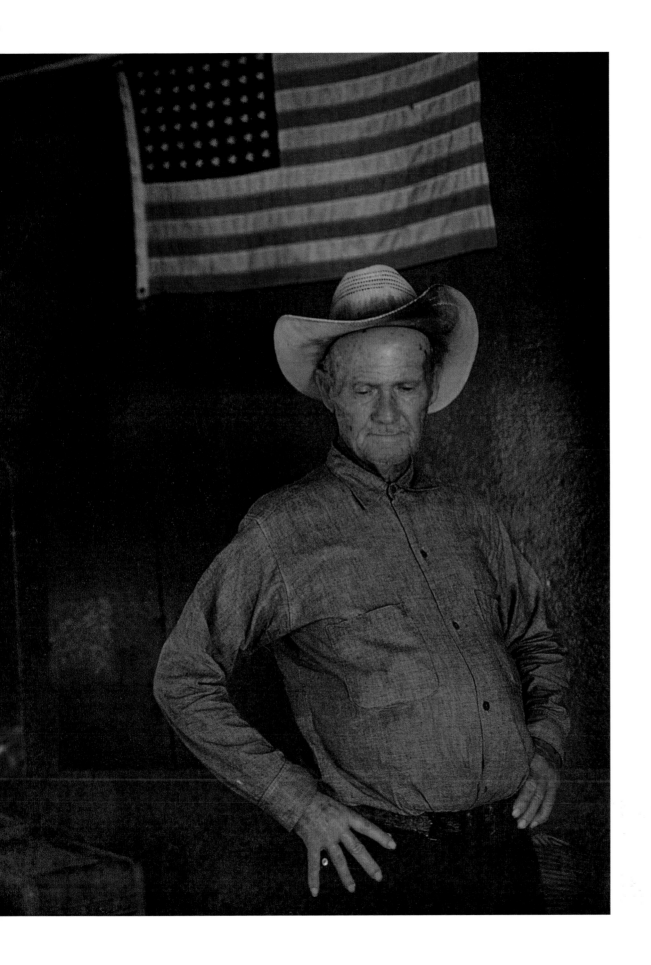

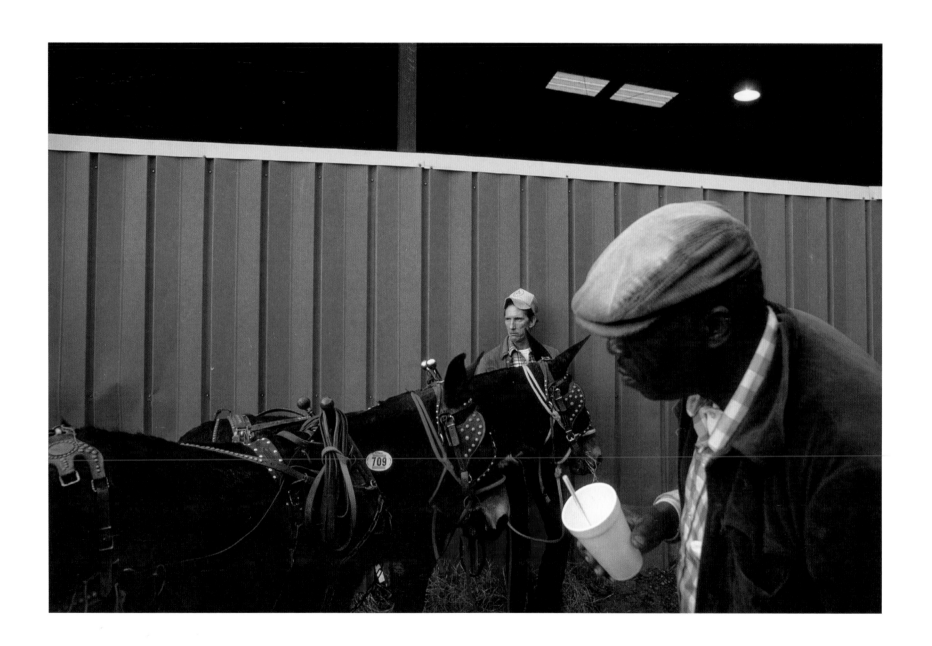

*Mule Auction, New Albany*

# FAULKNER COUNTRY

[ Mississippi 1986–1987 ]

IN MY LIBRARY AT HOME I HAVE A PAPERBACK BOOK ENTITLED *Three Famous Short Novels: Spotted Horses, Old Man, the Bear* by William Faulkner. Written on the inside of the cover is my name and an address in Minneapolis where I haven't lived for 40 years. Printed on the outside of the cover is the price: a dollar forty-five. Forty years ago I couldn't afford to buy very many books at any price, but whatever the cost, this book would have been a bargain, the work is so strong, so enduring. I guess if you wanted to try some William Faulkner on for size, read him for the first time, these three novellas would be a good place to start. They were for me. Although my first experience with William Faulkner was *As I Lay Dying,* I read these stories next, and it is to these works that I find myself most often returning.

My first time in the country that spawned these stories and characters was in the spring of 1968, shortly after the death of Martin Luther King. I went to Mississippi for just a few days to photograph the Poor Peoples' March on Washington for *LIFE* magazine. The *LIFE* reporter and I found ourselves in the delta town of Marks, west by about 45 miles from Oxford, the longtime home and wellspring and workplace of William Faulkner, who depicted both the dignity and tragedy of Mississippi blacks in his work. Blacks from around the area were gathering in Marks, where the following day they would board buses for the trip to Washington, D.C. There they hoped to somehow better themselves in the fight against poverty.

In a big canvas tent at the gathering place in Marks I met a black family named Irby. They told me there were ten of them living in a three-room shack in nearby Crenshaw, and they were all planning to leave on one of the buses headed for Washington. Bess Irby was a widow. The family included her daughter and son-in-law, her 17-year-old son, Hank, and his 15-year-old girlfriend, Ethel Mae. Hank made about ten dollars a week driving a tractor for the white man who owned the shack and the land it sat on. There were four little kids in the Irby family: one was called Sammy Davis and one was called Sugar Dew; I don't remember the names of the other two children.

I made a few pictures of the Irby family inside that tent in Marks, with a couple portraits of Hank wearing a jockey cap that made him look like a kid of the Depression era. That afternoon, the reporter and I went with them when they returned to their home for the evening. There wasn't much in that house in the way of visual comforts. The walls, except for a few strips of faded and peeling wallpaper, were mostly covered with cardboard. The floors were of bare, rough wood. A few naked light bulbs hung from the ceilings. I remember a simple board shelf holding a small plastic radio and a picture of John F. Kennedy. A stove crafted from a 50-gallon steel drum was the main heat source. There was no running water.

When I walked outside, Sugar Dew was kneeling in the tall grass, watching me. Ethel Mae was pumping water into a dented metal dipper from an old iron hand pump at the edge of a plowed field. She was wearing a pale, lime green dress with three-quarter-length sleeves ending in white cuffs. A line of little yellow buttons started at her midriff, dotting their way up to the white collar embracing her throat, and there was some kind of yellow emblem embroidered over her left breast. It was probably a Sunday dress; although it needed laundering, I don't think it was an everyday dress. She had a lovely, radiant smile.

The reporter from *LIFE* was waiting for me in the car while I photographed.

Back in the house I made a picture of Hank and Ethel Mae sitting on the end rail of a made-up bed in an otherwise absolutely bare room. Hank was in his stocking feet. Ethel Mae's dress clung close to her hips and thighs and crept up above her knees. Her legs and feet were bare. When I asked, awkwardly at best, if they were in fact sharing that bed, Ethel Mae told me, "We've been knowin' each other for two years now." In the background, through the open doorway of an adjoining room, against light breaking through a flimsy muslin window curtain, the small silhouettes of Sammy Davis and Sugar Dew stood silently watching.

For a few minutes I made pictures of Ethel Mae by herself sitting next to a wood-burning stove in the kitchen. The 15-year-old lit a cigarette and watched me with her large brilliant eyes while I tried to photograph in the darkening room. As I watched her through the camera viewfinder I saw other things as well. Days later, remembering that afternoon, I wrote:

*By a window in the kitchen Ethel Mae sits smoking.... Now, as you take her picture, a brown blur streaks along the edge of the smoke-blackened wall, passing inches from the girl's bare feet to a hiding place behind an open flour barrel. She doesn't see the rat and you don't mention it. Instead you move to another room in this house where human life, goodness, and God seem terribly out of reach....*

The reporter was getting nervous. He told me that while I was in the house photographing the Irby family, a pickup truck with two white men in it had been cruising slowly back and forth on the road out front. I didn't think to be worried; I hadn't been doing anything wrong, I thought. But I hadn't been to Mississippi before, either.

In the morning, when the buses loaded up for the trip to Washington, the Irby family was nowhere around. I knew something wasn't right when we drove back out to the Irby house. Nobody was there. We went down the road a way and stopped at the place of an old black man. He walked out to the road to talk to us, and coming along behind him in a wake of dust was a menagerie of fur and feathers: cats and dogs and ducks, and I think a chicken or two, were just trailing him, kind of like maybe there was going to be an animal act. That image stayed clear in my mind for years.

I asked him if he knew where the Irbys were, and he said the white boss had come by with a gun. He'd seen them talking to me. He'd told them they'd better get out or he was going to burn them out. Frightened, they must have scattered like a covey of quail, going off in different directions. They didn't make the buses, and we didn't see them again.

It would be almost 20 years before I would return to Mississippi, this time for National Geographic to work on a story about William Faulkner, to be written by Mississippian Willie Morris. In Faulkner I felt I was chasing the immense shadow of a genius. Greed, poverty, wealth, violence, sex, and the land; all seem to form the foundation of Faulkner's work, work that brought him the Nobel Prize in Literature in 1949.

I decided early on that I would simply react to what I saw down there, and if the pictures I made could be found to have a connection to Faulkner and his work, that would be great. But in the end I knew that although I was making pictures for a story about William Faulkner's Mississippi, my work was really going to be about the parts of Mississippi and its people as I saw them during a short but intense time in my life. The pictures would really be about *my* Mississippi. How could they be otherwise?

Oxford and Lafayette County—Faulkner called it Yoknapatawpha, and it took months before that would roll off my tongue without tangling on the way out—and the delta, made up the country Faulkner drew from during his lifetime. Although a lot has changed over the years, much of what he wrote about can still be found in one form or another: horses and mules and auction barns; cotton fields, kudzu, and country grocery stores; convicts in prison garb cleaning along highways on brilliant summer mornings or sand bagging levees when the river demands it; crafty men and beautiful women of all ages and dying delta towns and dogs for whom sympathy and concern was long ago relinquished. Although the "big woods" have vanished and men and boys no longer ride out to hunt in mule-drawn wagons, pickup trucks and all-terrain vehicles take them to private hunt clubs along wooded delta bottoms where white-tailed deer still abound. But they say all the bears are gone.

"A mule will work for you ten years for the privilege of kicking you once," Faulkner wrote in *Old Man*. Faulkner loved mules, but like many artists he was not the best at business matters and decided to get into selling mules just as most Mississippi farmers were switching to tractors. But there still is

a market today for mules, and I went to auctions in Pontotoc and New Albany where the smell of straw, fresh manure, and horse sweat permeated the air, and men would sit on wooden risers to appraise the animals trotted through the battered wooden doors leading to the auction floor. One man, portly and jowly in baggy bib overalls, leaned on a pen holding a pair of mules—a gray and a light brown. The man's cap read: "My wife ran away with my best friend and I really miss him."

At Parchman, the Mississippi state penitentiary, they raise cotton on the prison farm and the convicts still pick it by hand, dragging those long white sacks behind them. The inmates display a gallery of tattoos, scars, and stitch marks that sometimes zipper their abdomens; they are constantly watched by guards on horseback armed with shotguns or rifles.

It seems some of the South's most beautiful young women attend the University of Mississippi—"Ole Miss"—in Oxford. On Old South Day you could see them being hauled through town on a long flatbed trailer, their scoop-necked, crinoline-stiffened dresses blossoming outward. At Ole Miss football games they bless the stands with their beauty. I used to look for Temple Drake, the Ole Miss debutante in *Sanctuary*, who stepped off the train at nearby Taylor and ended up in a brothel in New Orleans. I looked and wondered, who could she be today, what would she look like? I thought I saw her once in crisp October sunlight at an Ole Miss football game, and then, again, one night at a fraternity party on campus.

One Ole Miss coed I found particularly attractive, and I asked if she would pose for a portrait. We made the photograph in the Isom Place, one of the antebellum homes off the square in Oxford thought by some to be the house Faulkner had in mind when he wrote "A Rose for Emily." The owner of the house had a wonderful collection of antique clothing and we chose a simple floor-length cotton shift. My model was 20-year-old Alexis Cassidy Burdine, and she was from San Angelo, Texas. Cassidy now has three kids and lives in Dallas. But I will always think of her as "Emily," curled gracefully on a settee in the upstairs sitting area of that stately old Mississippi house filled with untold stories, late afternoon sunlight falling softly on her shoulders and the side of her face, a single blood red rose in her hand.

In *The Sound and the Fury*, Faulkner's favorite work, there is a retarded young man named Benjy. I stopped one day at the North Mississippi Retardation Center in Oxford and photographed some of the young people living there, thinking perhaps I could make a picture that would relate to the subject of mental illness in Faulkner's work.

During an afternoon picnic a handsome boy of about 12 took a position in the yard and stayed there, standing in solitude for the full 15 minutes devoted to that playtime. His name was Ricky Murphree, and he had beautiful wavy yellow hair and wore an Ole Miss Rebels T-shirt given to him by a college friend. When I asked permission to use a photograph of Ricky in the magazine story, I was grateful for the enthusiastic response from both the retardation center and the boy's parents.

On Sundays I'd try to get out to Junior Kimbrough's house near Holly Springs, where hard Mississippi blues would be played in the living room by Junior and whoever else showed up. Junior's kids—he had a bunch—would be scattered about the house or playing in the band. There usually were just a few white people at Junior's in those days. Although in my mind I never made a direct connection between Faulkner and listening to blues music at Junior's, I knew it was, ultimately, all of one piece: the lives of blacks and whites, their worlds and Faulkner's, as intertwined as the kudzu woven into the landscape.

I was at Junior's place on Easter Sunday, when 15-year-old Paula, one of Junior's daughters, insisted on changing out of her shorts and blouse and into a silvery white dress. She wanted me to take pictures of her in her Easter dress, she said. She put on a scarlet hat. I didn't want her to pose, but she insisted and did so to varying degrees of provocativeness. The best picture was when Paula was leaning back against a door and her brother, David, was kissing his girlfriend as they sat on a couch covered by a *Star Wars* blanket, and on the nearby bed was a passed-out white girl whom I didn't know.

Junior's wife, Gearlina, would sit on the edge of her bed in a front bedroom on those Sunday afternoons, looking out a window, watching cars arrive. She'd sell cigarettes and beer; somebody else might be dealing in moonshine whiskey.

Sundays at Junior's would start in midafternoon with musicians coming in from here and there, the music building, subsiding, building again, people drinking and dancing. The day would slide into blue-gray dusk, then descend into dark, with a single light bulb dangling from the living room ceiling casting a yellow glow on all within its reach. I loved it and stayed late and when I finally drove away and back toward Oxford, my mind was filled with the music I'd heard and the things I'd seen. □

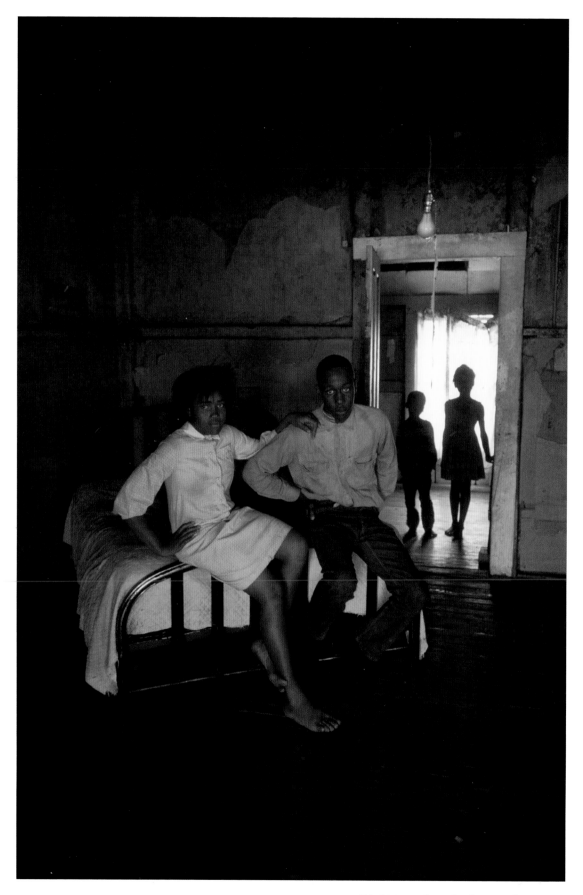

*Ethel Mae and Hank Irby, Crenshaw* 1968

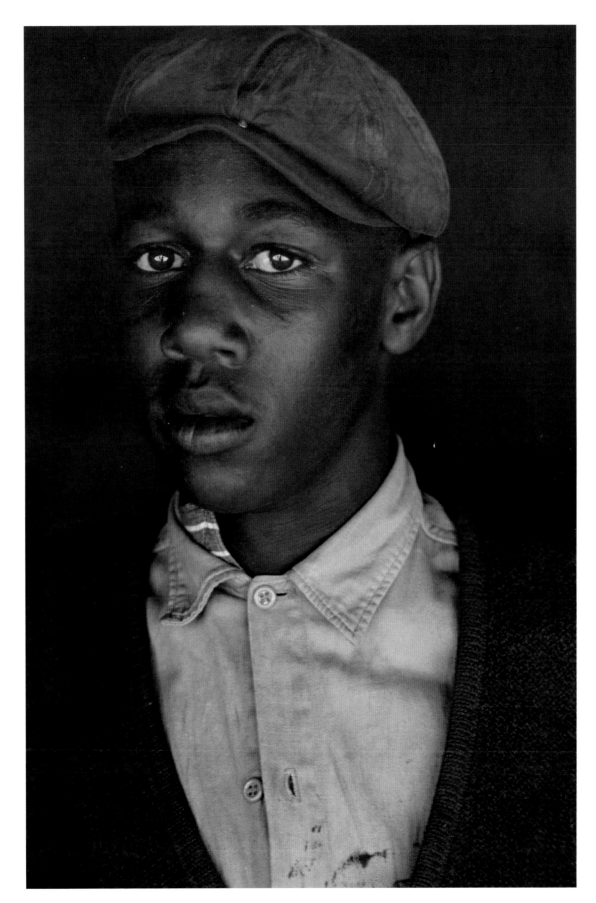

*Hank Irby, Crenshaw* 1968

*Hunting club on the delta*

*Picking cotton, Mississippi state prison farm, Parchman*

*Dove shoot on the delta*

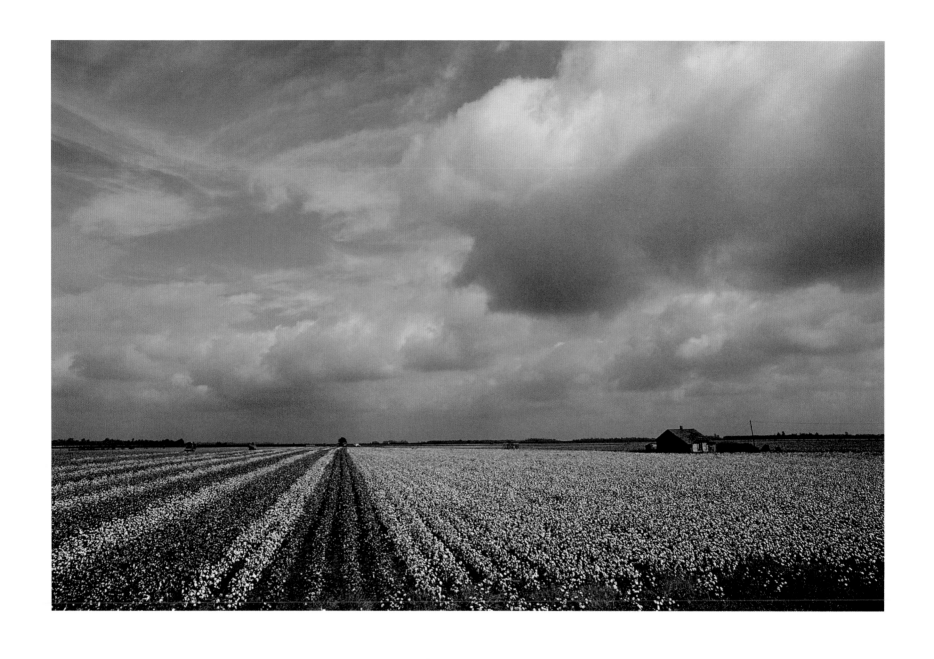

*Cotton field on the delta*

*Cotton gin near Taylor*

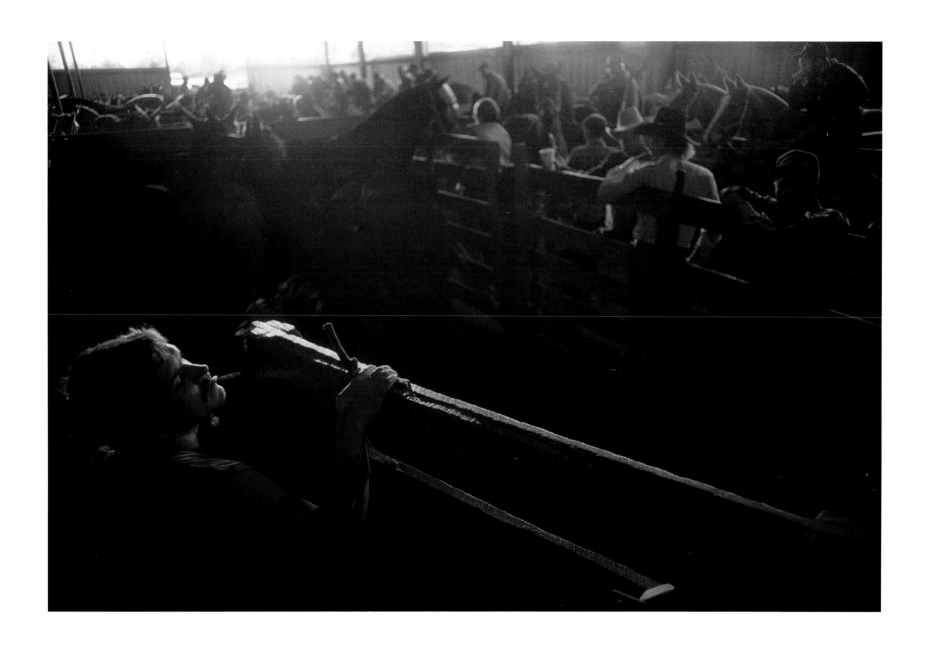

*Horse and mule auction, New Albany*

*Auction barn, Pontotoc*

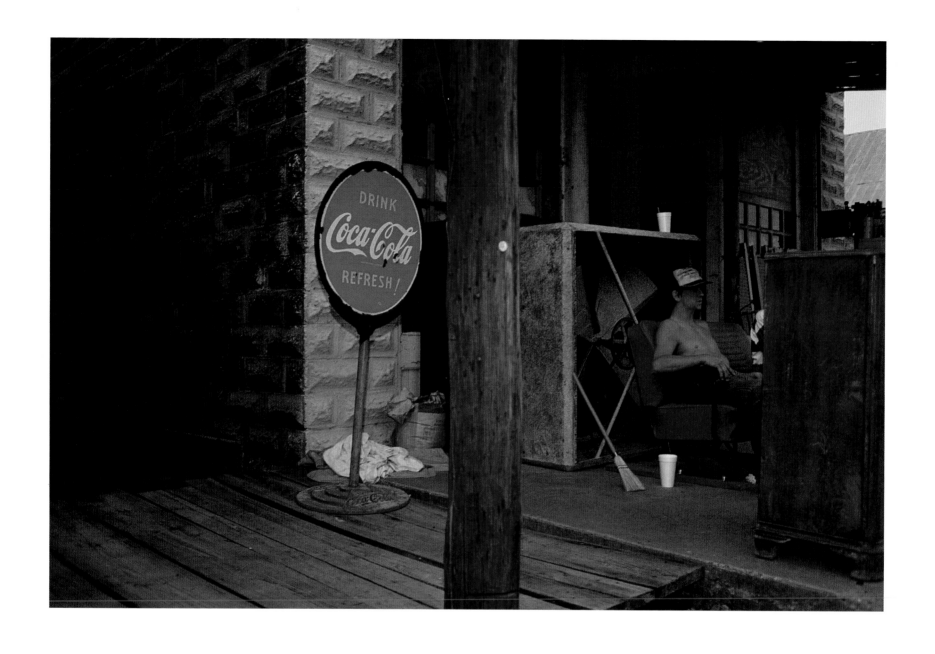

*Nicky Hewlett, Taylor*

*Ricky Murphree, North Mississippi Retardation Center, Oxford*

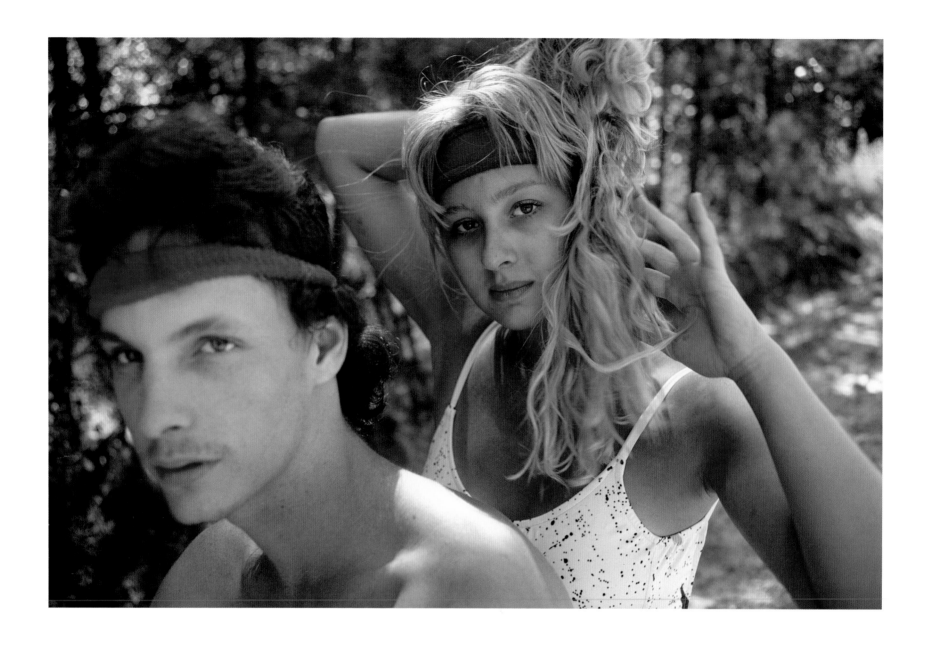

*Young couple, Lafayette County*

RIGHT: *Melanie Thompson Overby, Old South Day, University of Mississippi*

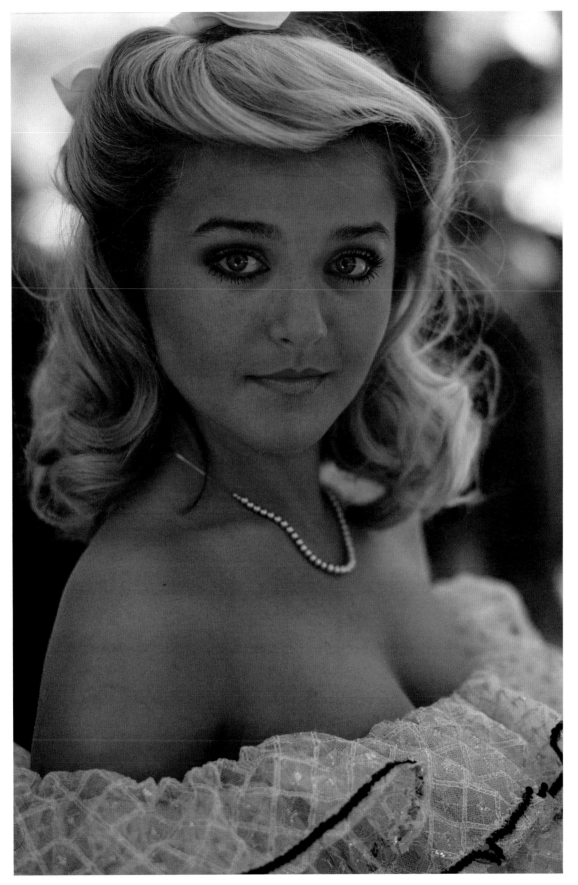

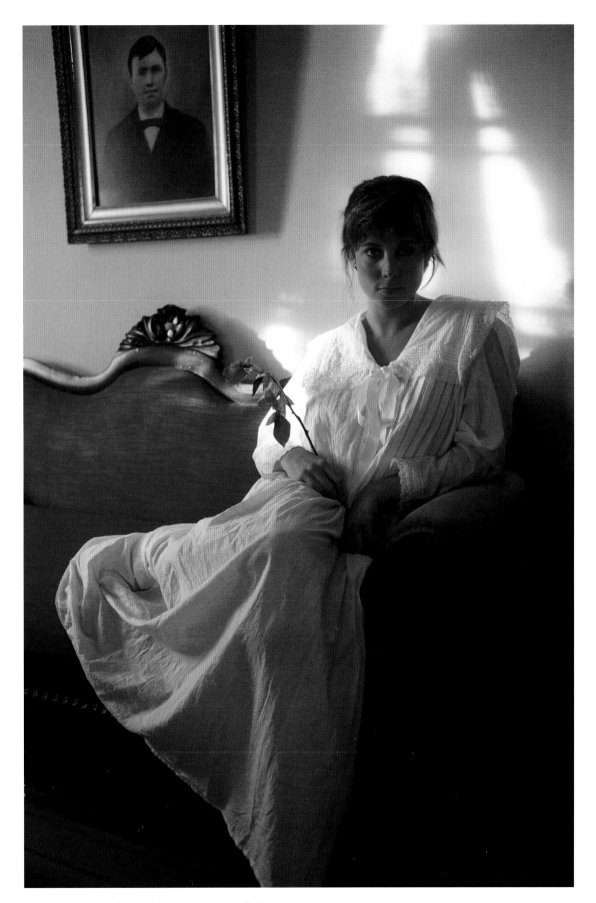

*Alexis Cassidy Burdine, in the Isom Place, Oxford*

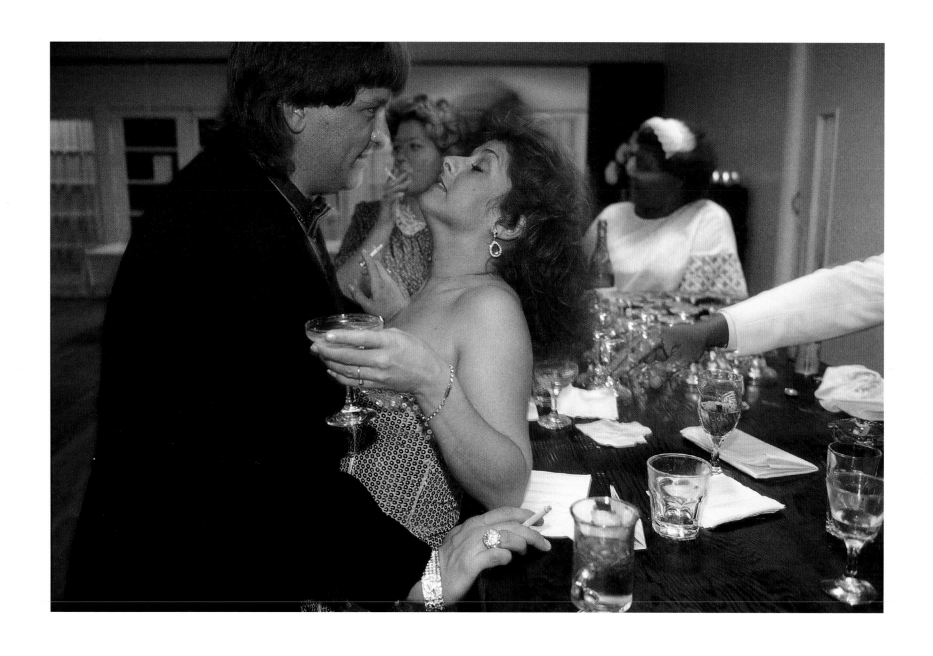

*Ducks Unlimited banquet, Oxford*

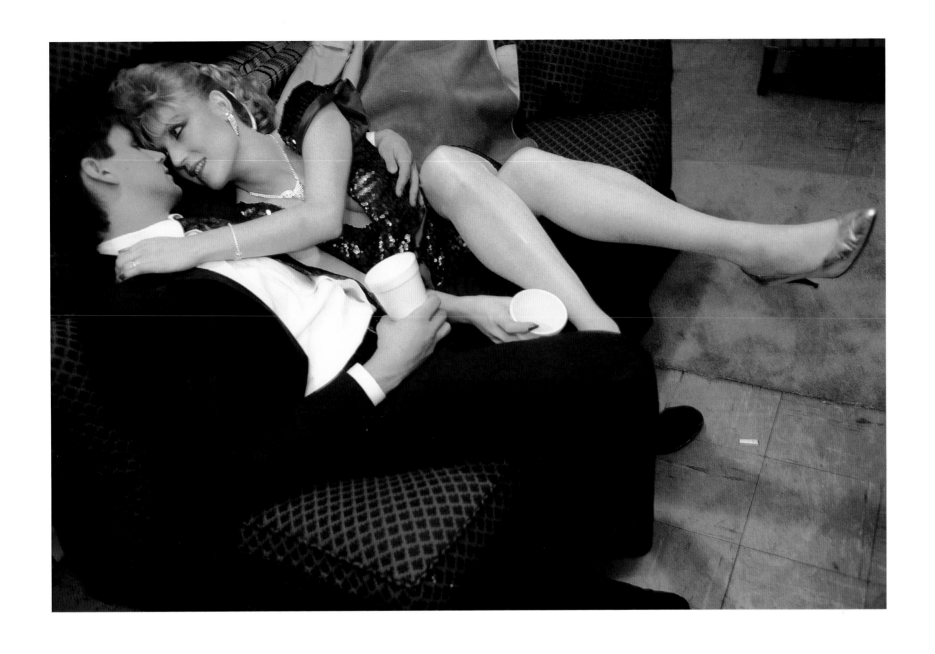

*Ole Miss fraternity Christmas party, Oxford*

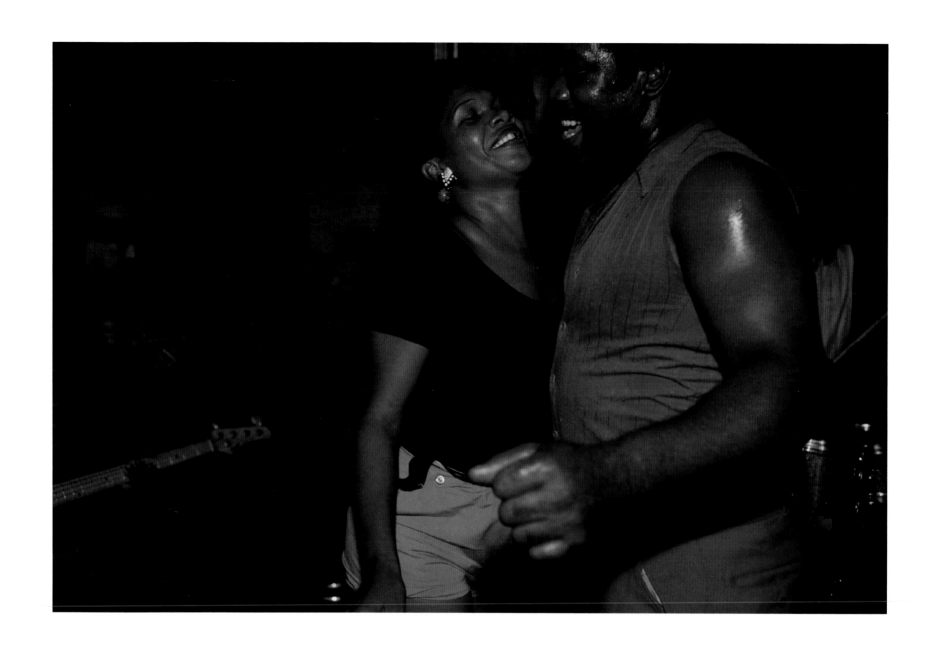

*Sunday afternoon at Junior Kimbrough's house, near Holly Springs*

*Elizabeth Howorth, cocktail party, Taylor*

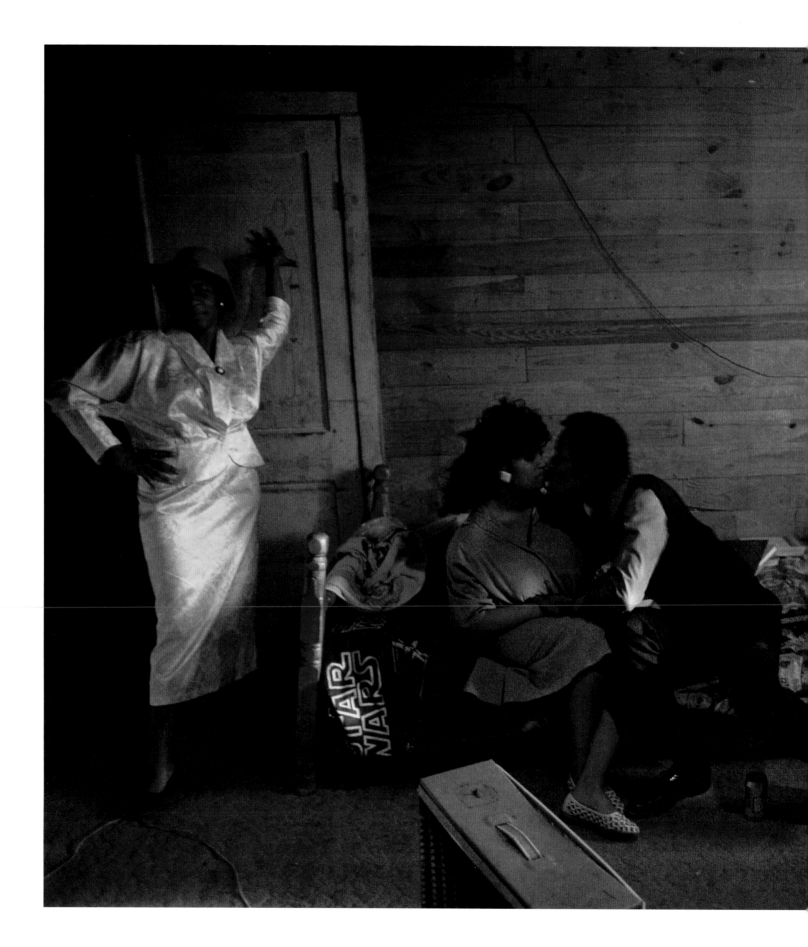

*Paula Kimbrough in her Easter dress, Junior Kimbrough's house, near Holly Springs*

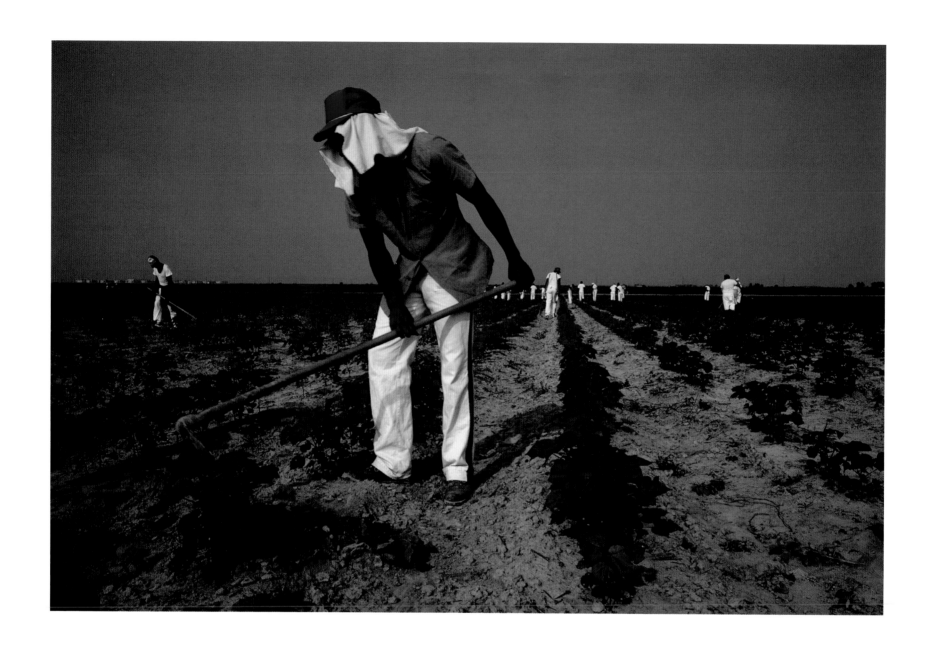

*Hoeing cotton, Mississippi state prison farm, Parchman*

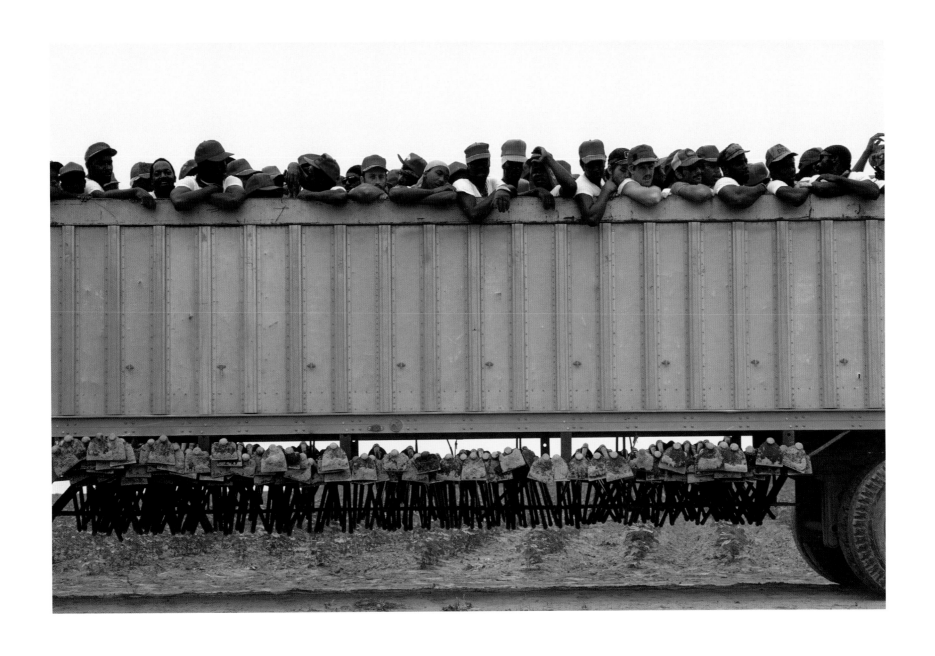

*Convicts and their hoes, Mississippi state prison farm, Parchman*

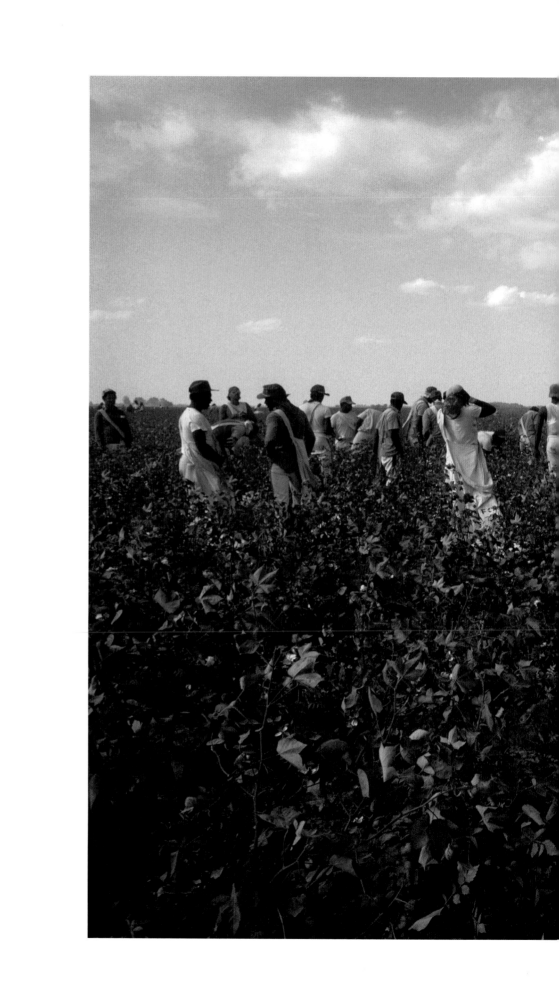

*Convicts picking cotton, Mississippi state prison farm, Parchman*

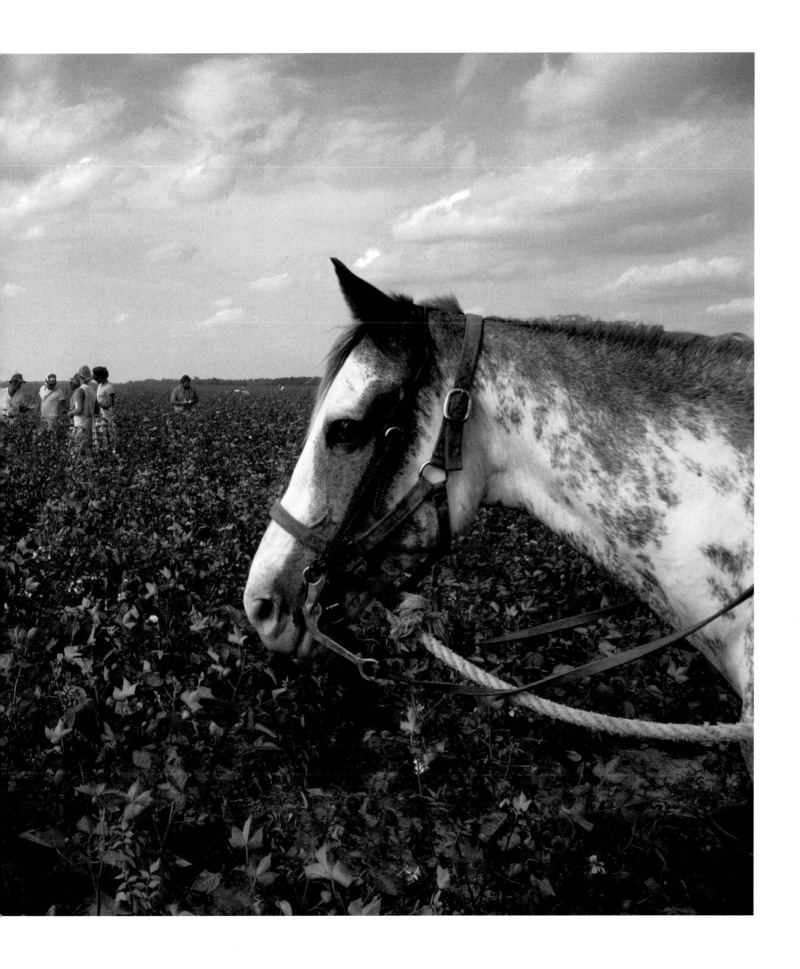

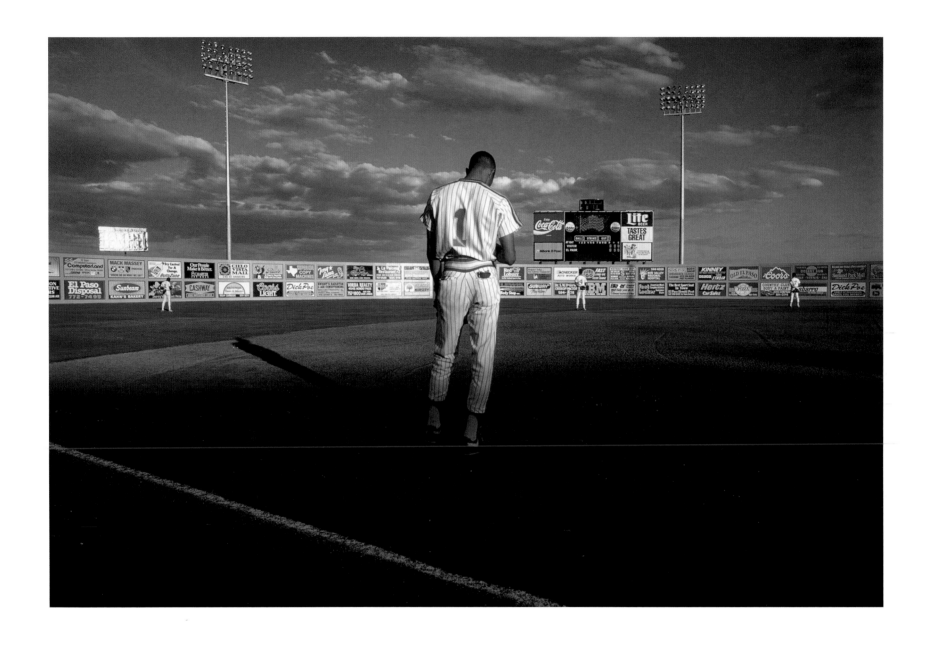

*Cohen Stadium, Class AA Texas League, El Paso, Texas*

# MINOR LEAGUE BASEBALL

## [ 1990 ]

*Well beat the drum and hold the phone*
*The sun came out today*
*We're born again there's new grass on the field*
*A-'roundin' third and headed for home*
*It's a brown-eyed handsome man*
*Anyone can understand the way I feel*

*Put me in Coach*
*I'm ready to play today*
*Put me in Coach*
*I'm ready to play today*
*Look at me*
*I can be*
*Centerfield...*

I GREW UP WITH THE PRIVILEGE OF HAVING A VACANT lot just down the street from my house on Lyndale Avenue in north Minneapolis. Probably very few city children today know what a vacant lot is. For the kids in my neighborhood that place was the center of our universe. Before we were teenagers and expanded our territories, it was our all-around ball field, our big yard in common. A bit of an eyesore, the lot was across the alley from the rear of a Skelly gas station where worn-out tires and empty oilcans lay abandoned. Open to the streets on the left and center, flanked tightly on the right by a house owned by a motorcycle cop, that narrow, scruffy stretch of ground at the end of the block drew us from our homes almost daily, in almost any kind of weather. There we could play softball and football after school, choosing sides and playing until we were called home for supper.

On summer nights, blessed by light lasting long beyond supper time, I'd help with the dishes, and then—assuming I wasn't grounded for some infraction—dash out the back-porch screen door, grab my bicycle with my fielder's glove still skewered to the handlebar, and wheel off as fast as possible to the big yard to rejoin my pals, and we'd play, hard and sweaty, until dark.

Home plate might be the lid of a paint can. Maybe a scrap of cardboard. The other bases were similarly marked. The batter's box was a slight depression worn into the ground. Any vegetation on that field was some variety of weed incidental to the dirt and dust of the base paths and the beat-up infield. The outfield was pockmarked with holes. When the game finally ended at dark, we straggled back through the alley. Upon arriving home, baths were always needed, if not wanted.

We played softball on that dirt patch, not baseball. Small as we were, we were still capable of driving a hardball more easily toward trouble than a softball. Ever mindful of the windows of the motorcycle cop's house, we reserved baseball games for the school playground much farther away, a larger space backed up by concrete walls and distance.

The truth of the matter is, however, I never played much real baseball.

As a little kid, I was a good enough athlete to sometimes get asked to play with the kids two or three years older than I, guys in their early teens, bigger and stronger. Then, one summer afternoon under the elm trees on Aldrich Avenue, I got hit in the head pretty good when I didn't bail out on an inside pitch. I was crouching on the sidewalk in a batting stance but with no bat, just pretending to be a batter so one of the older kids could practice his pitching. I think it was Earl Johnson who beaned me. And that was that for my baseball future. Months of headaches followed, and from that afternoon on, right through my teenage years, I couldn't face a fastball coming my way at the plate. In the field I was okay to pretty good with my glove. But at the plate—hard as I may have wanted to—I couldn't stand in against the pitch. I was a strikeout waiting to happen.

Although unfortunate, my inability to play baseball well didn't kill my love for the game. Not then and not now. I grew up still in love with various sports, playing on softball teams and getting into pickup touch football games. But I was always a bit in awe, I guess, of those graceful, hard-throwing, hard-hitting

baseball players. And I harbored, I suppose, the fantasy of being with them on the playing field. Throwing the ball 'round the horn in the summer twilight. Standing on deck under the lights for a night game, checking out what the pitcher's got and maybe stealing a look or two over to the baseline seats to see what lovely young feminine fans might be in attendance. Taking a fast ball deep, in the bottom of the ninth with the score tied and two outs. Circling the bases. What might that be like? How good could *that* feel?

There is a term in baseball called "going to the yard," which means, basically, going to a ballpark to play baseball. I don't think anybody knows exactly how that term came to be, but it's still used by those who play the game professionally. In 1990 I had the pleasure of spending most of my summer going to the yard for a NATIONAL GEOGRAPHIC magazine article about minor league baseball. I traveled with my cameras to cities and towns around the country in pursuit of the game and the places where it was played. I concentrated on the lower levels of the minors, where the teams are made up of many young men who will not reach the major leagues but will always be able to say that they played professional baseball. From Arizona to California to Utah and Montana, with stops in Texas, Wisconsin, Iowa, Illinois, Tennessee, North Carolina, and West Virginia, this was a summer I treasured. It brought me back to days long past, in the 1940s and '50s, when baseball seemed a part of every boy's life, when the sport needed no apologies, and its heroes stayed heroes. When baseball was truly the great American game and a part of our consciousness—even for those, like myself, who couldn't play it very well.

Perhaps the best thing about minor league baseball is that you can get so close to the game, if not onto the field itself. Minor league ballparks, especially those in the rookie leagues and in Class A and Double A, offer wonderful accessibility to both the game and the players. A few bucks will get you a great seat in most minor league parks. The typical minor league player isn't yet making more money than his personality can handle, and an autograph doesn't come with grudging compliance or a price tag. Maybe this is because the average minor league player knows that along with all those endless bus rides and life on a fast food budget, his chances of making it to the big leagues, or "the show," are 1 in 14, and he had better stay in contact with reality.

Baseball is a game of frequent failure. A player who is having serious problems with his game is said to be "struggling." A player who isn't considered to be struggling still manages to get a hit in perhaps only three out of ten attempts. In order to avoid struggle and achieve success, batters work on their swing constantly, hoping that muscle memory will lead to a fluid and flawless effort to meet the ball and get the hit. Their bats are their constant companions. Always the bats. In El Paso, at the end of a game that began with a home-plate marriage between Charlie "Choo-Choo" Montoyo and Dana Espinosa, I made a picture of the Diablo second baseman as he walked off the field, his glove tucked under his arm, a large Coke in one hand, his new wife—resplendent in her youth and white wedding gown—in the other. Actually, she was holding onto his wrist. He was holding his bats.

Although a lot of the old ballparks with their charming antique wooden structures now exist only in memories, like them the new parks are still open to the sky, and most have fields of real grass. I loved coming into a minor league baseball park for the first time. There was always an immediate visual rush, like walking into El Paso's old Dudley Field for the first time and seeing all the reds and blues and greens and yellows. A Texas League baseball park located on the Mexican border, it was a place of fiesta. Painted in large letters across the top of the visiting team's dugout was the word ENEMY. I loved that. When a Diablo hit a home run, fans would scurry down the steps to stuff dollar bills into the mesh of the backstop, their generosity supplementing the player's meager, minor league income.

If possible, I would have visited every minor league ballpark in the country. Each has its individual personality and offerings. At Tefler Park in Beloit, you can watch a Beloit Snappers (formerly the Brewers) Midwest League game from a picnic table on a wooden deck in right field and enjoy your choice of Wisconsin beers with a bratwurst or a grilled pork tenderloin sandwich, served up by friendly volunteers. Fiscalini Field in San Bernardino offers dining tables along both outfield foul lines. Outside Sam Lynn field in Bakersfield, where the California League Dodgers play, there is a complex of batting cages where you can nurture your fantasies, pound out your frustrations, or just get a little exercise. At just about any minor league park, if they call your ticket-stub number you will win *something*—maybe a free lube job at a local garage or perhaps a pizza or a large Coke and medium fries. And there's always music pumped out of the public address system prior to the game and between innings. The hand-clapping backbeat of J.C. Fogerty's

"Centerfield" will get you in the spirit, if not in the game itself.

During the course of that summer I photographed around the edges of baseball games more than the games themselves. I wanted to make images that had the feeling of being at the yard, pictures of the players and the parks, but not necessarily action pictures; pictures of both sides of the game, the fun and the serious. Maybe I'd photograph the Famous Chicken making an appearance, scaring babies, delighting parents. Or I'd show the young, lean-jawed faces of the youths of the Americas in the dugouts and dressing rooms—the sadness of a loss or the deep funk of a pitcher taken off the mound and sent to the showers after a disastrous outing. And the near-tragedy of serious injury such as on that early evening in Springfield when right-handed Beloit pitcher Joe Andrzejewski got hit in the face by a line drive back through the mound and went down faster than you could pronounce his name, almost as if he'd been shot. I thought he might be dead. He was taken off by stretcher and brought to the local hospital, the curved imprint of the ball's stitches clearly evident on the side of his face like multiple snake bites. He was deemed OK by the doctors, and he returned in time to make the team bus. The joke, of course, was that when they x-rayed Joe's head at the hospital, they found nothing.

On a warm July afternoon in Beloit, Billy Castro, the Milwaukee Brewers major league pitching instructor, down from the front office, was working with the Beloit pitchers. He took a break and invited me to take some swings. He'd been telling me for a while that I should take some batting practice. I accepted, abandoned my cameras, and stepped up to the plate, wondering if I'd be able to make contact. The last time I'd swung at a baseball thrown by a pitcher, I was still too young to shave.

The first couple of pitches I fouled off, then I managed to hit a grounder between third and second, a bit more up the middle than maybe the average shortstop could reach. I lofted an easy-out soft fly over Castro's head, and then connected solidly and drove one well into left field. A couple of the Beloit players were watching. From behind his protective screen Castro was throwing typical batting practice pitches, no heat, just serving them up well in the strike zone. I kept connecting. Then I took one deep into left center that brought a sweet feeling of bat on ball to my hands and arms. "Hey!" said one of the minor leaguers: "He might hit one out of the yard." I had built up a sweat, partly from exertion and partly from the exuberance of my illusions. Maybe, I found myself thinking, after I walked away from the plate without having embarrassed myself, maybe this is a game I could have played. And maybe not. But that afternoon, if only for a few minutes, something missing in my childhood had been replaced.

On a book-lined, glass-topped table in my living room is an antique baseball glove I picked up somewhere in West Virginia. It must have been well taken care of, oiled regularly, because the leather, although darkened to mahogany and creased with time, is not cracked. The Rawlings label is faded, almost unreadable. By today's standards it's a small, uncomplicated glove. I sometimes wonder about its former owner. Could he play well? Did the glove ride to games slung along the chrome handlebar of a Schwinn bike, fast-pedaled by a kid whose dreams were to play the game as a man, before he could possibly know that it seems to stay a kids' game no matter how old the player becomes?

Although, in truth, baseball has enough complexities to satisfy and inspire mathematicians and poets alike, it is a simple game to most of us. We like to think of it as easygoing, with no time limits. Remember the observations of minor league catcher Crash Davis's manager in the movie *Bull Durham?* "Baseball is a simple game," he says. "You throw the ball. You hit the ball. You catch the ball."

That seems to be about enough for most of us. ☐

*Got a beat-up glove a homemade bat*
*And a brand new pair of shoes*
*You know I think it's time*
*To give this game a ride*
*Just to hit the ball and touch*
*'em all*
*A moment in the sun*
*It's gone and you can tell that one*
*Goodbye*

*Put me in Coach*
*I'm ready to play today*
*Put me in Coach*
*I'm ready to play today*
*Look at me*
*I can be*
*Centerfield*          —J.C. Fogerty ©1984 Wenaha

*John Jaha, Stockton Ports, Class A California League, game at Bakersfield, California*

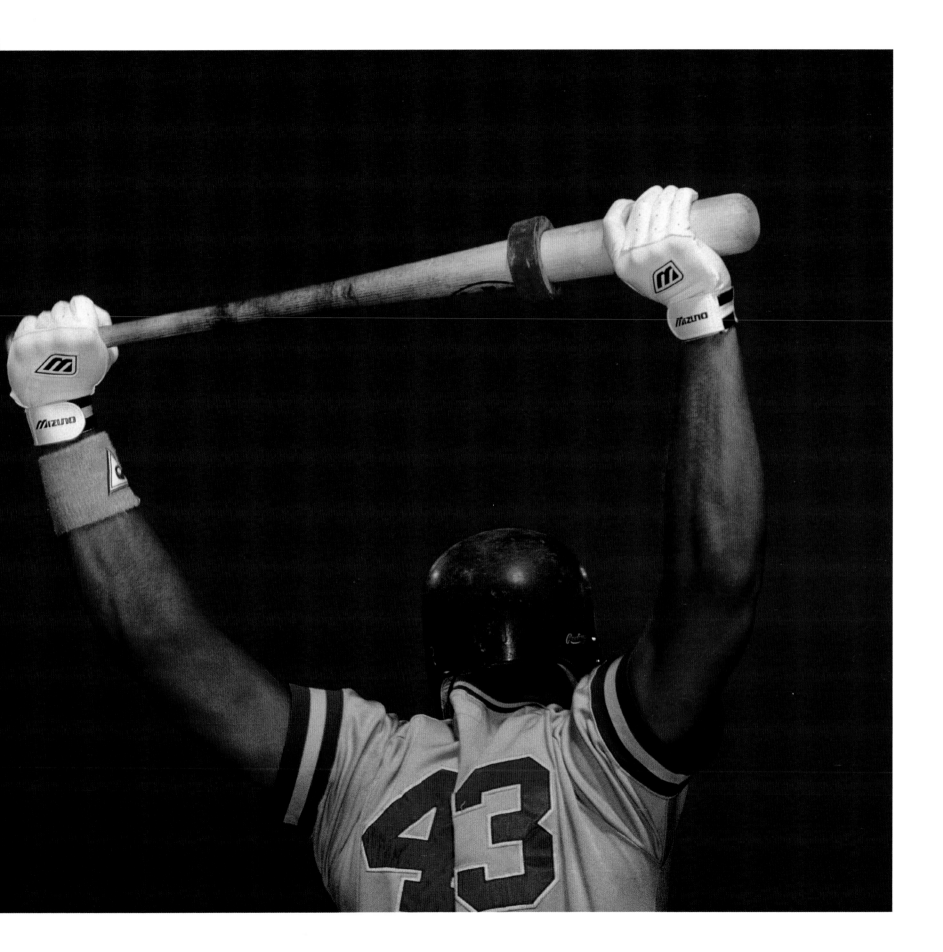

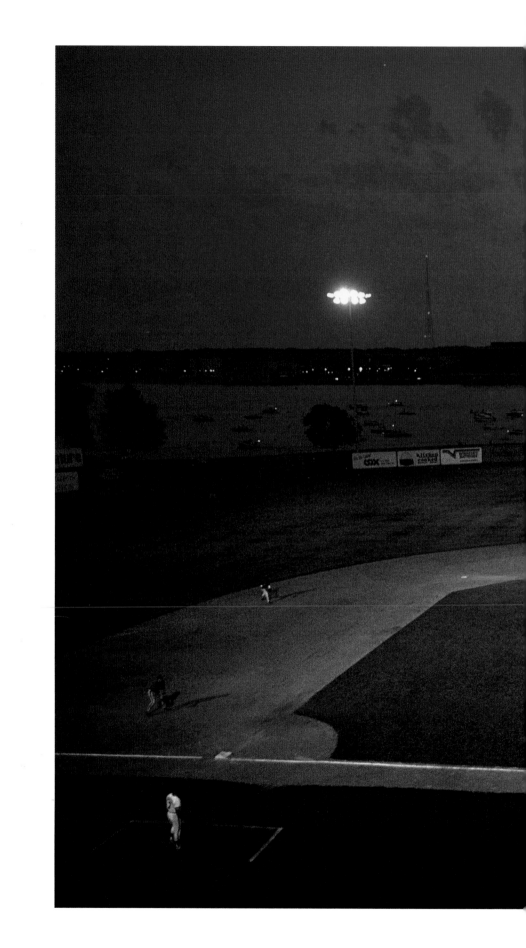

*Baseball on the Mississippi River, John O'Donnell Stadium,*

*Davenport, Iowa, home of Quad City Angels, Class A Midwest League*

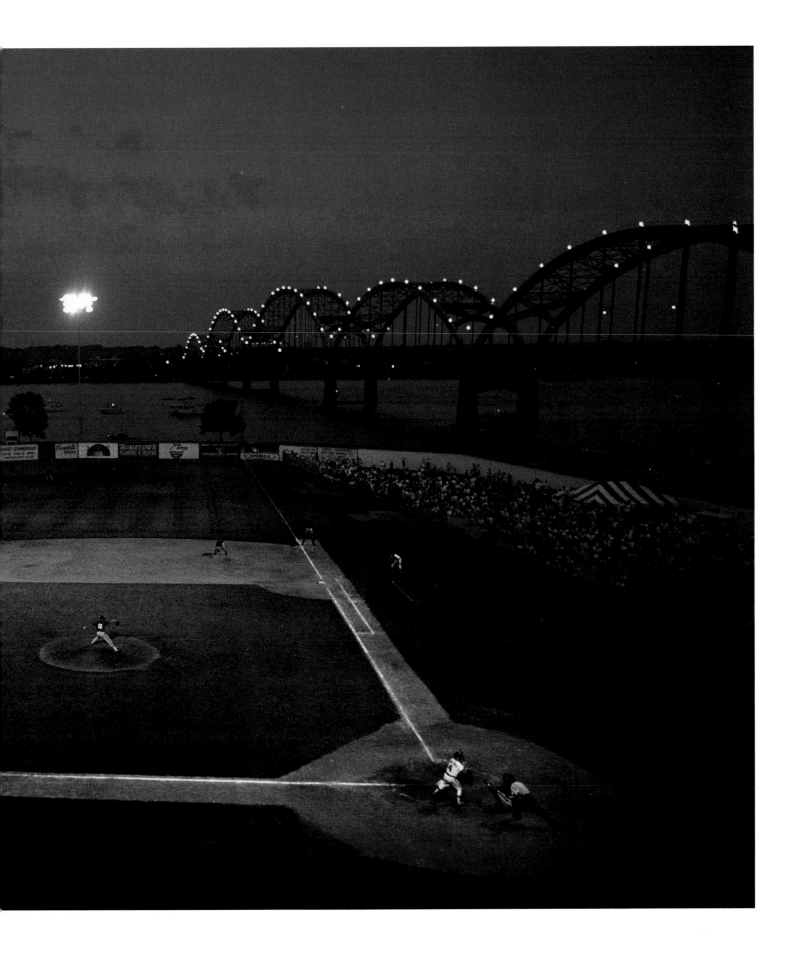

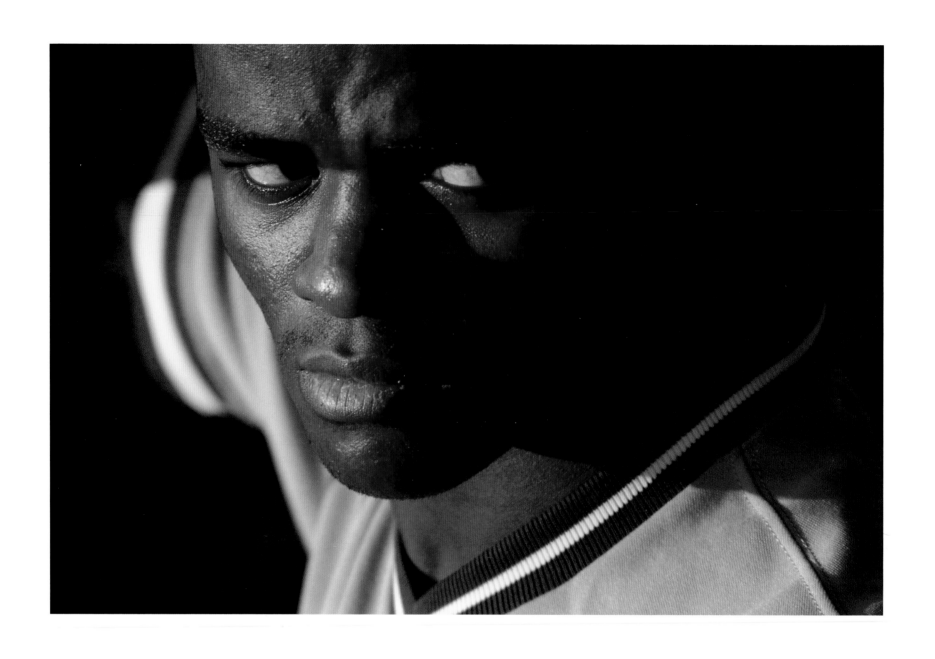

*Player for Medicine Hat Blue Jays, Pioneer Rookie League, Helena, Montana*

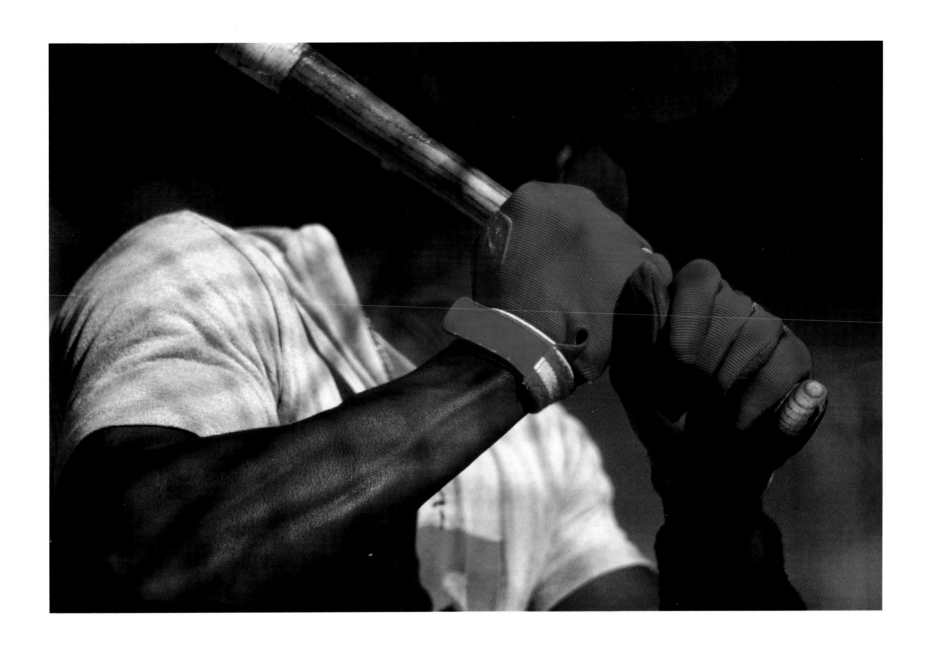

*Batting Practice, San Bernardino Spirit, Class A California League*

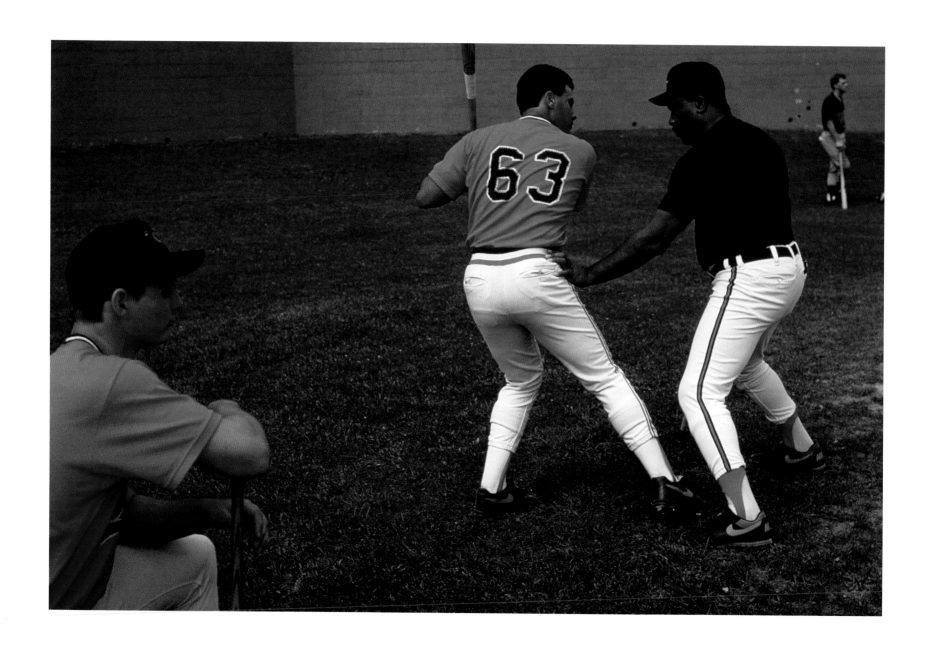

*Batting instruction, Bluefield Orioles, Appalachian Rookie League, Bluefield, Virginia*

*Visiting team's dugout, Tefler Park, Class A Midwest League, Beloit, Wisconsin*

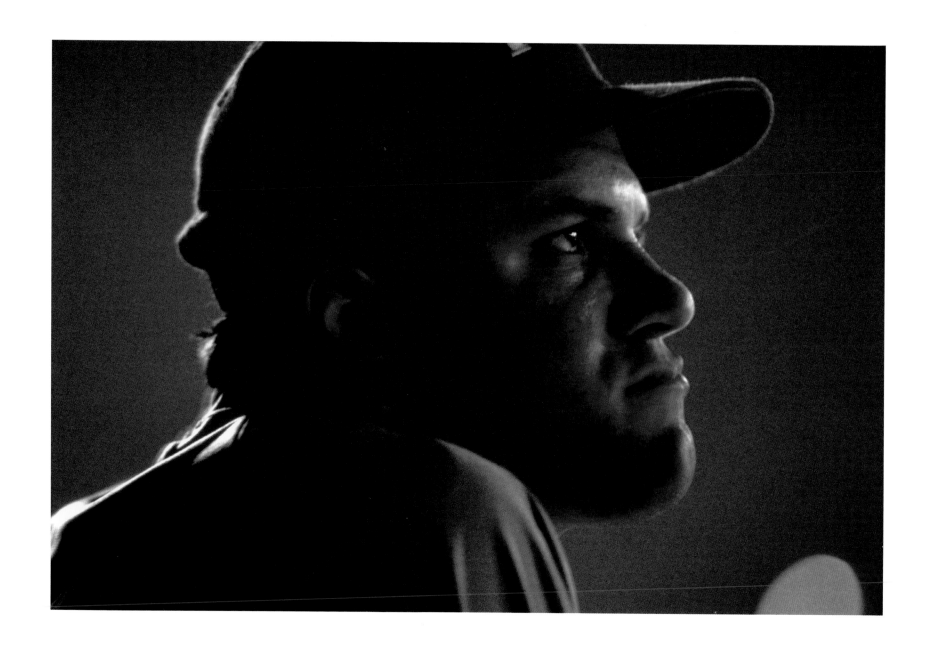

*John Jaha, Stockton Ports, Class A California League, Stockton, California*

RIGHT: *Chris Bando, manager, Stockton Ports, Class A California League, Stockton, California*

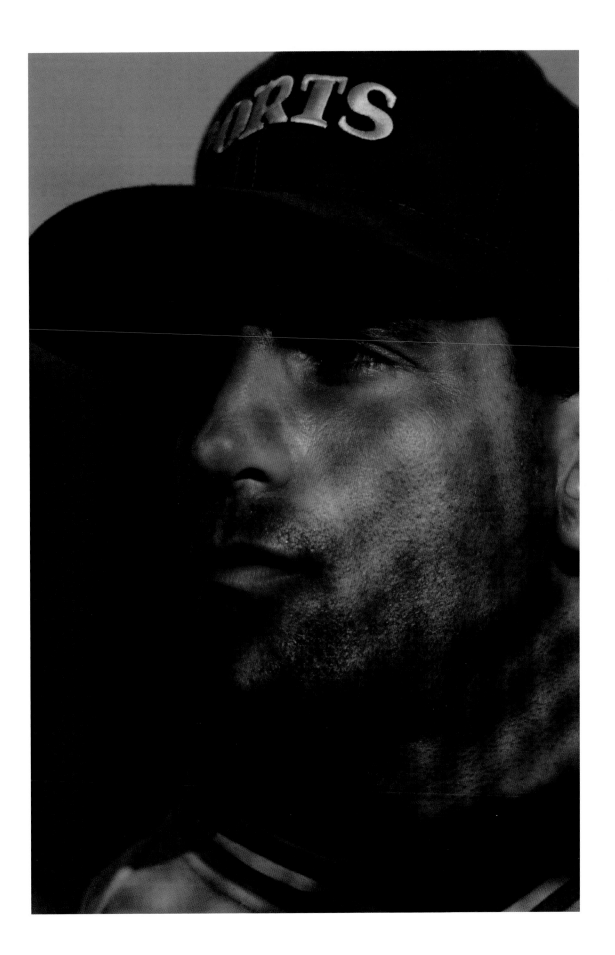

*Helena Brewers dugout, Pioneer Rookie League, Salt Lake City, Utah*

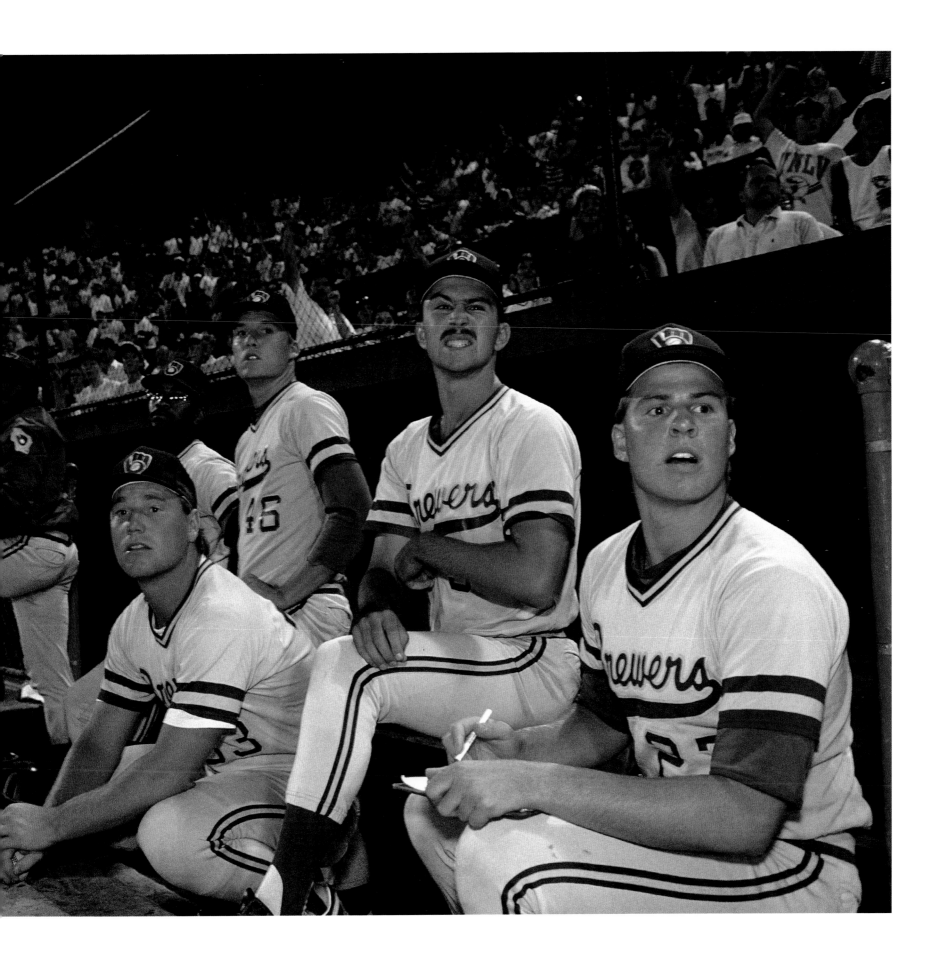

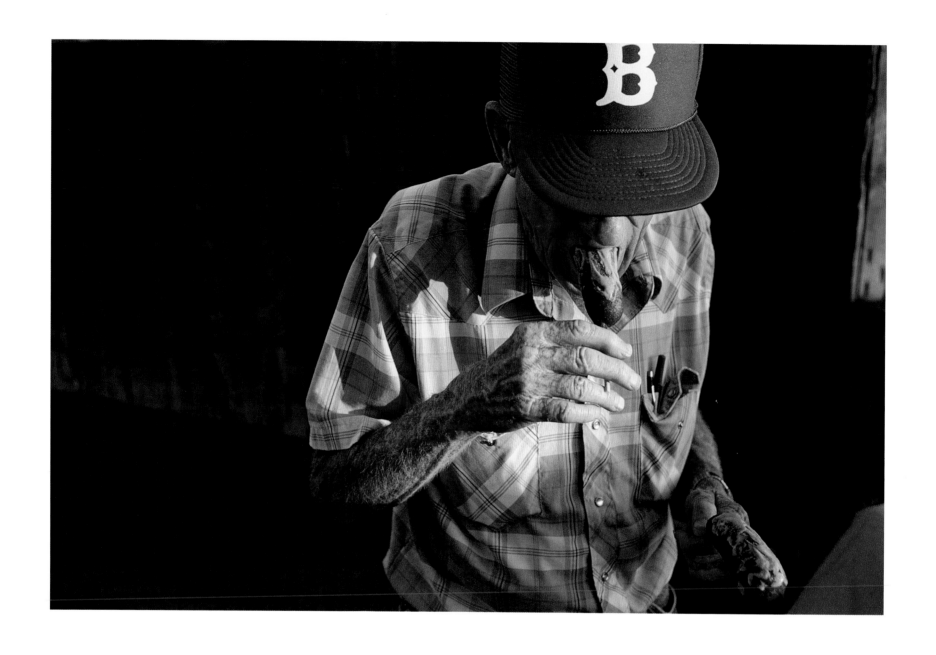

*Sam Lynn Ballpark, Bakersfield Dodgers, Class A California League, Bakersfield, California*

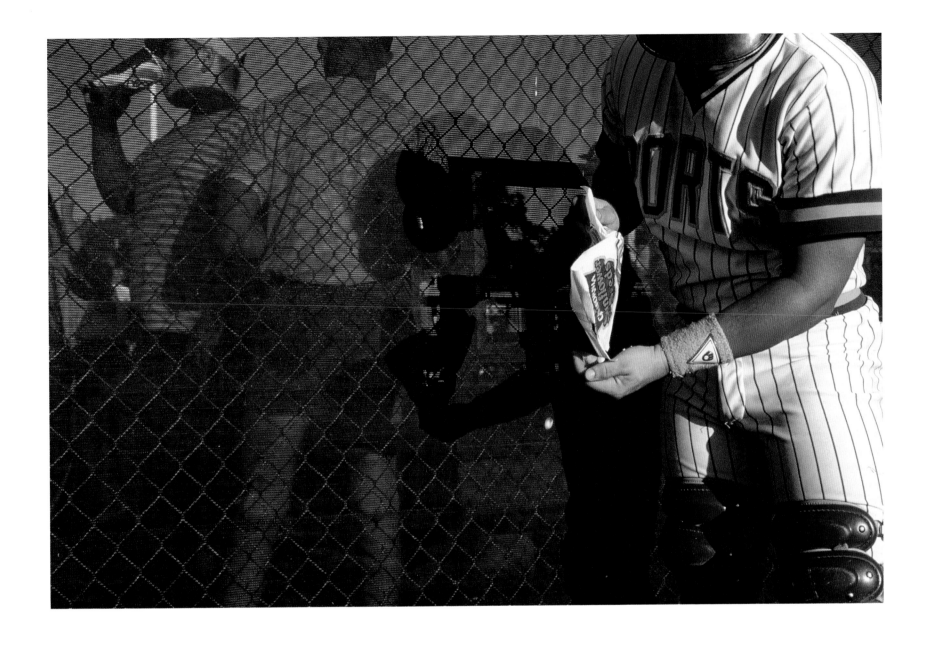

*Herbert Field, Class A California League, Stockton, California,*

*Pioneer Rookie League, Great Falls, Montana*

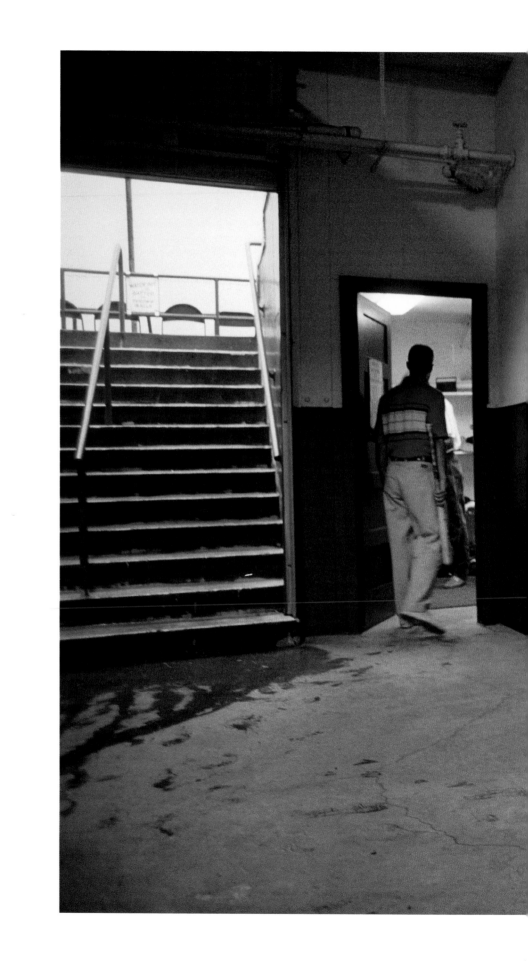

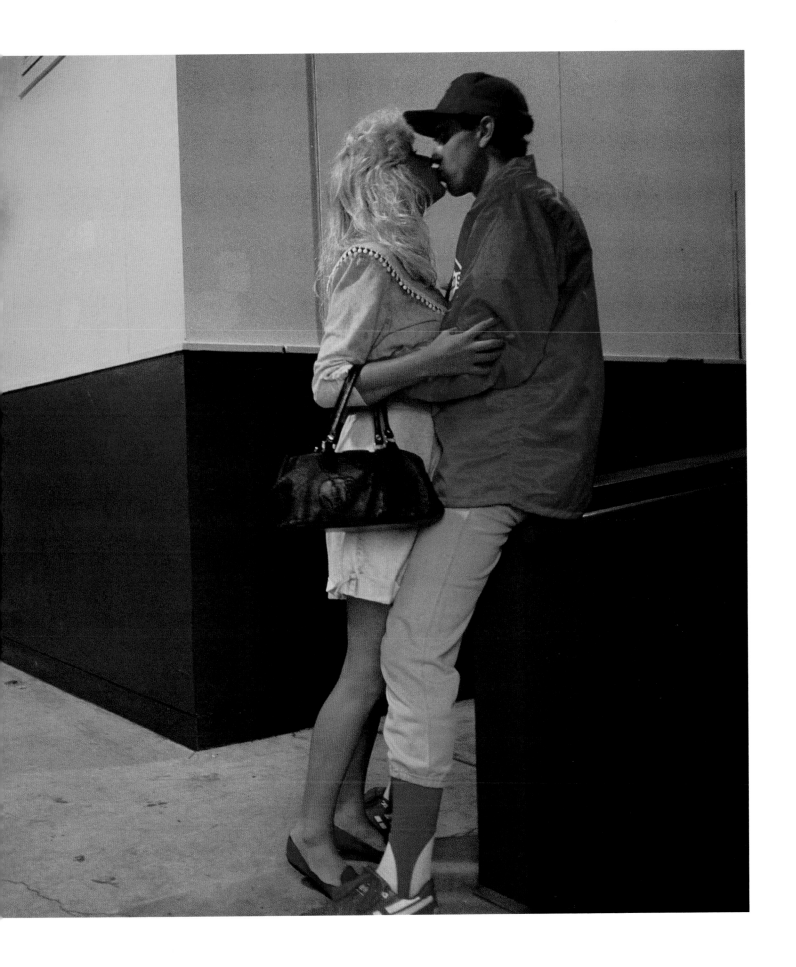

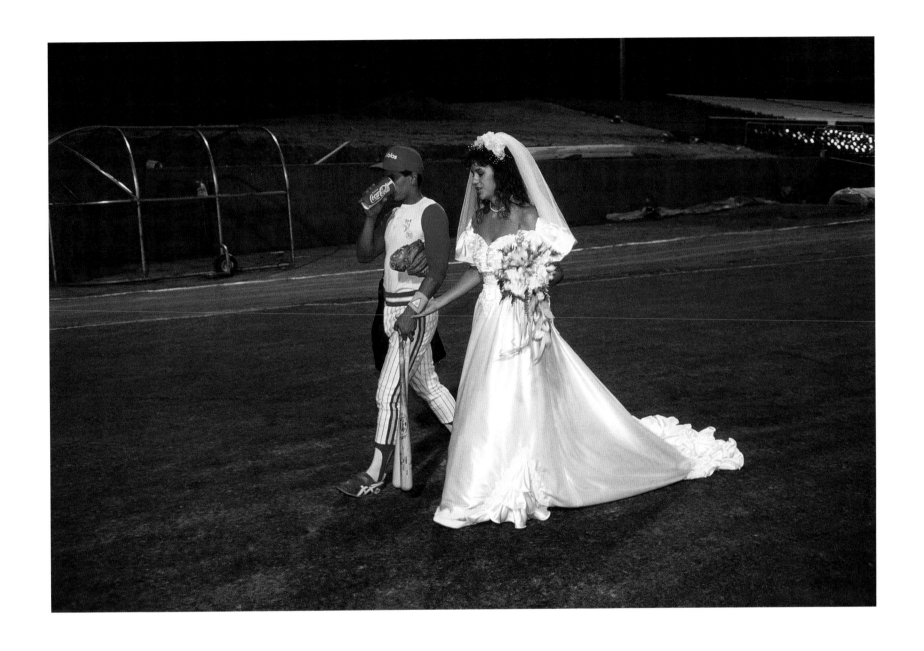

*Charlie "Choo-Choo" Montoyo of the El Paso Diablos and Dana Espinosa, married before the game,*

*leave the field after the game, Texas League, Cohen Stadium, El Paso, Texas.*

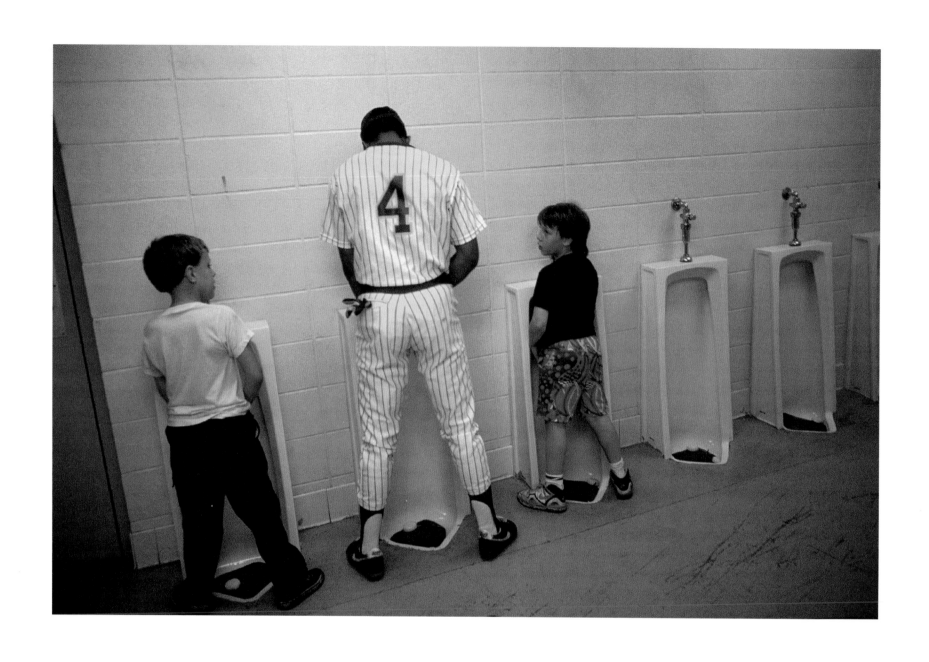

*Tefler Park, home of the Beloit Brewers, Class A Midwest League, Beloit, Wisconsin*

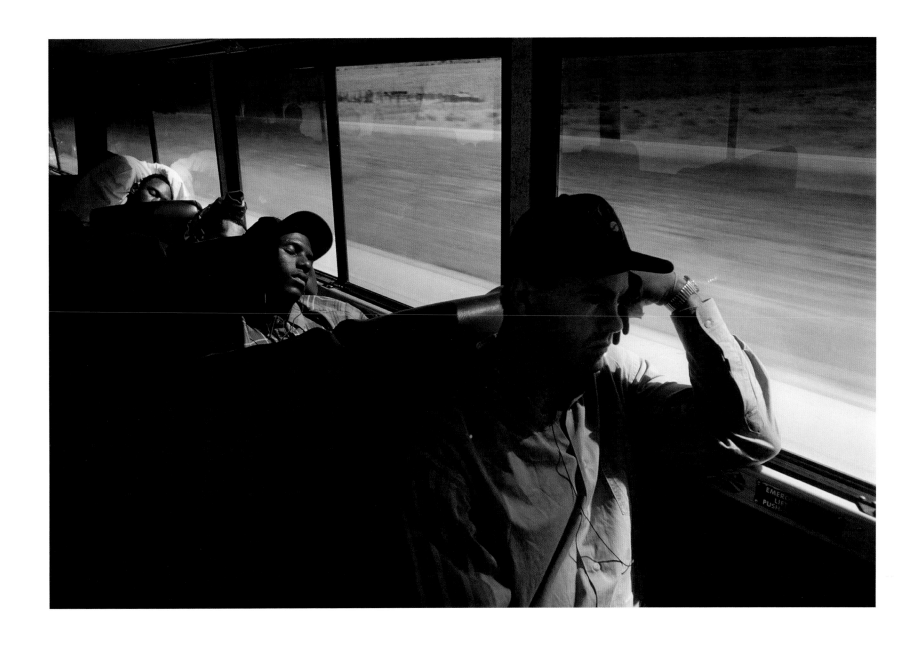

*Helena Brewers, Pioneer Rookie League, on bus bound for Salt Lake City*

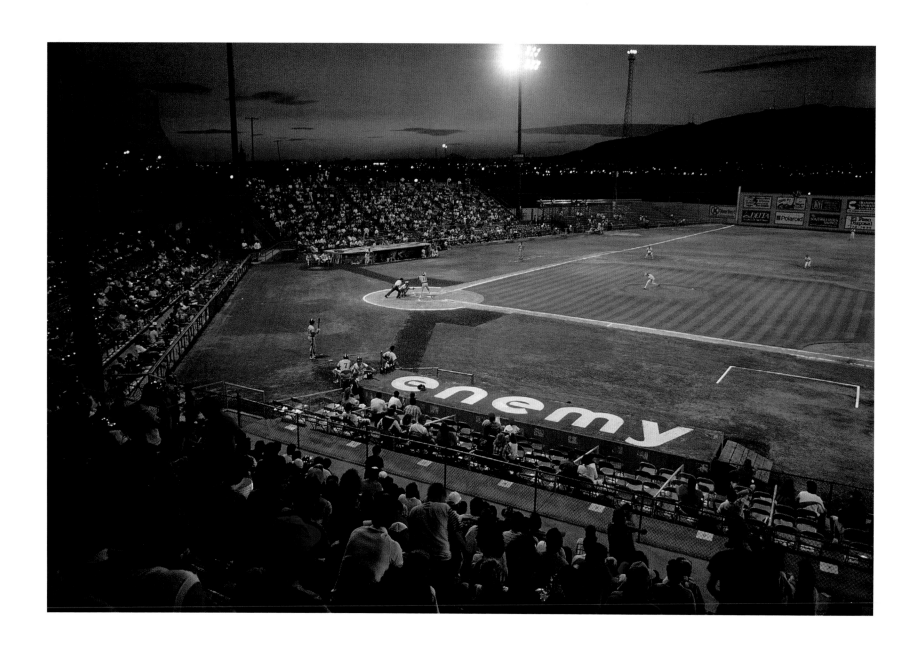

*Cohen Stadium, El Paso Diablos, Class AA Texas League, El Paso, Texas*

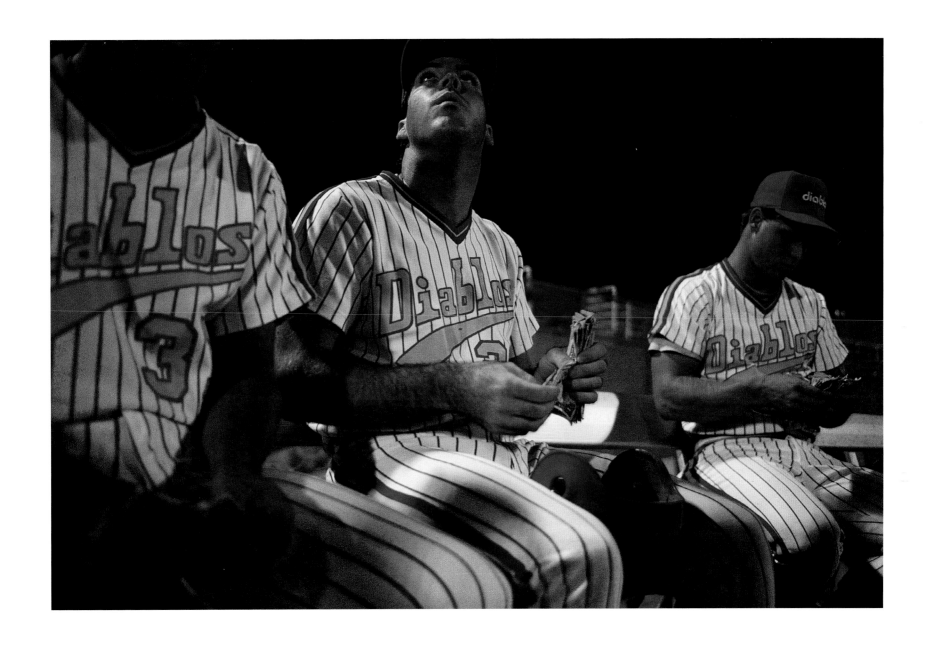

*Shon Ashley and Dean Freeman (right) count home run money, Dudley Field, Class AA Texas League, El Paso, Texas.*

*El Paso Diablos celebrate winning their division, Class AA Texas League, El Paso, Texas.*

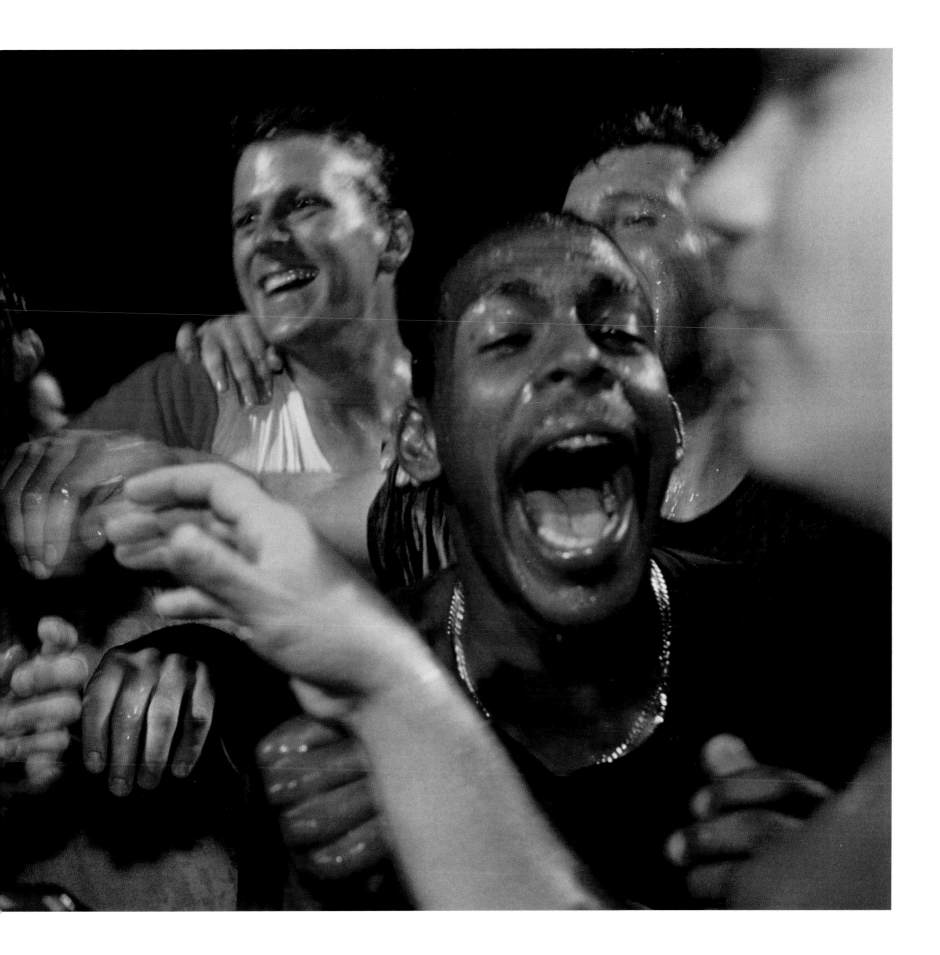

*El Paso Diablos pitcher Steve Monson in dressing room after bad outing,*

*Cohen Stadium, Class AA Texas League, El Paso, Texas*

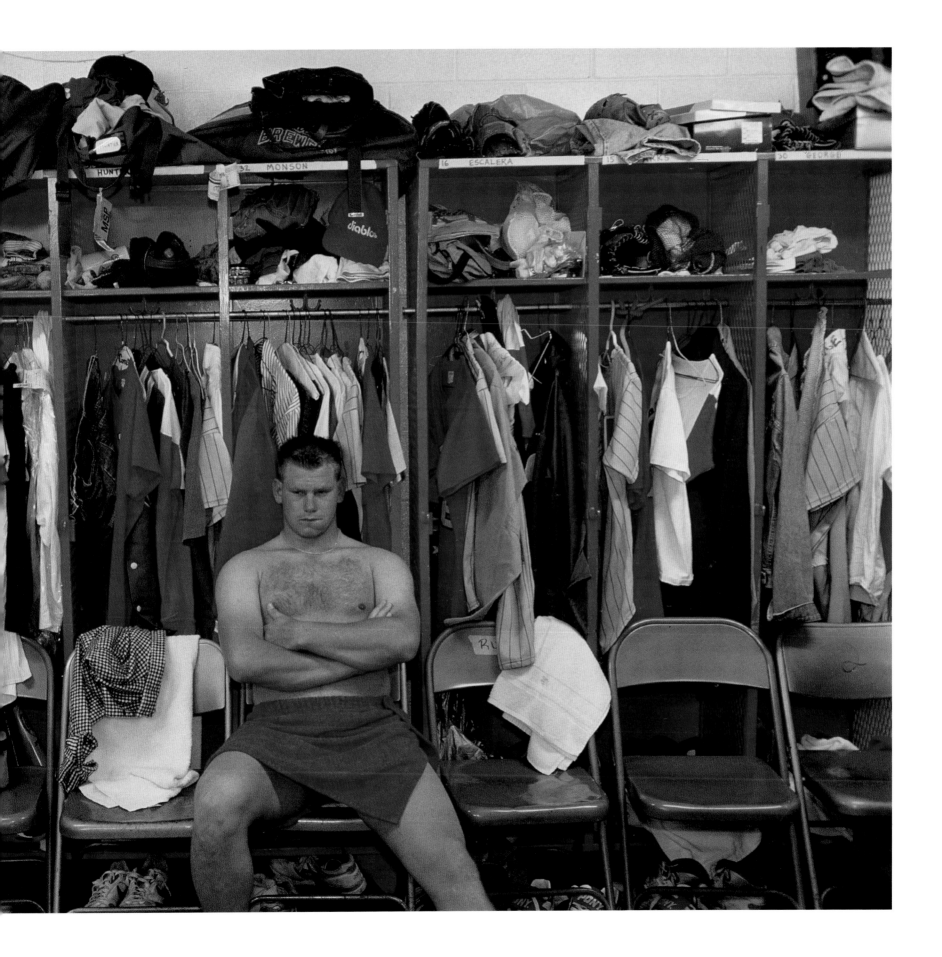

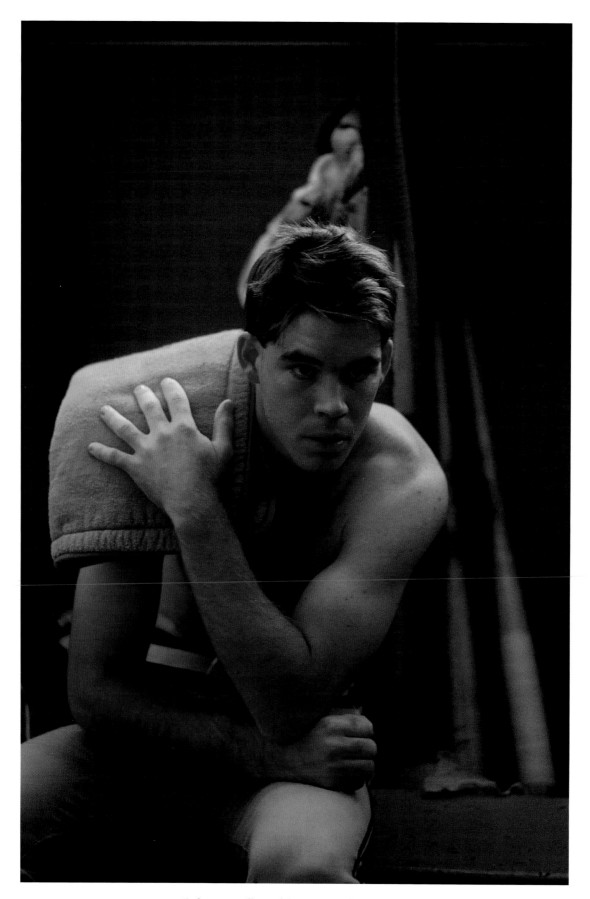

*Pitcher Pat Miller, Beloit Brewers, Class A Midwest League, at Appleton, Wisconsin*

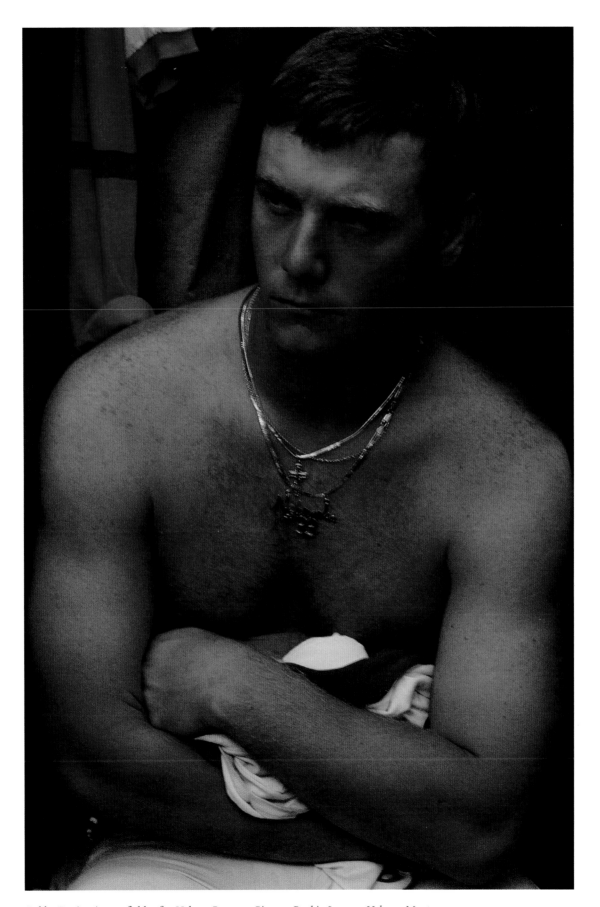

*Bobby Benjamin, outfielder for Helena Brewers, Pioneer Rookie League, Helena, Montana*

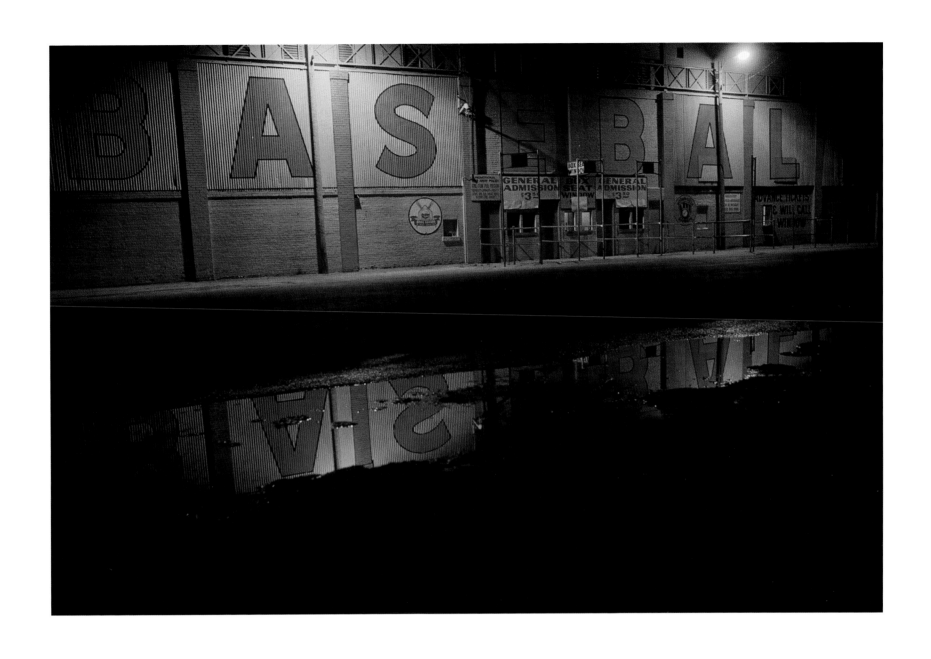

*Dudley Field, former home of El Paso Diablos, Class AA Texas League, El Paso, Texas*

*Waiting for an autograph, Dudley Field, Class AA Texas League, El Paso, Texas*

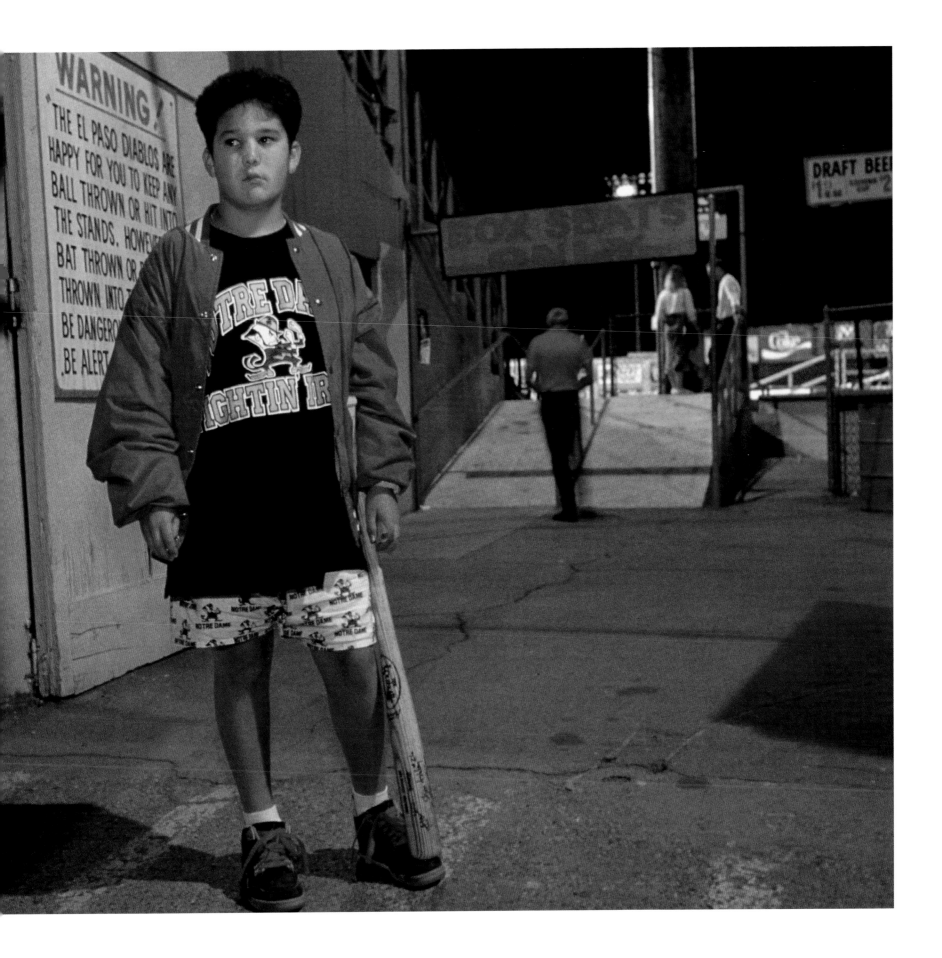

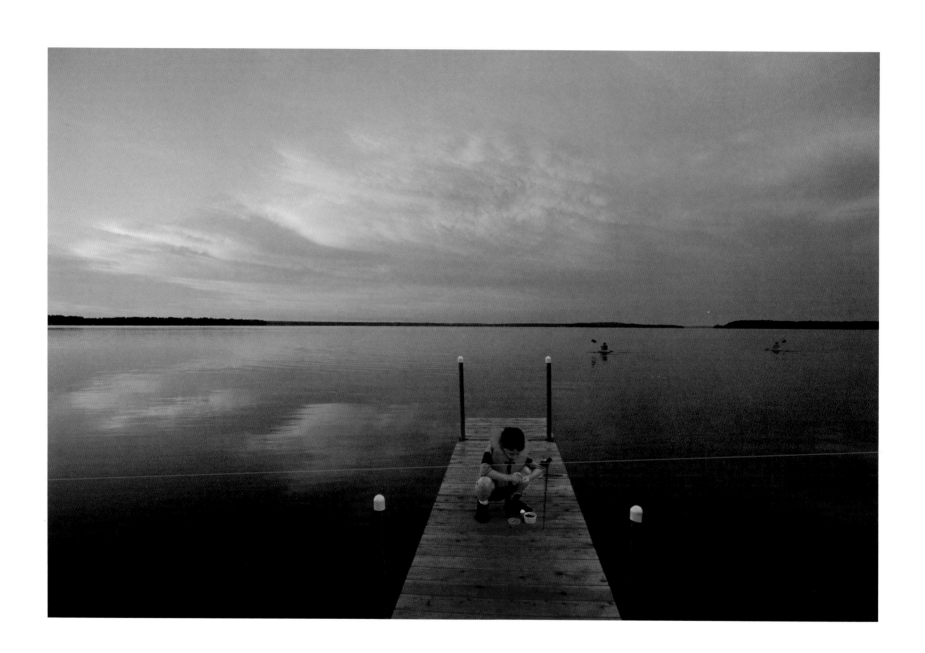

*After a storm, Upper Whitefish Lake* 1991

# TIME AT THE LAKE

## [ MINNESOTA 1991, 1994–1995 ]

FOR 60 YEARS MY FAMILY SPENT A SMALL FRACTION OF EACH SUMMER AT A LITTLE lake in northern Minnesota. Sixty summers. No winters. We were not an ice-fishing family. As a child, the winter wind chill factor was not something I ever heard discussed in my neighborhood, other than, maybe, "Jeez, that's a helluva cold wind, ain't it?" Twenty or thirty degrees below zero did not require any breeze to enforce itself. You could freeze an ear, your nose, or to death, without a breath of moving air. We were a dysfunctional family in our ways, perhaps, but not masochistic. When it came to being out on the lake, we were summer people.

At first, of course, it was just my mother and father, Willie and George. He was handsome and she was pretty and they were young. It was the 1920s and they'd drive up to Gladstone, a lake that today is about a two-hour drive from the Twin Cities. They'd motor up in a Model T, jouncing and skittering over rutted roads that weren't much better than graveled cow paths. I don't know how long

it took them; I never asked but I don't recall ever hearing them complain.

Gladstone, one of those smaller blue stains on a map of Minnesota, is a 400-acre lake in Nisswa, just north of Brainerd, and in those years it was teeming with fish. They'd catch fish for breakfast, fish for lunch, and fish for dinner. I imagine they ate *something* other than fish, but with the majority of your food budget just swimming around out there in front of the cabin for the taking, well, why not? The entire state was a fisherman's paradise, with over 15,000 lakes varying in size from ten acres to those best described in terms of miles across, about half of them fishable. Anybody still alive who can remember the 1920s and '30s up north will tell you, I'm sure, that the fishing today isn't anything like it used to be. Well, what is?

An interesting trivia statistic is that Minnesota has more shoreline than California, Florida, and Hawaii combined. Maybe that's not trivia considering Minnesota lakes still produce more than 73 million pounds of fish each year and a monetary harvest from tourism for the state of about 1.5 billion dollars.

My father was a working man who didn't get much vacation, and there were always things that needed doing around the house, so we could only go up north for one week each summer. That was probably the most important week of the year to me. And probably to my father.

Over the years at Gladstone, my family always stayed at what have traditionally been called mom-and-pop resorts: a handful of rustic cabins and a few boats rented out by a man and wife probably just getting by, the wife sometimes doing all the housekeeping and the husband often holding down a full-time day job. In earlier years, the cabins didn't always have indoor toilets and the drinking water was usually what we called "skunky," with a lot of iron in it evidenced by an ugly rusty brown stain around the drain in the cabin sink. You could drink the water but the smell was unpleasant.

We didn't have an outboard motor. My father never did have one until he retired and his kids gave him one as a present, but I don't think he ever used it. Most people who did have motors had five- or ten-horsepower outboards you could throw in the trunk of a car. A big motor in those days was a 25 horse. You could really go with one of those and I used to envy people

who could zip out to places far across the lake where I just knew the fish must be bigger.

We'd creep out on the water, me in the back of the rowboat; my mother in the bow, wearing some kind of broad-brimmed straw hat; and my dad in the center, manning the oars. The oarlocks creaking and clunking, the oars dipping and glistening, we'd ease across the water to a spot my father thought looked good. We were never very far from the resort when we dropped anchor.

We only fished for "sunnies," using night crawlers we gathered in coffee cans at home in the evenings just before going up north. We'd look for them in the yellow beam of a flashlight, pulling them up from the soaked and spongy grass of our heavily watered backyard. I don't think we ever bought worms at a bait shop when I was a kid.

We fished with cane poles rigged with black silk line and bobbers. Not exactly high tech. We put the keepers, as my mother called them, in a wire mesh basket tied to the side of the boat. It was fishing in its most basic form, and as a boy, I loved it.

For some reason, my father lost his sense of adventure in fishing (in my opinion) at an early age, before I grew very old. I can't remember him ever fishing for anything but pan fish. Never bass—great fighters; never northern pike or muskies—the ruffians and thugs of fresh water; and never, and this is almost sacrilegious, walleyes—fish just short of sainthood status in Minnesota. I know he fished for them as a younger man because I have pictures of him with stringers heavy with catches of walleyes, northerns, and bass. I guess he and my mother just came to love those sunfish, usually easy to catch and although bony as the devil, about as good eating fish as you could dream of. Better, I think, than walleye. A plateful of bluegills, their sweet flesh battered or just dredged in seasoned flour and fried in butter to a slight outer crispiness, is, in the minds of the cholesterol conscious, akin to serving up a mortal sin. But what a delectable way to do so. Pass the lemon, please.

As I grew older, I preferred to fish for largemouth bass and northerns for the sport. Although a good-size sunfish provides great fight on light tackle, bass and northerns were bigger and tougher. I'd always heard that walleyes weren't much fun to catch and, in fact, I don't believe I've ever caught one. One must confess to that very quietly in Minnesota or long,

doubting looks will be given by others, and one's aptness for lake life may be questioned.

In the later years of my parents' lives, sometimes all the siblings made it up to Gladstone, grandkids in tow. We stayed at a resort called Oak Grove. There'd be lots of family dinners, and at night some card games, and always the joking that was like a disease afflicting the three brothers and one sister. In our family most of us shied away from being very serious. Dangerous ground, maybe, I don't know. When brought together as a family, it was almost impossible for any subject to be discussed with a semblance of seriousness on the part of the Allard children. Funny asides would have to be made; a sort of competitive humor would take over the conversation. I think we got our sense of humor from our father, although he didn't use his as often as we wished. My mother, on the other hand, simply never could tell a joke of any kind, which, I guess, made her the serious one in the family. "Ohmahgod!" was her answer to almost anything we said when we tried to be funny or shocking.

After I moved out East to begin my career, I found fewer chances to get back to northern Minnesota. Or perhaps, through distance, I just lost my desire to go there for a while. When my older brother, Bob, died in 1982, we gathered as a family for the last time in the cabins under the trees at Oak Grove. It was the last resort left on Gladstone. We scattered his ashes on the other side of the lake in a small cove where he liked to fish.

I didn't return for another nine years. Then in 1991 I had an urge to go back to see and photograph the lake country I'd fallen in love with and cherished as a child. I went back that summer to make pictures of the lakes and the people, not so much the fishing because there's far more than that up there. Upon my return I discovered that the Oak Grove cabins had been bulldozed and there are no resorts of any kind to stay at on Gladstone anymore. So I discovered other resorts big and small on other lakes huge and tiny. Going back that year renewed a need in me to return each summer for a couple of weeks if possible with my wife, Ani, and our son, Anthony. Now, if for some reason it's not possible, I desperately miss it.

With the death of my parents in 1986, the family house in Minneapolis was sold. Nobody in the family lives in north Minneapolis anymore, but whenever I go back to Minnesota I always take a drive around my old neighborhood before heading

up north. Time has been less generous with some parts of the neighborhood than with others over the almost 40 years since I left it. Like faces at a high school reunion, some of the houses have not aged well. Maybe they never were graceful or stately, just small, one-family homes, but they were once well cared for, the grass lawns nourished and groomed, the flower beds weeded.

I always drive up the alley behind our old house on Lyndale. The kids on our block played a lot in that narrow throughway. Basketball in the winter, shooting hoops on the backboard attached to Russell Allanson's garage, straddling icy ruts in the alley trying for long set shots. There was no such thing as a three-pointer then. Hell, the jump shot hadn't yet been invented. In early spring we'd float Popsicle-stick rafts along the flowing waters from melting ice. In the earliest years of my memory, before the alley was paved, the junk man came through a couple times a month with his horse-drawn wagon. And the milkman and the bread man and everybody else who, in those days, actually delivered fresh products to your house. They all came by way of the alley.

Going through the alley I always drive past, but don't usually stop, behind our old garage, still painted yellow, where my brother Bob took his life on Memorial Day 19 years ago. In his mid-50s, he'd lost his job, which was everything he was about, maybe the only thing except perhaps for the occasional forays up to Gladstone where he'd fish for sunnies.

Later that summer we scattered his ashes on the lake on an absolutely beautiful northern Minnesota afternoon. The sun was brilliant, becoming a golden wash over the landscape and ourselves as it lowered. We went out in a boat, my mother, my sister, Ann, my younger brother, Bruce, and me. My father, frail, his eyesight gone, stayed onshore. Bruce ran our dad's unused three-horse motor and we purred across the lake to that cove Bob loved. As we slowly circled within its waters, Bruce squinted away tears and poured the ashes out, and they vanished forever in a bone gray swirl.

After we returned to shore, we walked up from the dock and crossed the grassy slope below the Oak Grove cabins. My father stood alone, waiting. My mother came up to him and clutched him and for a moment pressed her head against his chest. He stood motionless, his arms by his sides. I sometimes wonder why it was so difficult for my father to show emotion. He was a good and kind man and not a cold person. Although he and my mother fought often and sometimes bitterly over the years, I don't think they ever seriously entertained the idea of a divorce, although there were times when it might have been the right thing for my mother to do.

Four years after Bob died, my father, not quite 87, lay dying in a nursing home. He penciled something for my mother on a piece of paper that she kept and later showed us. It was squiggly and uneven and hard to read, but we all agreed that what it said was: "I have always loved you." I don't think anybody ever joked about that piece of paper. My mother, seemingly in vigorous health, died unexpectedly later that same year at the age of 79.

I've taken my son Anthony to Gladstone Lake every time we've been able to go up north. We tow our boat from Virginia to Minnesota, and no matter where we stay we always try to take the boat over to Gladstone for an afternoon. I have a picture of Anthony when he was a little boy walking around in overgrown grass where the Oak Grove cabins used to be. As I write this Anthony is not quite 13, but he's tall for his age and only moments away from looking down on his dad, literally. In that picture he is three-and-a-half, just a little boy in a yellow pullover and suspenders, standing in the grass with his hands in his pockets looking quizzically out at the lake. He's seeing part of his family heritage for the first time.

When I look at that picture now and try, I can almost hear the sound of oarlocks creaking and the splash of an anchor descending. □

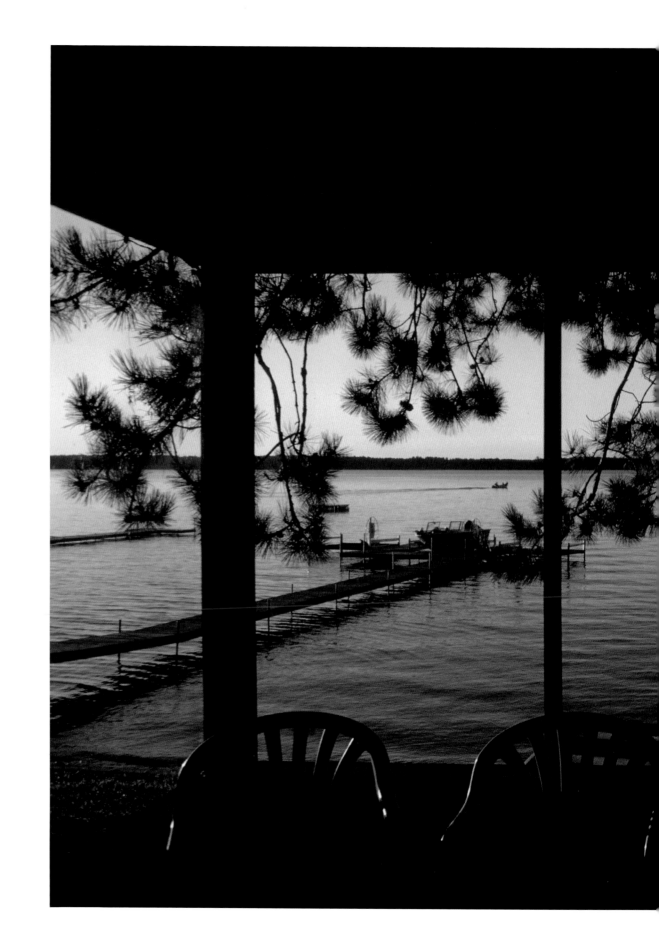

*Early morning, Alluring Pines Resort,*

*Lake Hubert* 1995

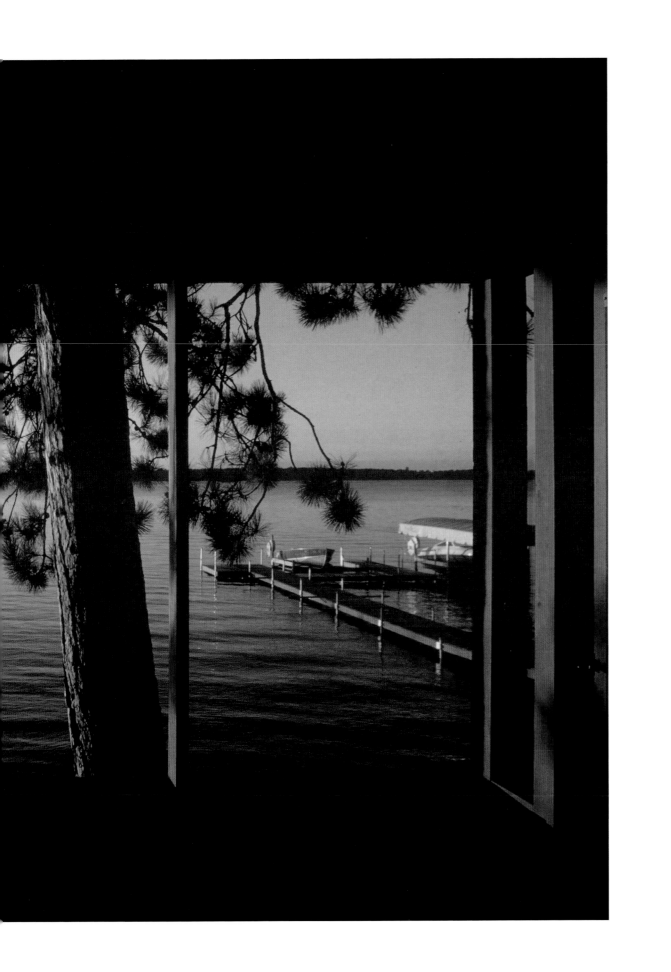

*Grand View Resort, Gull Lake* 1991

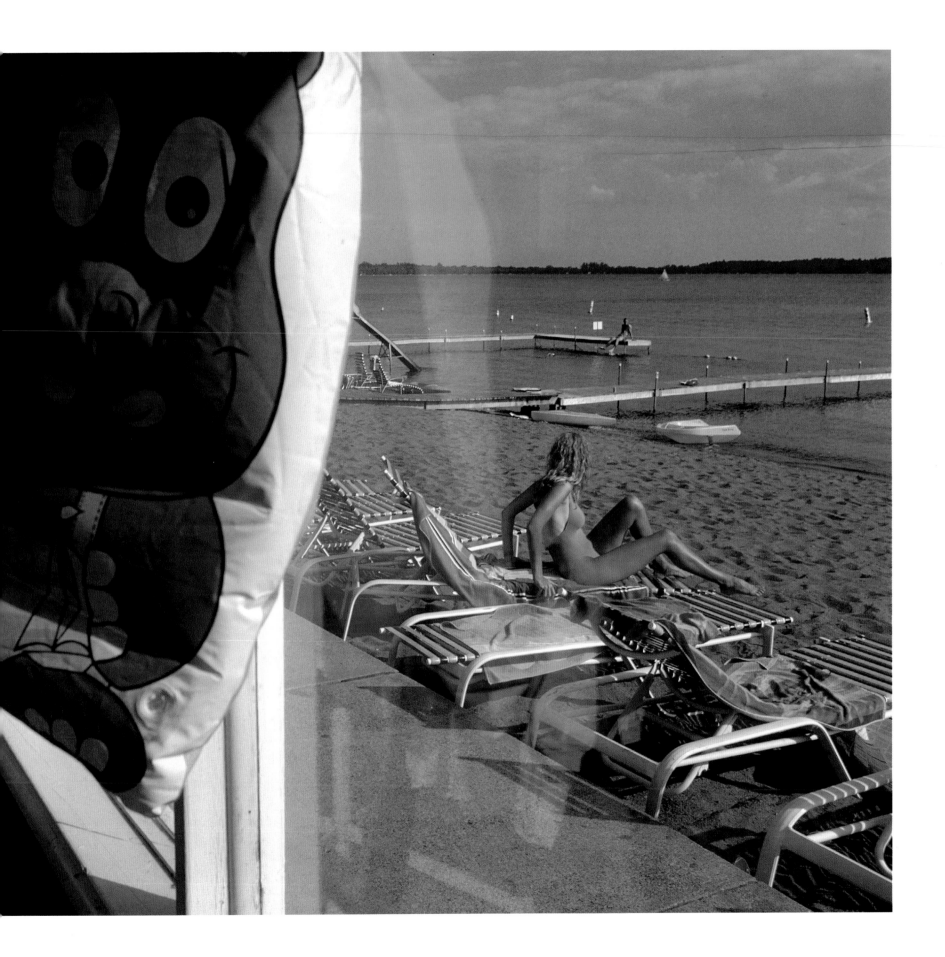

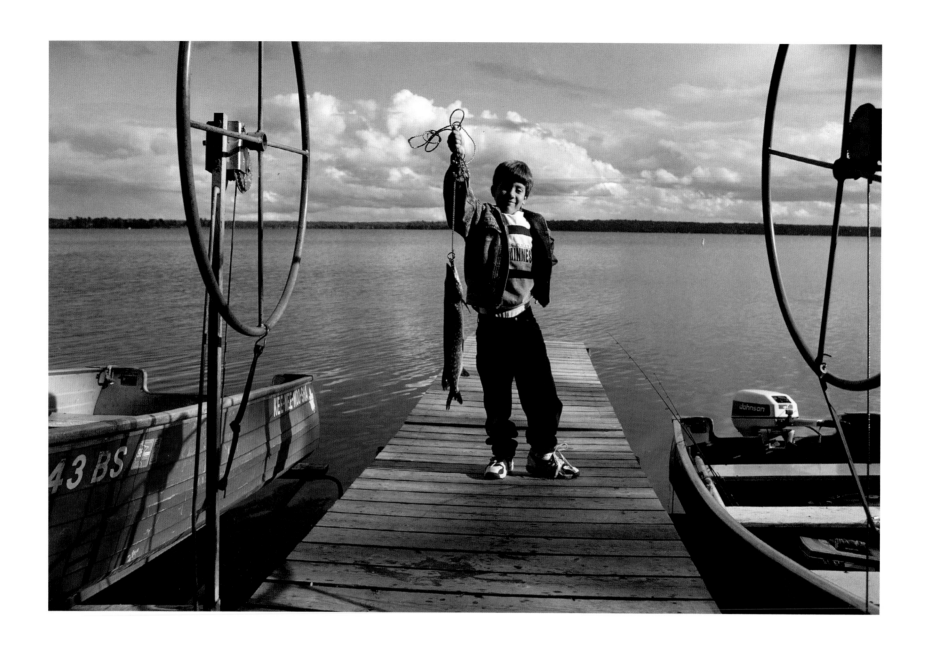

*Anthony with his first northern, Kee-Nee-Moo-Sha Resort, Woman Lake* 1994

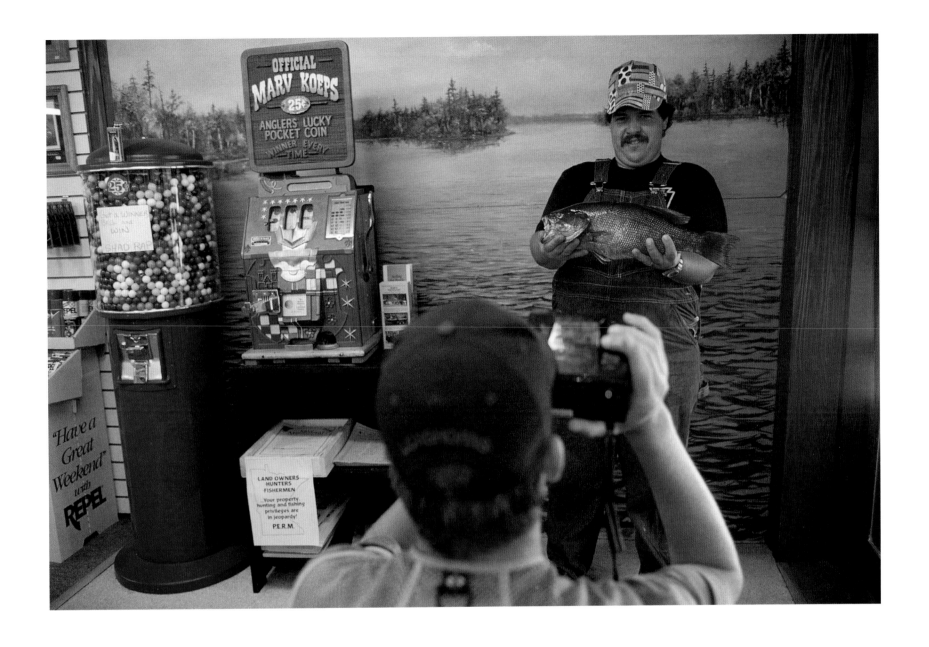

*Checking in a bass, Marv Koeps bait shop, Nisswa* 1995

*Duck hunting, Leech Lake* 1991

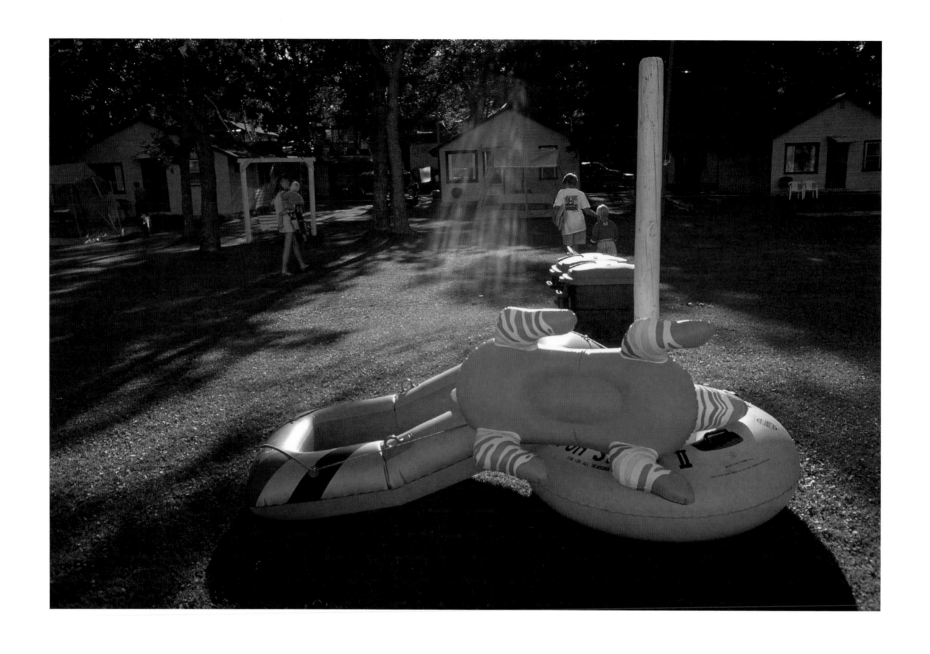

*Birch Villa Resort, Cass Lake* 1991

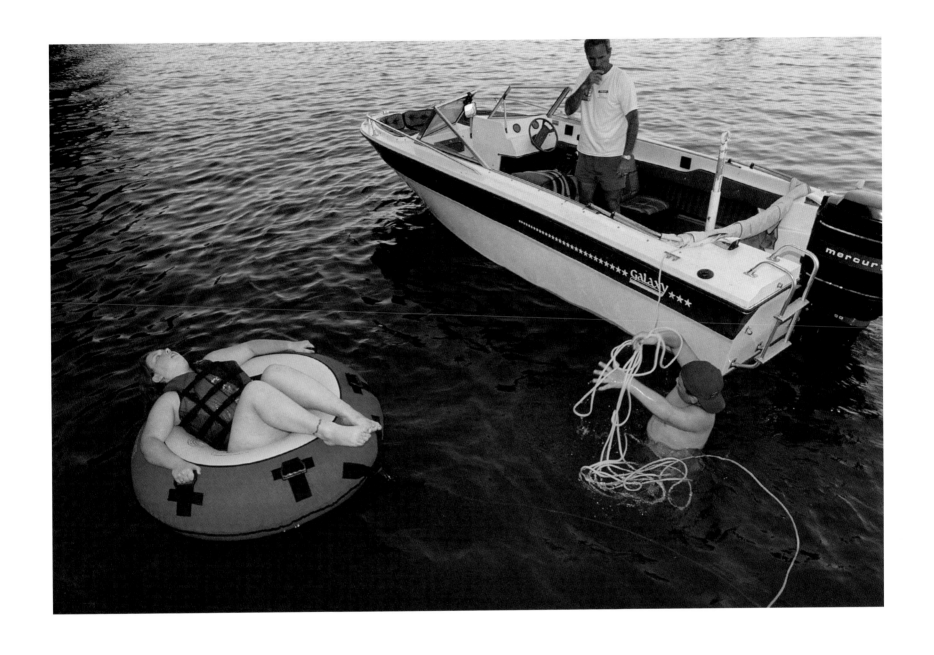

*Kee-Nee-Moo-Sha Resort, Woman Lake* 1995

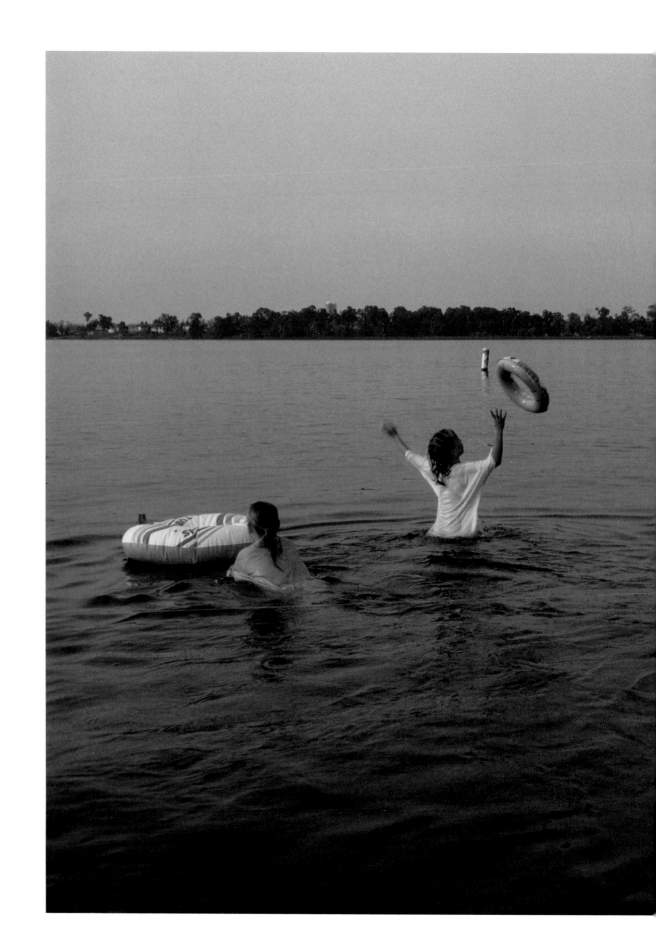

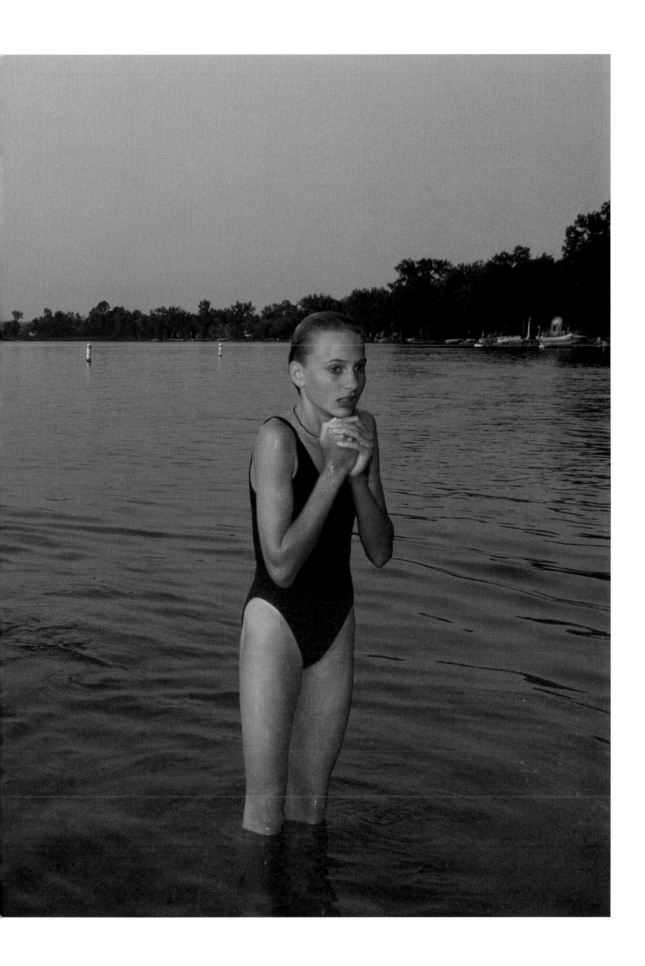

*Madsen Grove Resort, Little Floyd Lake* 1995

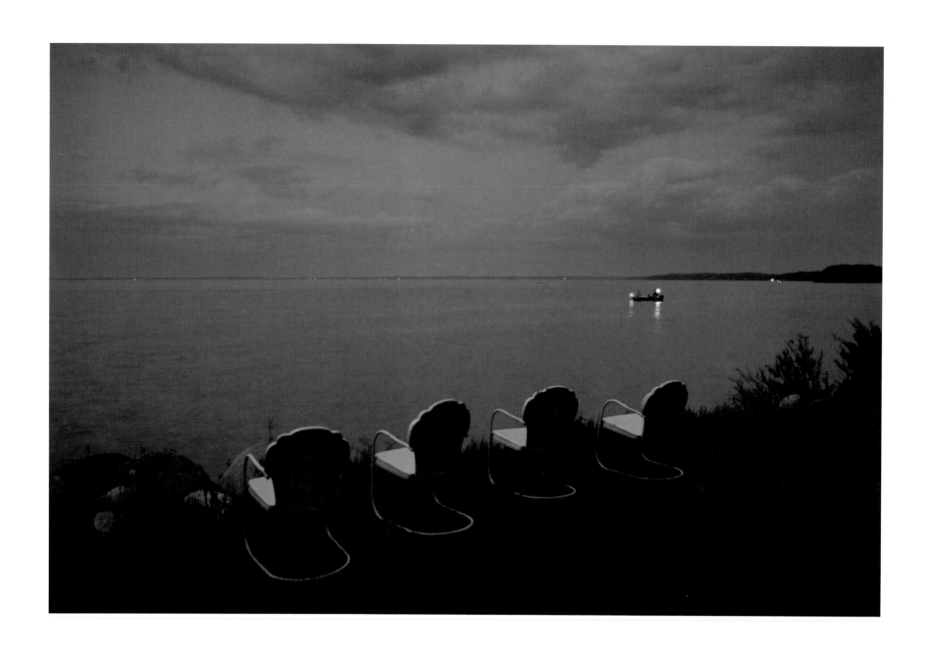

*Big Rock Resort, Leech Lake* 1991

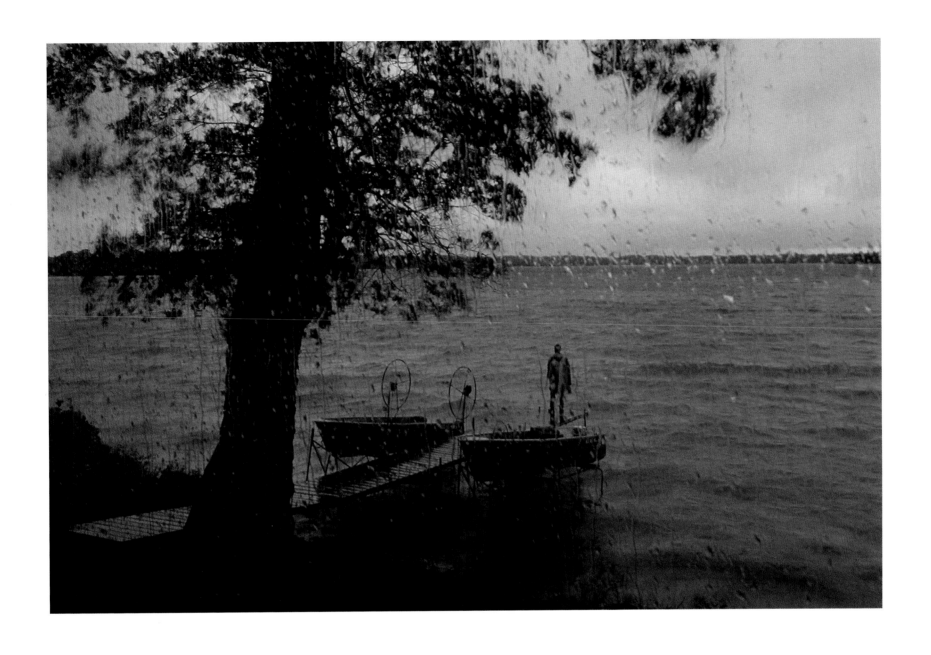

*Kee-Nee-Moo-Sha Resort, Woman Lake* 1995

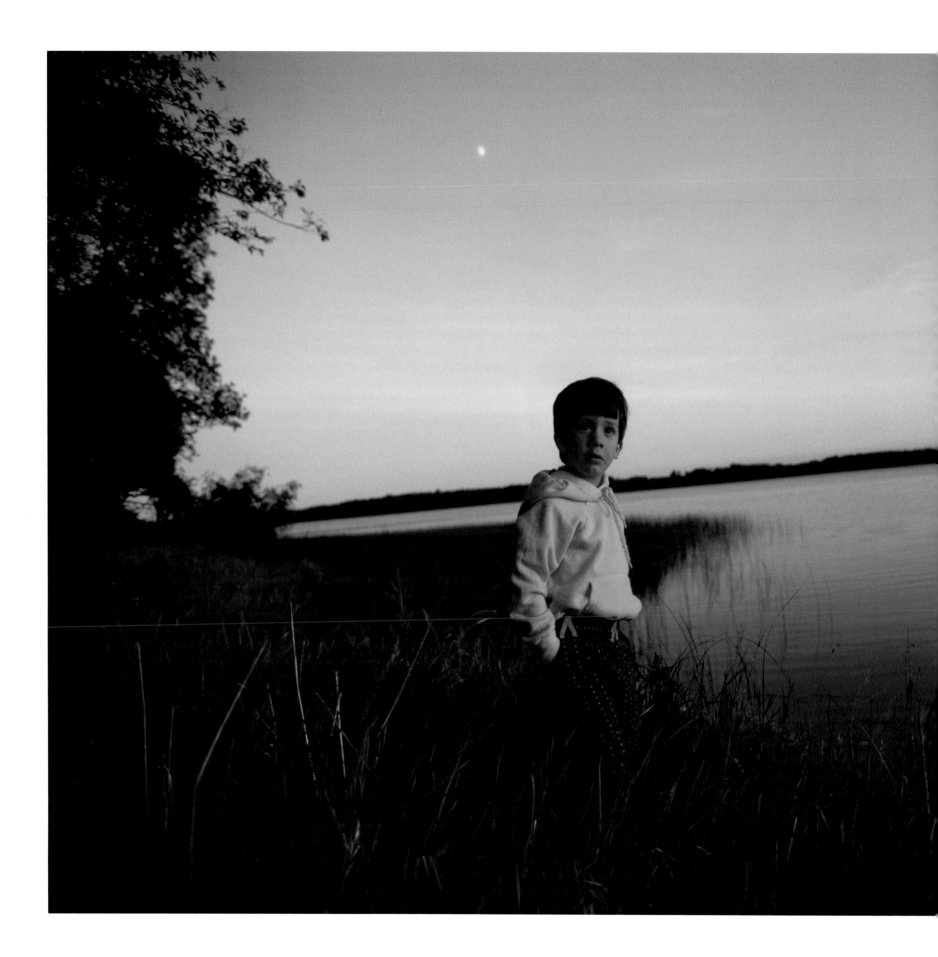

*Anthony at the site of Oak Grove Resort, Gladstone Lake* 1991

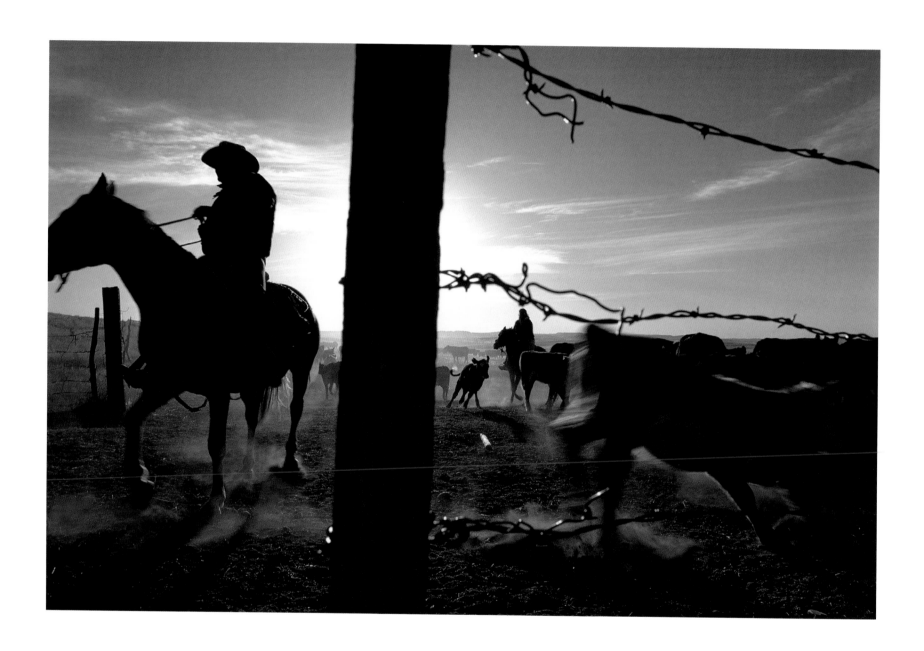

*Weaning Calves*

# THE MISSOURI BREAKS

## [ MONTANA 1996 ]

*God grant me the serenity to accept the things I cannot change, the courage to change the things I can, and the wisdom to hide the bodies of those people I had to kill because they pissed me off.*
—SIGN IN THE MIDWAY BAR

"WELL," SAID A HEAVYSET YOUNG MAN IN WELL-WORN JEANS, WORK BOOTS, A BEAT-UP plaid shirt, and a grain elevator cap, "I wonder if it's gonna be as big a rat race as it was yesterday. My shirttail never hit my ass."

"I didn't think the wind was blowin' that hard," said a much older man, laconically, sitting on the stool next to him.

Somebody farther down the counter guffawed softly and from elsewhere in the room came a sharp, almost doglike bark of laughter. A cowhand wearing a sweated-up Stetson was recalling the time he got a boot hung up in a stirrup and got dragged when his horse stepped in a badger hole and spooked. "I got to thinkin' about all the bad things I'd done and that maybe I shudda done 'em worse 'cause I'm probably not gonna see anymore...."

You hear a lot of such talk in the Winifred Tavern and Cafe, referred to by locals as the "Up Above," as well as in the Trails Inn, a bar next door also known as the "Down Below." These small buildings—separated by a mere narrow rectangle of grass—are the two watering holes and hangouts in Winifred, Montana. You hear lots of country songs and lots of good stories if you hang around these places and listen. You hear a lot of bullshit, too, of course.

Established in 1913, the town was bigger once. In 1920 there were two banks, a hardware store, a drugstore, a bathhouse and a *daily* paper. Today the population is about 150 not counting the dogs, and the main street is a couple of blocks long with a grocery store and a post office opposite the Up Above and the Down Below. Coming up from the south, out of Lewistown, Winifred is the last stop before heading into the Missouri Breaks country, a high-plains stretch of townless Montana sometimes called "The Big Empty," "The Big Open," "The Big Dry," or, my favorite, the perfect title for a low light,

late night country song: "The Big Lonesome." For people living in or near the Breaks it's as common to drive a 200-mile round-trip to one of the outlying small towns to see a high school girls' basketball game or to visit friends as it is to wave to a passing vehicle carrying strangers. They do it all the time.

On most days—morning, noon, or night—you can find Winifred area locals at either the Up Above or the Down Below, catching breakfast or lunch or a drink or just fending off some of that big lonesome. Customers might be ranchers or cowhands, farmers, truck drivers, school teachers or students, crop-dusting pilots, hunters passing through. You see the backsides of a lot of Wranglers and Levis and the occasional Lees, butts hunkered down on stools, wallets stuffed in hip pockets below wide leather belts with the hand tooled names of Ray and Merle and Daryl. Curled around coffee mugs, the hands of old ranchers are gnarly, with a swollen knuckle or two and maybe a blackened thumbnail, or perhaps a missing thumb or finger on the dally roping hand.

Back around 1990, it's said, a major beer manufacturer determined that Winifred, Montana, had the most beer consumption per capita in the entire United States. I don't know

173

how they figure such things, but in Winifred, that's the prideful word on the street, short as it is.

A T-shirt proclaims Winifred is located "Where the oil ends and the West begins." "Oil" refers to the paved road leading into town from the south, solid and secure unless sheeted with ice or drifted over with wind-whipped snow. Some say there's nothing between the Arctic Circle and the Breaks to stop the wind, and in winter it brings intense wind chill factors; summer brings the opposite, with winds oven hot and parching.

Heading north out of Winifred toward the Breaks along the Missouri River are two roads I often traveled looking for landscape pictures or heading to somebody's ranch to say hello and maybe photograph a branding or whatever. Both roads leading out of Winifred are gravel, both a little snaky if you're going too fast into a turn, and dusty as hell if it hasn't rained, which can be most of the time, and you don't want to follow anybody too closely because you'll be both blinded and choked by their dust. When it does rain, the secondary roads can turn impassable in a heartbeat from the wet gumbo that will fill the wheel wells of the best four-wheel drive ever made and mire it beyond hope.

The serrated badlands flanking the river that gives the Missouri Breaks its name run east to west, Fort Benton to Fort Peck, almost 300 miles in length and about 10 to 20 miles deep on either side. The upper part of the Missouri is designated a wild and scenic river, and along that stretch it's still possible to see the river and its edges about the way Lewis and Clark would have seen it on their voyage from 1803 to 1806, although there would have been more cottonwood trees then. I was once photographing on the river in late afternoon when the White Cliffs were beautifully mirrored on the water's surface. When dusk brought the river into shadow, Castle Rock, from its commanding position above, in the last glow of sunlight, was stunning. One would have to be devoid of imagination not to think of how thrilling it must have been to be among the first of one's civilization to view these river images and be humbled by their beauty.

At the lower end of the Breaks is the Fort Peck Dam and Reservoir, the greatest of all the Public Works Administration projects of the Depression era, flooding 250,000 acres of river bottom. Not nearly as pretty, perhaps, but duly impressive.

Lewis and Clark referred to the region as "the deserts of America." And someone else once said the Breaks country is so poor you'd have to buy a quart of whiskey to raise hell on it. In reality it's far from that once you get away from the erosion ravaged bluffs and slopes that plunge to the river below the irrigated benchlands where wheat fields flourish. In summer, cattle feed down in the river breaks and are gathered up out of that rough country again in the fall.

There are only three bridges across the Missouri between Fort Benton and Fort Peck, plus a couple of ferry crossings. At one of those the ferryboat operator would talk loudly to himself while taking my truck across the sullen river. Because he was basically deaf he may not have realized that all his thoughts were being distinctly announced to me. Maybe years of working alone on the river will do that. But maybe he'd be that way anywhere.

With the exception of the grizzly bear, all the wild game Lewis and Clark would have seen in the Breaks still thrive as well as some the explorers didn't see, such as the ring-necked pheasant and the Hungarian partridge, which were brought into the country much later. Elk, originally a prairie animal but eventually pressured up into high country, were reintroduced to the Breaks and have become abundant in the million-acre Charles M. Russell National Wildlife Refuge. Buffalo that were everywhere in the days of Lewis and Clark are raised on several ranches in the area today.

But the animal that has most strongly figured in the past of this rugged land is the horse. For centuries the Missouri Breaks has been horse country. Raise them, ride them, steal them, hide them. In the late 1800s horse thieves used the Breaks as a place to hide what they'd stolen until they could get them out to sell or use.

During the early decades of the last century when a lot of homesteaders couldn't make it in the Breaks, they often simply abandoned their livestock when they quit and left. For a long time horses ran free and bred in the Breaks, and men made decent livings for a while gathering these semiwild animals to sell for saddle horses or to sell to canning factories in the Midwest that turned them into dog food.

"When a homesteader went busted, he just turned his horses loose and caught a ride out of the country," said Jack Hinnaland, when I met him, a 48-year-old, third generation horse rancher from Circle, Montana. "There were a lot of

horses taken out of this country and sold for ridin' and workin' horses. Quite a few got sold to the Army. And there were a couple of big horse outfits that raised 'em for canners. There was the old 44 Ranch. They had their own cannery in Illinois."

Hinnaland runs about 400 horses on his ranch and provides bucking stock for semiprofessional, amateur, and high school rodeos throughout Montana.

"My granddad come out here in 'o1 and he did all his farmin' with horses. Then my dad run a lot a horses and he had a small string of buckin' horses. But I'm the only one in the family that has raised 'em for rodeo broncs."

I'd driven out to Jack's place on a morning Jack, his sons, Quinn and Zane, and his wife, Debby, were driving some mares, foals, and older stud colts in to the ranch corrals where they would rope and brand some foals and castrate some colts. They separated the horses into different corrals, Quinn slipping around opening and closing corral gates while a rolling stream of horseflesh funneled through in a rush of flowing manes, pounding hooves, and dust; horses of all colors, duns and bays and chestnuts, strawberry roans and paints.

In a high-railed circular corral, Jack, on foot, threw a wide loop and front-footed a big paint stud colt, and the other hands helped throw it down on the trampled dirt, the catch rope zipping and burning as they anchored it to a snubbing post worn and darkened by countless ropings. Then they hog-tied the paint's legs with a series of loops and hitches in a way he couldn't kick, in a way that raised one hind leg high and he couldn't do much more than roll his eyes in terror and grunt and groan as Jack used his pocketknife to slice the scrotum open and pull out the testicles; then the paint was no longer a stud colt. His underside and Jack Hinnalands's hands were splotched with blood.

We took a break for lunch in Jack's house. We ate well, but you always do at these outfits. They may work you long and hard and dirty, but I've never been to a ranch that didn't feed a man good. After lunch they branded some spindly-legged foals, Jack on horseback roping them by the neck, his sons wrestling them to the ground for Debby to apply the hot iron, burning Jack's Lazy E J brand into the foal's left thigh, sending a miniature cumulus cloud of smoke up toward the others high in the blue Montana sky.

At the end of the afternoon, all the castrating and branding done, Jack was squatting on his heels: his hat was off, his hair sweat-matted to a pale brow, and he leaned back against the corral rails, his eyes closed in a grimace, his left hand cupped lightly against his right rib cage. A few nights before, coming home with Debby from Glasgow on the weekly livestock auction day they had both fallen asleep, and with Debby at the wheel of their one-ton pickup hauling a stock trailer, they ran straight through the T at the junction of Highways 200 and 24, crashing through a barbed wire fence and out into a field, pretty much demolishing the truck and trailer but luckily not killing or seriously injuring either of themselves. Jack did break some ribs in the wreck but didn't go to a doctor. "Oh, I've busted some ribs before," he said. "I know what that feels like."

So, now, a couple of days later, he was back in the saddle gathering horses, driving them in, roping and cutting and branding. With a short break for lunch.

It's just all in a day's work out in the Big Lonesome. □

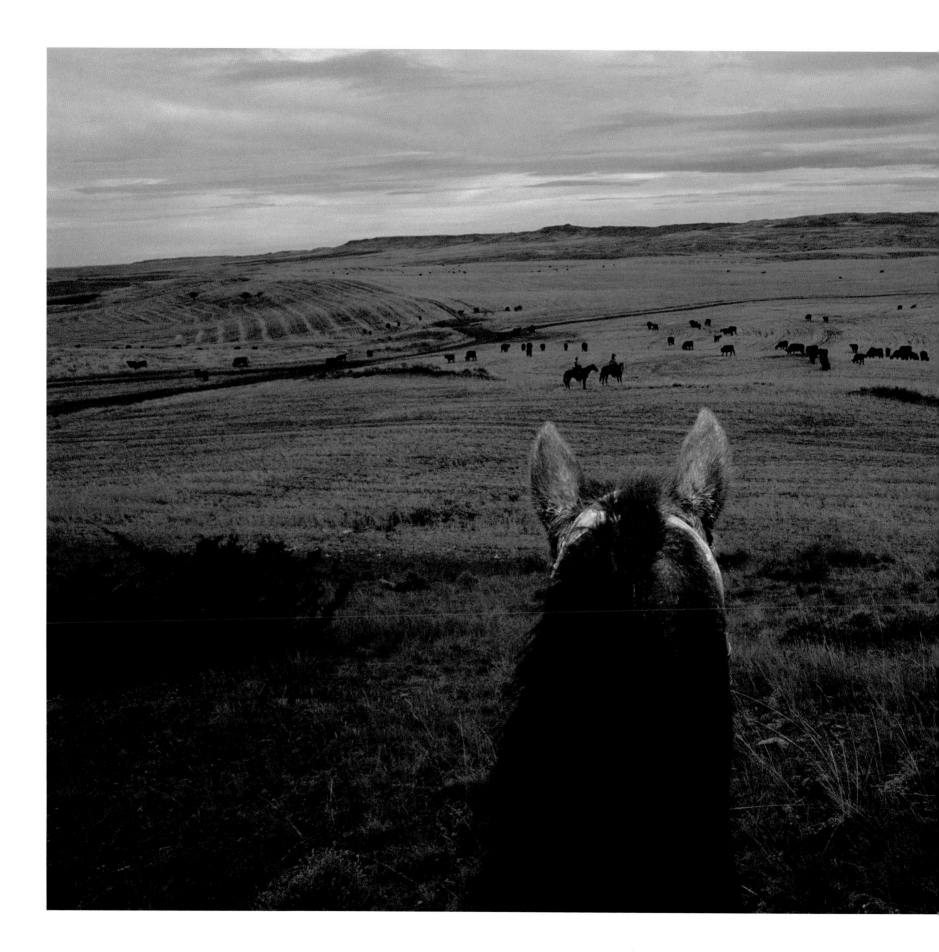

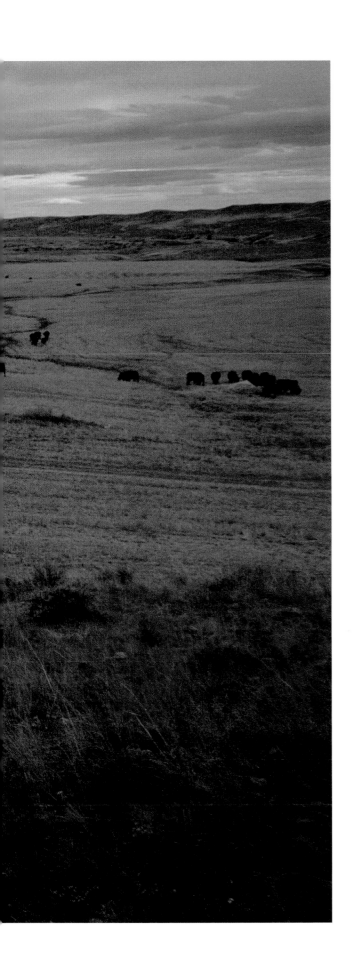

*Knox Ranch, Winifred*

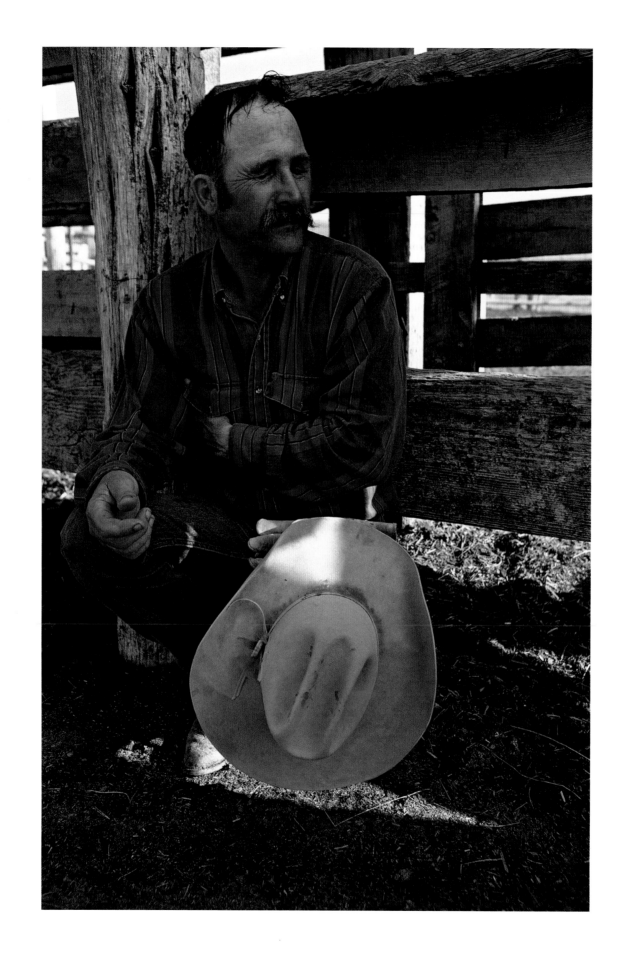

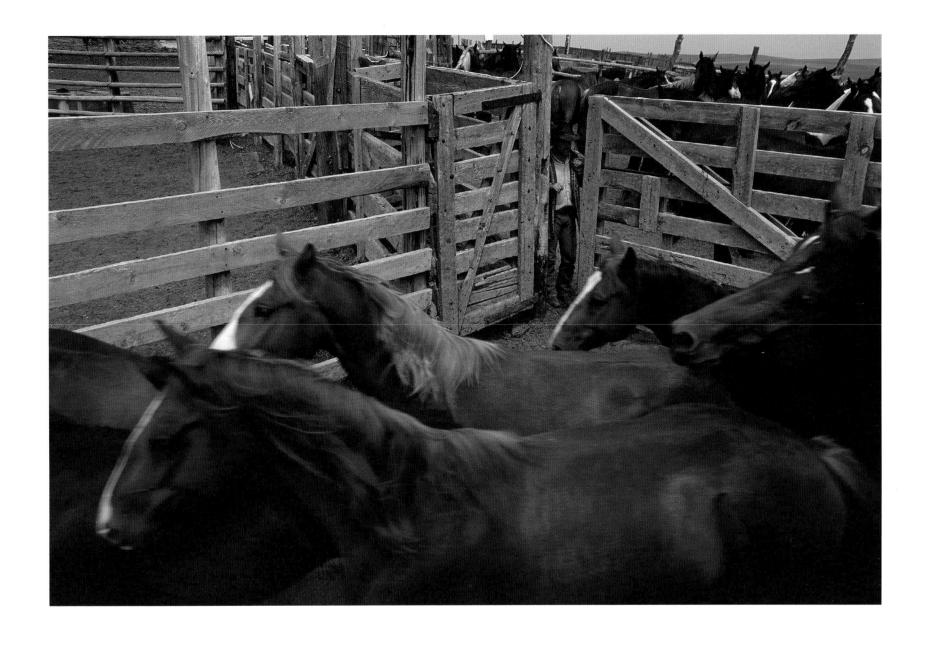

*Separating horses in the corrals, Hinnaland Ranch, Circle*

LEFT: *Rancher Jack Hinnaland with broken ribs, Circle*

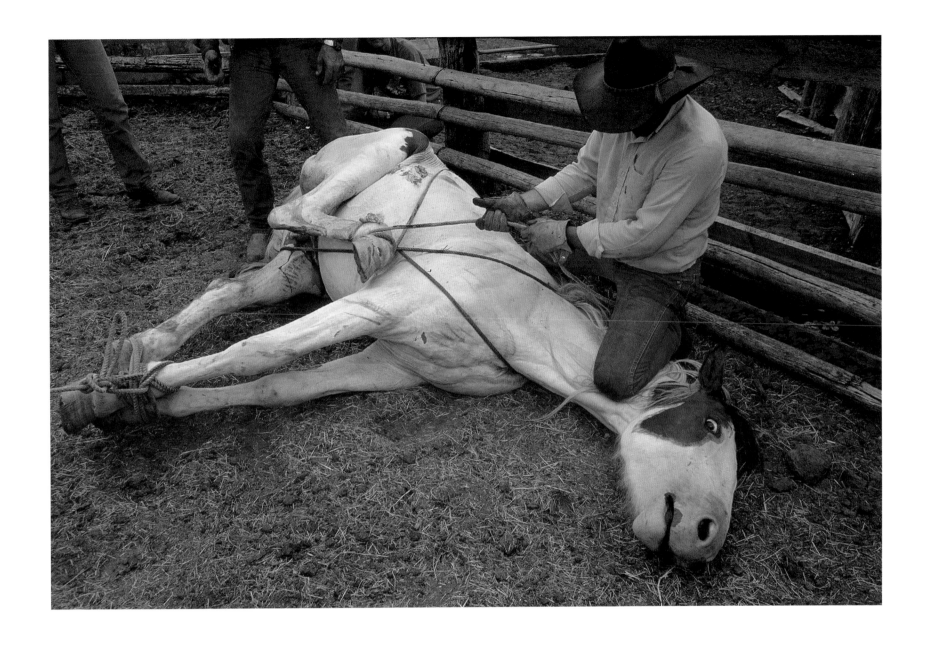

*Castrated colt, Hinnaland Ranch, Circle*

*Castle Rock, upper Missouri River*

*Road warning sign near Winifred*

*Opening day of pheasant season, near Glasgow*

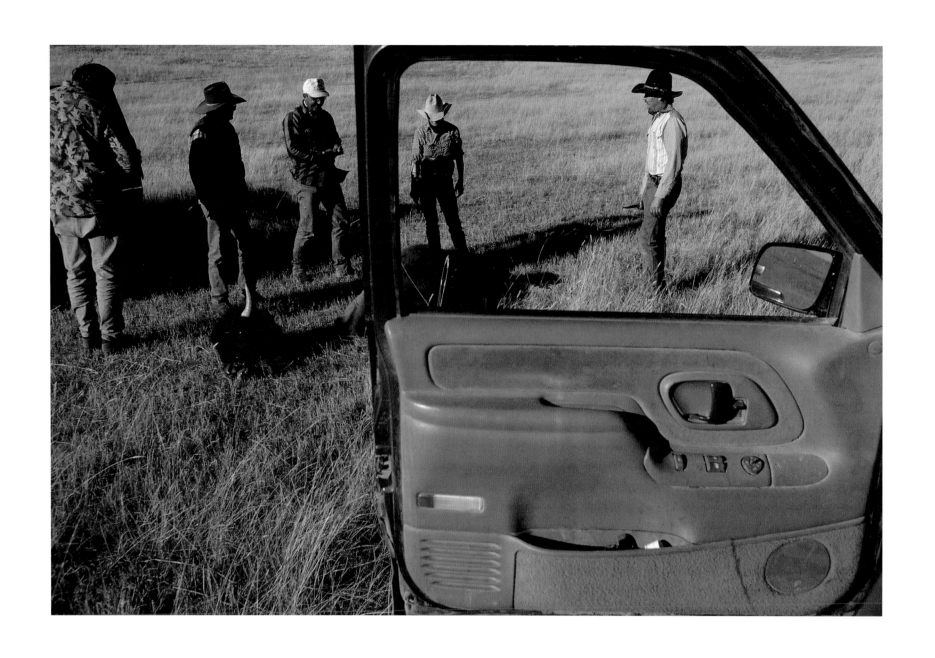

*Killing a buffalo, 7W Buffalo Ranch near Jordan*

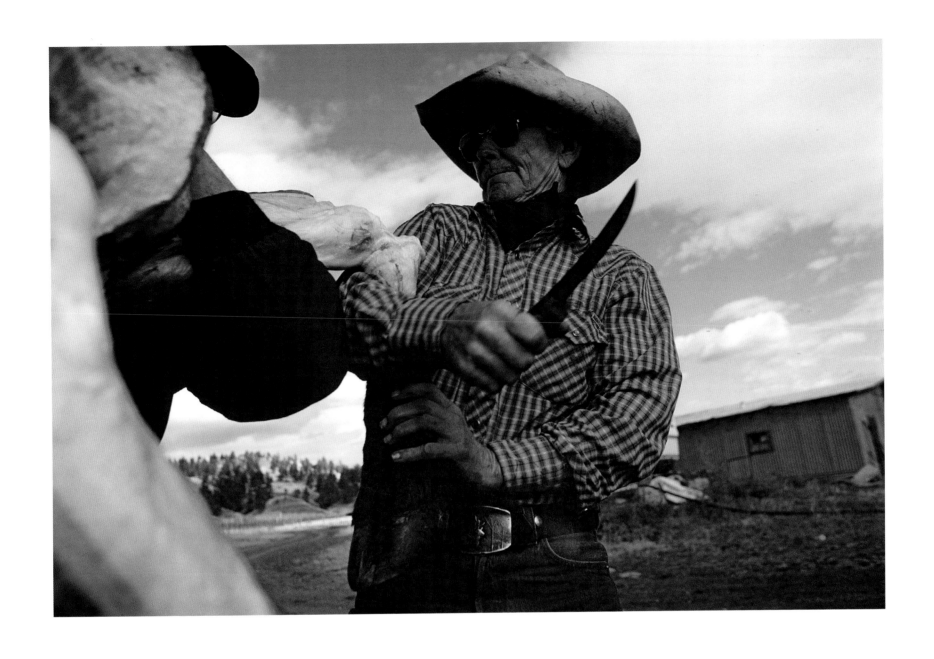

*Glena Reynolds, manager of 7W Buffalo Ranch, butchering a buffalo*

*The Dick Knox family bringing cattle up out of the Breaks in autumn*

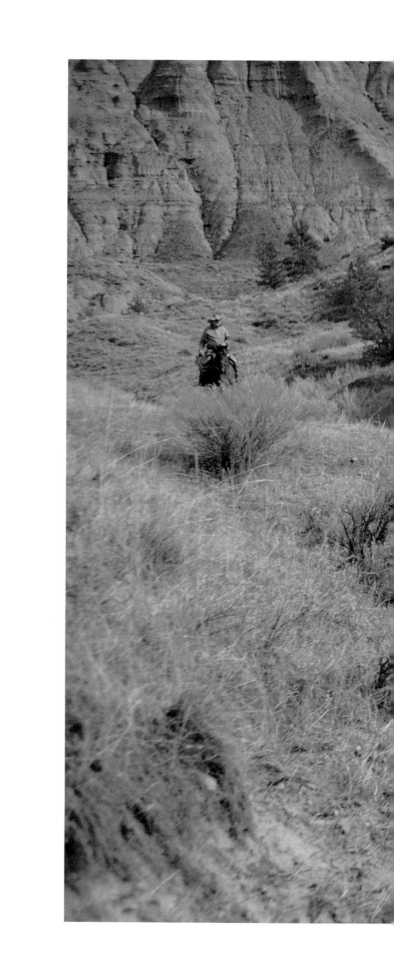

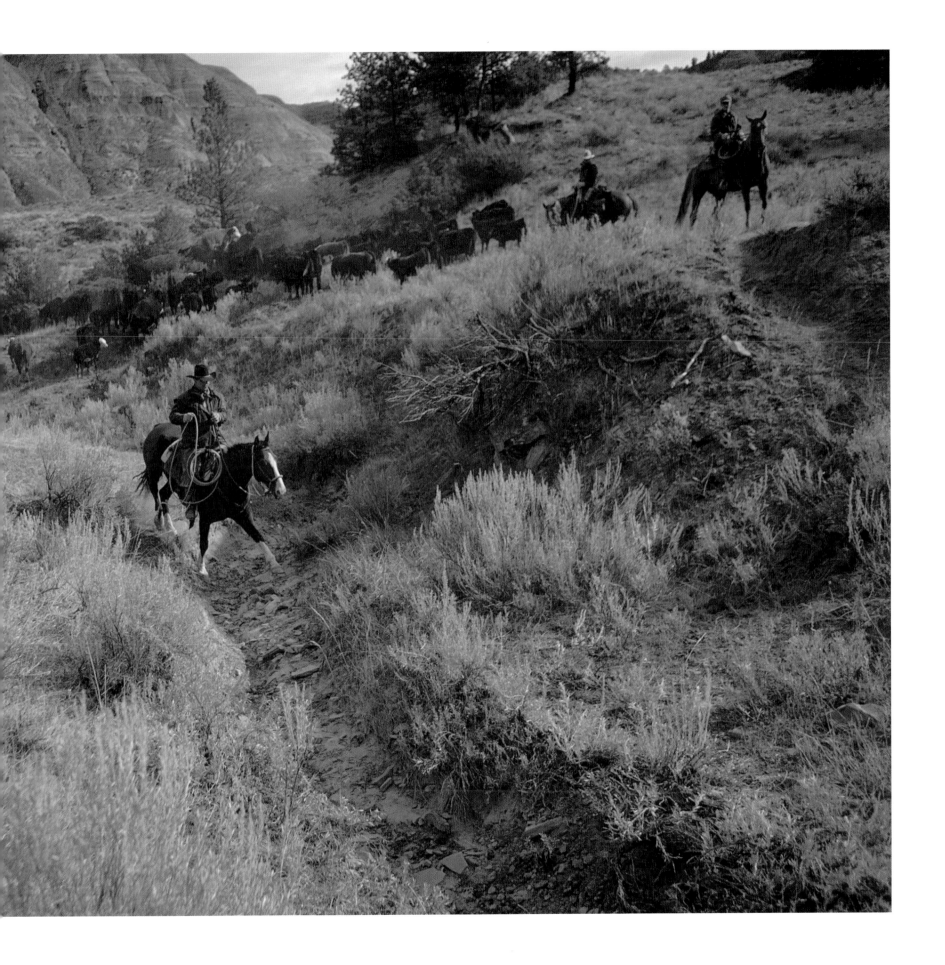

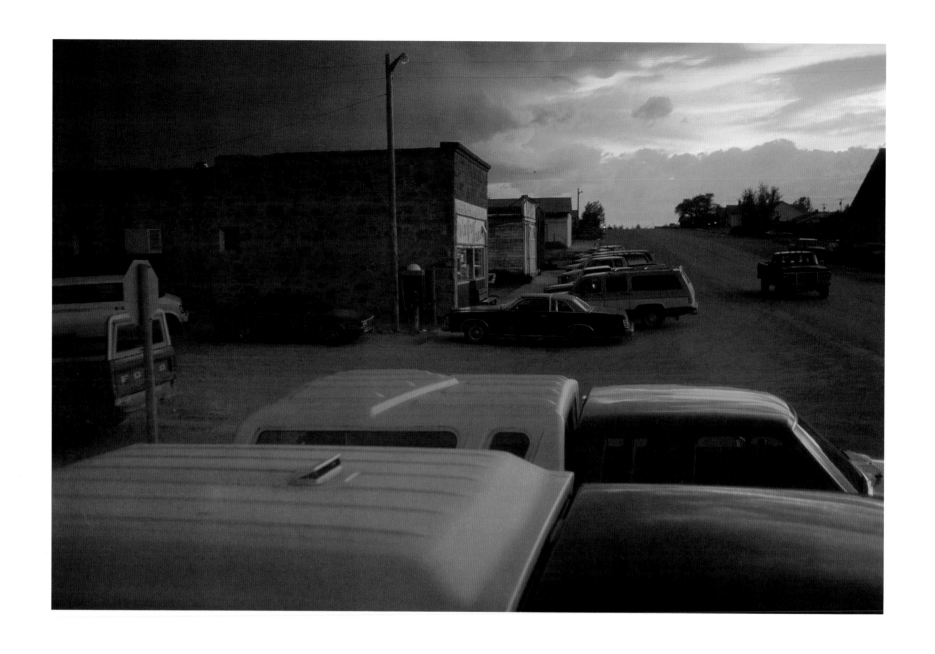

*Main Street, Winifred*

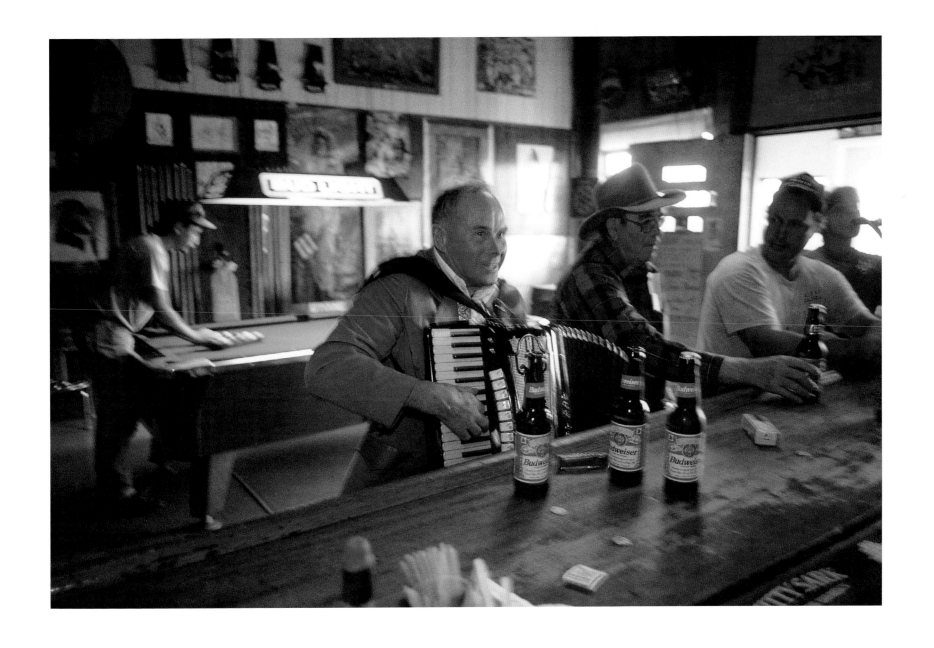

*Ervin Zimmerman, Pioneer Bar, Hilger*

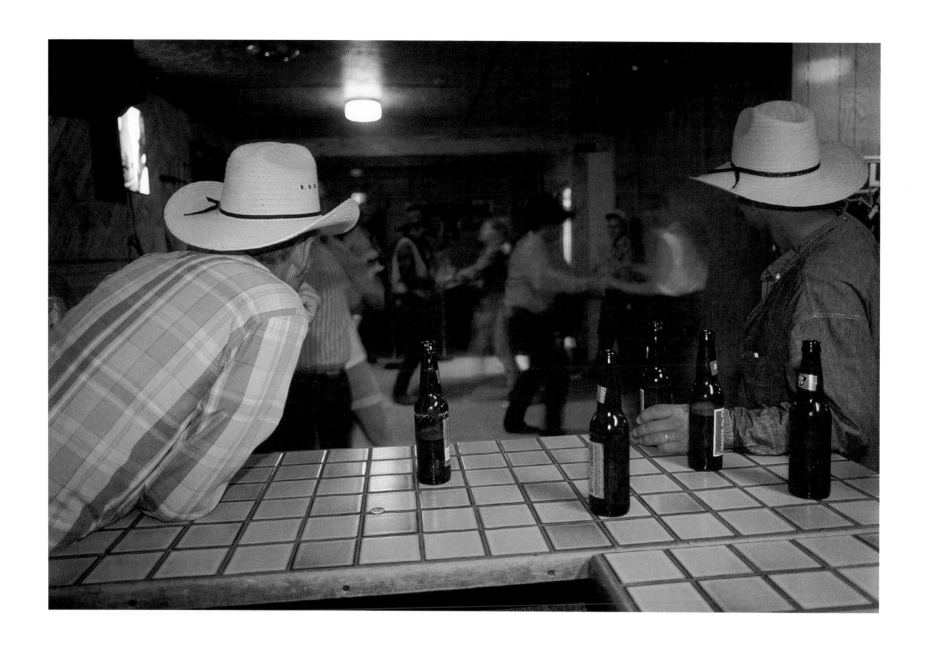

*Winifred Tavern and Cafe*

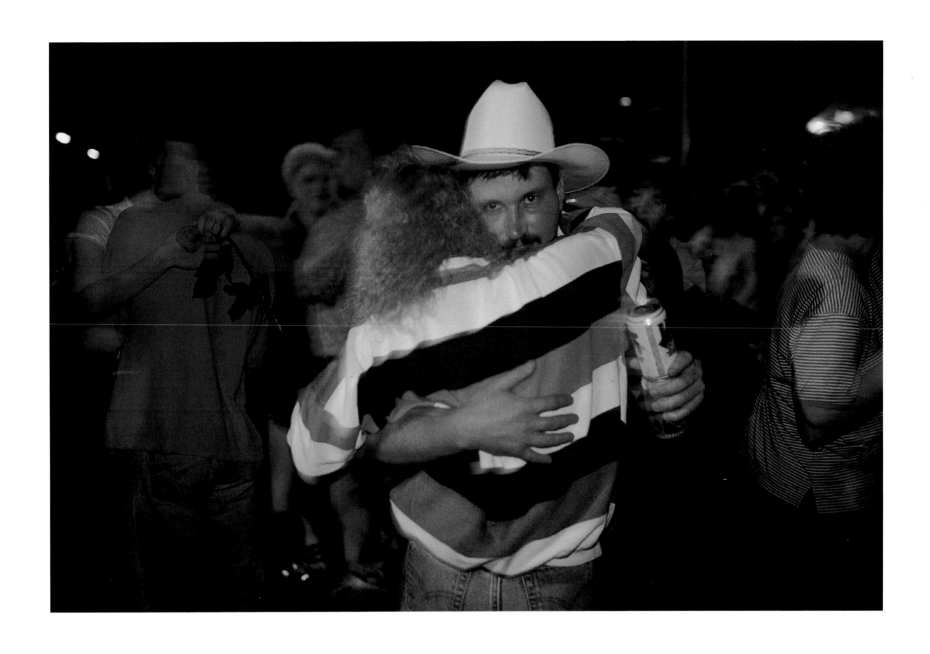

*Street dance, Fort Benton*

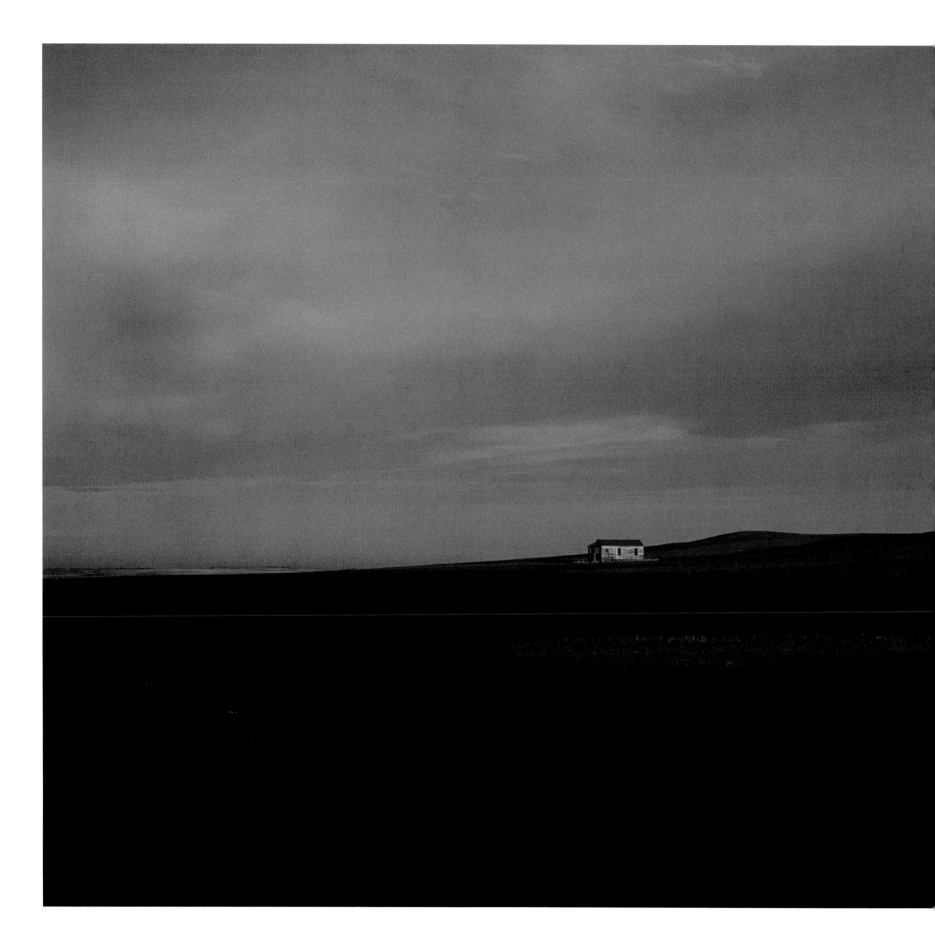

*Remnants of a homestead near Winifred*

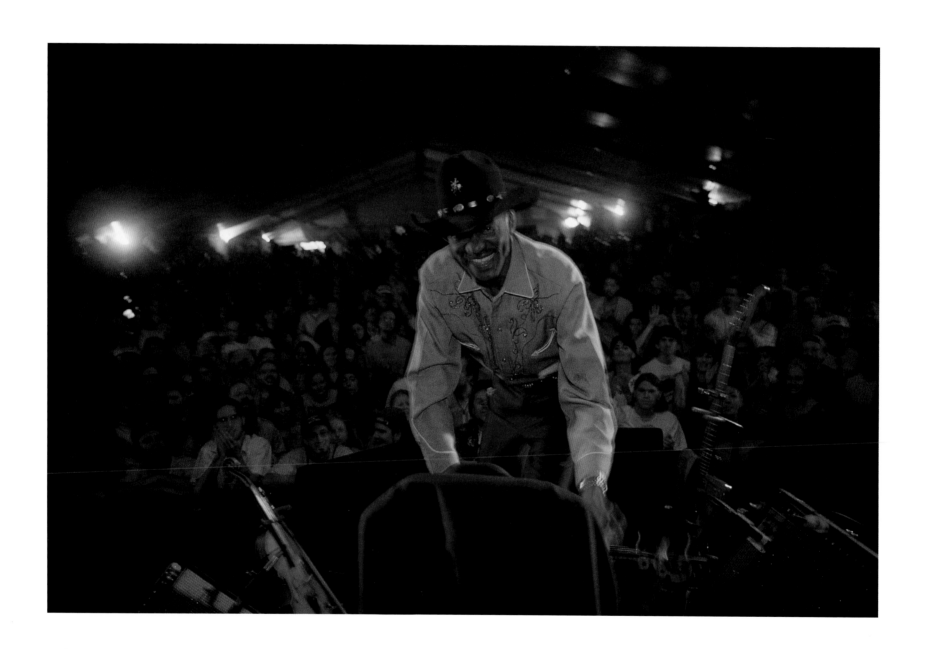

*Clarence "Gatemouth" Brown, Memphis in May Festival*

# A VIEW OF THE BLUES

## [ 1997 ]

*I got your letter this mornin', baby*
*And I read every word you had to say*
*I got your letter this mornin', baby*
*And I read every word you had to say*
*But if you love me like you say you do, baby*
*Then why in the world did you go away...*

IF I HAD NOT BECOME A PHOTOGRAPHER AND A WRITER, I think I'd be a musician. I sometimes wish I were one now. I mean a full-time, professional musician, somebody who practices every day and performs for a living. Not a never practicing, almost never playing amateur, which is what I am.

Music is a driving force in my life; I can't imagine being without it. As a child, music was always in my house. Everyone in my family played an instrument at one time or another. My father played accordion and my mother played piano. In the 1940s and '50s they played for Scandinavian lodge dances and I'd tag along with them on humid Minnesota summer nights to sweaty, second floor walk-up halls on the north and northeast sides of Minneapolis. They'd play waltzes and foxtrots, old and current pop songs, and the occasional lilting Swedish melody, my father sometimes humming out a kind of nasal harmony, his volume dependent upon the number of cold beers he'd consumed; he was basically a shy man. At home they played in our small living room where the upright piano commanded the wall opposite the couch and my father's old button accordion in its musty-smelling, crushed-velvet-lined case, maintained residence in the closet by the front door.

My two brothers and I were compulsive whistlers, blowing off nervous energy or whatever, usually unaware of the effort, just whistling our ways through life. Maybe the only thing good about that is that we never just whistle a straight tune, we throw in some riffs, a lot of improvisation on the basic melody. But I imagine it could drive you crazy if you had to be around us a lot.

My older brother, Bob, played trumpet in the high school band. At 17 he left school shortly before graduation to join the Navy and the World War that was almost over, although we didn't know it. I remember walking up to the stage in the school auditorium to receive his diploma for him. I was seven. I don't think Bob played the horn again after coming home at the end of the war. I inherited it, a silver trumpet with mother-of-pearl valve stem caps.

My sister, Ann, just a few years older than I, plays piano and sings; she has a beautiful voice. And my younger brother, Bruce, plays violin, trumpet, and flügelhorn, a kind of pregnant-looking trumpet or cornet with a darker, more mellow tone. Bruce turned professional at age 11 and has been a fine and versatile musician for more than 40 years. Classical or jazz, trumpet or fiddle, he can do it all. I love to hear him play.

And me? I had my chances. I could have taken lessons on any instrument of my choosing at anytime as a kid but I didn't. I simply never took the time to become really serious or truly dedicated to an instrument. I learned to play trumpet by ear; I never learned to read music. I still own a couple of horns and at times I can sound like I know how to play, if the moon's in the right phase or I'm a bit loose, and better yet, alone, free from threat of embarrassment. Loose and alone, that's the ticket. But although the tone and feeling can be good for a while, it's consistency that separates real musicians from the dilettantes or the amateurs, the consistency that comes from dedication and practice. Just like in photography and writing. Hard work. And through work—daily practice—comes what musicians call "chops," the ability not just to play but to play hard and long and get out of your instrument everything you can.

Although I was raised in a family of musicians, I didn't grow up with the blues. Unless, of course, you count the tendency toward melancholy I inherited from my Swedish-born father. My parents were Lawrence Welk devotees. The man from North Dakota with his accordion could do no wrong in their book. When his program was on, with its saccharine

music and calico-clad female singers, George and Willie were usually seated in front of the television. With all due respect to the late band conductor, I was not a fan of his music. "Wonerful..., ah, wonerful...," as he used to say, was not so wonderful to me. It was like having warm chocolate pudding poured into my ears. But they loved him. Hell, we might as well have been living on the plains of North Dakota.

I preferred the far more edgy and exuberant music of jazz great Louis Armstrong. In high school my friends and I danced to the big band records of Glenn Miller, Les Brown, and Les Elgart. We'd go to the Prom Ballroom in St. Paul to hear the bands of Ray Anthony, Stan Kenton, and my favorite vocal group, the Four Freshmen, who were also good instrumentalists and put out a jazzy sound compared to the music of most pop singers getting radio play in the '50s. They especially appealed to me because I was also a singer. At the Prom Ballroom we'd stand in front of the bandstand for entire sets, but it was never a mob scene like today's rock concerts.

Quite a few years ago I was in Williamsport, Pennsylvania, on assignment, and I walked into my hotel's ballroom one night to discover Count Basie's band playing. I walked through an amazingly small crowd and stood in front of a line of sax players backed up by brass, trombones, and trumpets. Basie was at the piano, and I was able to stand there and feel the music coming off my body, some of it seeming to penetrate, passing right on through. Today I can't remember what the assignment was that brought me there and I can't remember what the band played. I just remember how good it was to feel the music hit me.

As a small boy I'd spend a few weeks each summer up on my aunt and uncle's farm north of Minneapolis. Aunt Margaret would tell my mother, "We always know where Billy is because we can hear him singing." In high school I started a vocal quartet, which stayed together as a trio for a while after we graduated. We'd work local clubs, singing a cappella since none of us were accomplished instrumentalists. We sang a variety of stuff, sometimes trying the Four Freshmen's style of harmonies. Our trio broke up when the other two wanted to go on the road "to become stars," and I wanted to finish college. They didn't make it, but they gave it a try. And I finished what I'd started.

The best job I ever had in my life prior to becoming a photographer was just out of high school. For a few months

I worked at the Melody Record Shop on Hennepin Avenue in the old downtown Minneapolis. Now long gone, it was just a narrow little store with bins full of 45s and 33 LPs, a few tiny listening booths, and a small, glassed-in sound room with some high-fidelity equipment for sale and a big floor-stand ashtray. I made, was it 95 cents an hour? Sounds about right. No money, but I could listen to whatever I wanted to whenever I wanted to.

Somehow I didn't get any exposure to blues music at the record store, and certainly not in my home where the North Dakota polka meister reigned supreme. I'd get some jazz here and there, but I never really entered the world of blues music until making the photographs for a NATIONAL GEOGRAPHIC article called "Traveling the Blues Highway." The photographs here were done over ten weeks during 1997, when I was photographing along the blues highway, the extensive geography over which millions of African Americans in the Deep South migrated north from about 1915 to 1970, bringing with them their evolving music. Because it was a story about the history of black people in America, I concentrated on black musicians, even though there are many accomplished whites playing blues.

During those weeks of photographing at blues festivals, juke joints, blues bars, and private homes, I focused my cameras on a lot of wonderful musicians who welcomed me into their world. Too many passed away before the year was out: Luther Allison, Johnny Clyde Copeland, Jimmy Rogers, Willie James, and Ollie Nightingale. And then in January 1998, the legendary Junior Wells died.

I first saw Junior on a fine June afternoon in the Checkerboard Lounge on Chicago's South Side. He wasn't playing, just hanging out. There was something about the harp player's foppish style, an attitude dressed to kill, that made me decide to concentrate on photographing him when I returned to Chicago in the fall. But he became ill, and other than briefly later during the Chicago Blues Festival that June, I didn't see him again until he was lying with his hat on in his casket at the funeral home.

Whenever I listen to Junior's classic Chicago Blues album, *Hoodoo Man Blues,* I think of him in his white suit and elegant tie, black fedora on top, a slight man, no swagger, just a cool presence among friends in the Checkerboard, a joint he helped put on the blues map.

Of all the juke joints I was able to get to that year, Junior

Kimbrough's, near Holly Springs, Mississippi, was a favorite. I'd been out to his house ten years earlier while working on my William Faulkner story, before he had his joint, and the musicians played in his living room. Junior died in 1998, and now his joint, too, has passed away, having burned to the ground in the summer of 2000. Although you could never be sure if there'd be live music or not, Sundays drew people to Junior's like bugs to a porch light on a summer night. Parked cars cordoned off the shabby, one-level structure, and small groups of black men clustered around the joint. A pint of moonshine would be finding its way around, passed hand to hand.

Inside there would usually be a mix of blacks and some whites and, as the place became more popular over the years to blues fans seeking out what they hoped would be the real thing, it wouldn't be unusual to find visitors from Sweden or maybe Japan, taking a look and drinking the cold beers for sale in the back of the joint, back there where a huge floor fan would blow the hot air around and push the filmy paisley fabric of a black woman's summer dress tight against her buttocks and the backs of her legs.

One particularly sticky Sunday night at Junior's I watched an attractive white bookstore clerk from Oxford centered in a swirl of dancers. Rivulets of sweat were snaking down my spine to below the small of my back, creeping south like a wet tickle. The woman was short, full-breasted in a tight red T-shirt. She had a roundish face with red, bowed lips. She could have been 21, maybe younger. Her long, chestnut hair rose and fell around her torso with the beat of the music, framing first her face and then her breasts. Her eyes were closed. She moved trance-like a foot or two away from the pumping muscular arms of the young black man who was her dancing partner. The band was playing "What Ever Happened to Bo Diddley's Money?" When I think of her now, I'm reminded of something I heard on a jazz and blues radio station in Washington, D.C., not long ago. As he signed off, the disc jockey advised: "Work like you don't need money. Love like you've never been hurt. And dance like nobody's watching." I like that. And the good-looking bookstore clerk at Junior's was taking the last part of that advice to the bank. She was just lettin' it go. Givin' it up.

I owe a debt to all the musicians who allowed me into their space while performing. Some of the pictures in "A View of the Blues" I couldn't have made without their understanding. I usually find more visual interest in the periphery of an event or a performance than I do in the actual performance. When I photographed the annual Memphis Blues Festival—which features a series of stages of various sizes, some in tents along the Mississippi River—the stage crew of the Blues Tent truly appreciated my need to work the edges and gave me freedom to roam. I should have been charged stagehand union dues for being allowed to make my photograph of Clarence "Gatemouth" Brown in the Blues Tent, ending his set and the festival. I was all but playing in the band at the end of his last song, and when he turned and saw me standing between himself and his drummer, he flashed that Gatemouth smile and those Gatemouth eyes glimmered in the face of the then 73-year-old Louisiana-born musician. It was like he expected me to be there. To play my part.

If I brought something of my own to documenting the blues besides my love for music, perhaps it was my search and feeling for the light and shadow and color of where the music is made and listened to. But, of course, I had so much help. While making many of these pictures, I was listening to wonderful music made by passionate, dedicated artists. Through their artistry and generosity I was able to make my own kind of music from my own view of the blues. You can't ask for more than that.

And maybe someday I'll pick up on a suggestion that appeared on my computer screen one night as I was firing it up and getting ready to write. It was one of those inspirational hints:

"It's never too late to learn to play the piano." □

*Nobody loves me but my mother*
*And she could be jivin' too*
*Nobody loves me but my mother*
*And she could be jivin' too*
*Now you know why I act so funny with you, baby*
*When you do the things you do*

—B. B. KING © 1970

*On board the* City of New Orleans, *leaving Mississippi, bound for Chicago*

*Big Jack Johnson, his daughter, and granddaughter, Red's, Clarksdale, Mississippi*

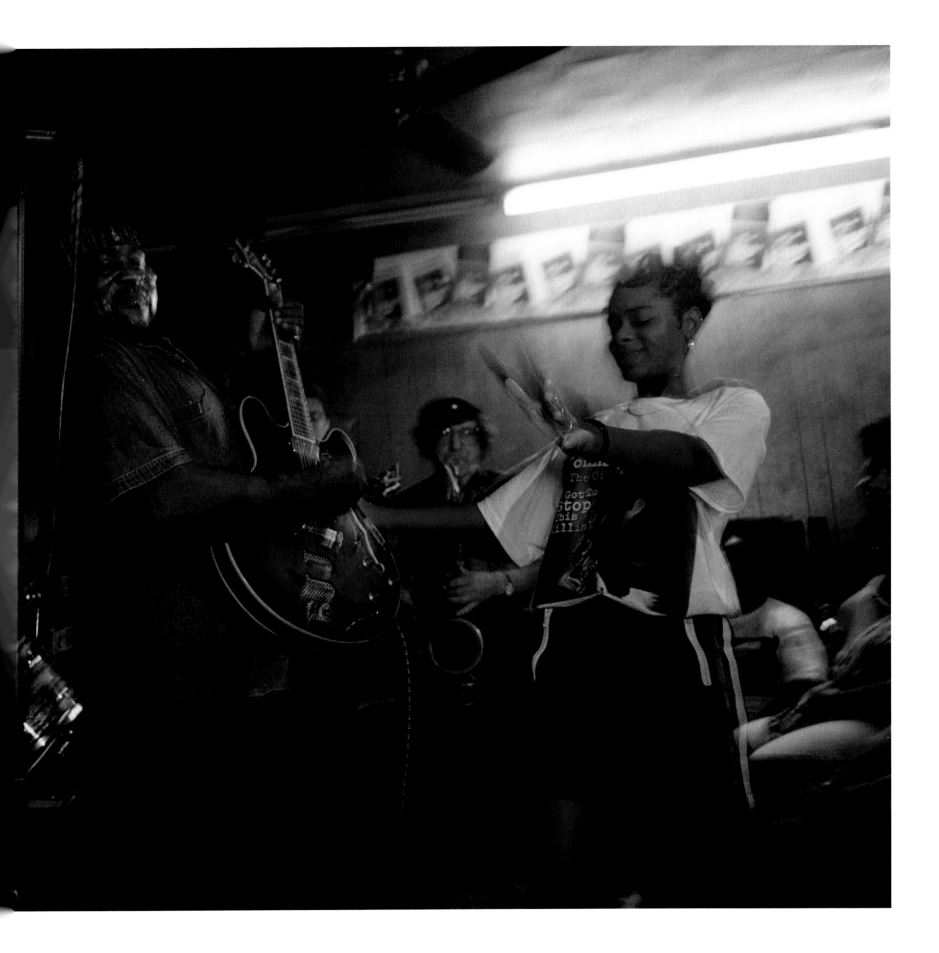

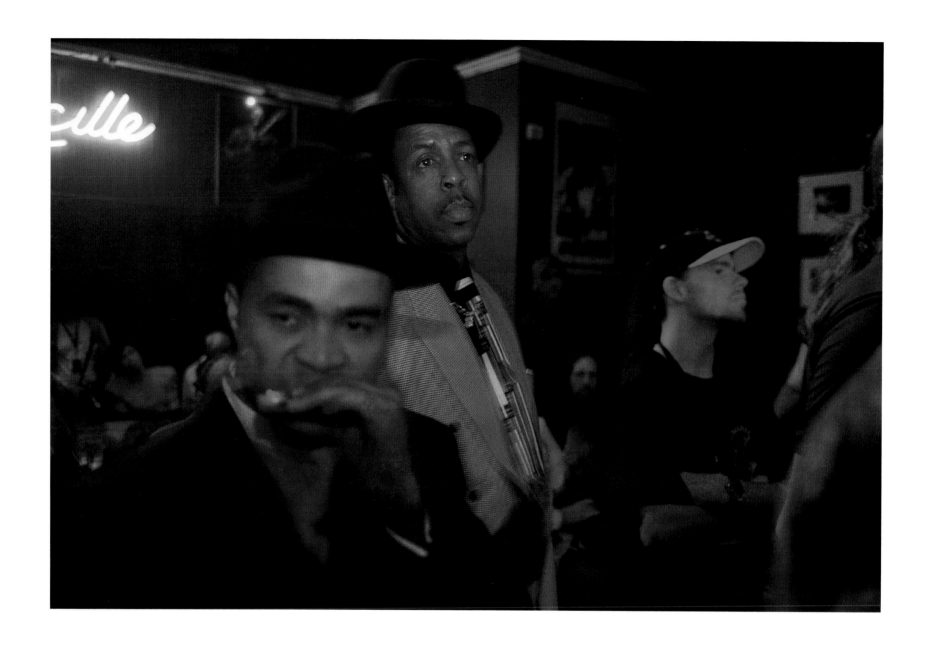

*Willie Hayes, drummer, B.B.King's on Beale Street, Memphis*

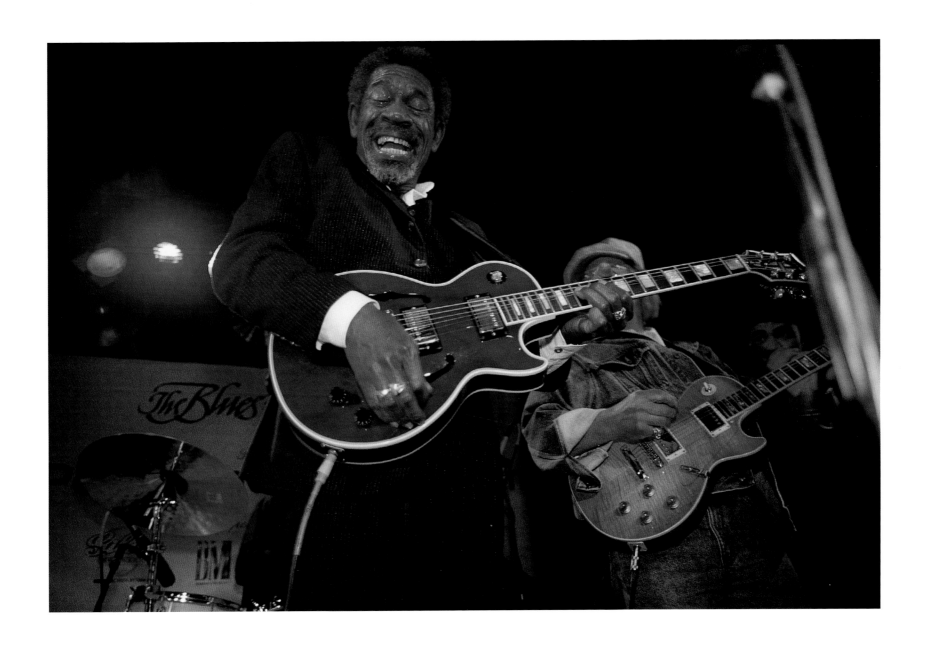

*Luther Allison, B.B. King's on Beale Street, Memphis*

*Junior Kimbrough's juke joint near Holly Springs, Mississippi*

*Po' Monkey's Lounge, Merigold, Mississippi*

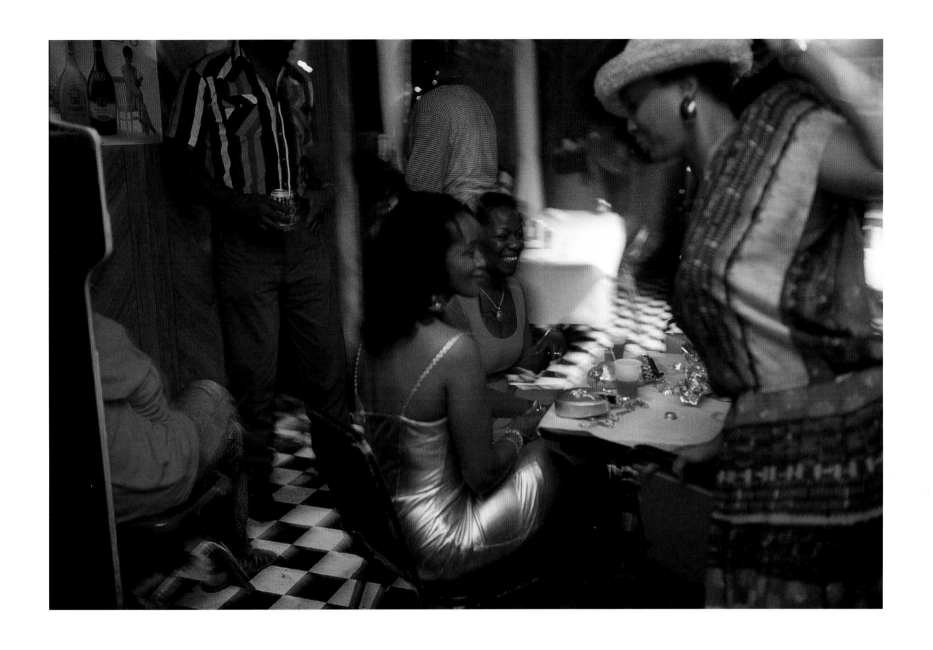

*Club Ebony, Indianola, Mississippi*

*Friday Night, Beale Street, Memphis*

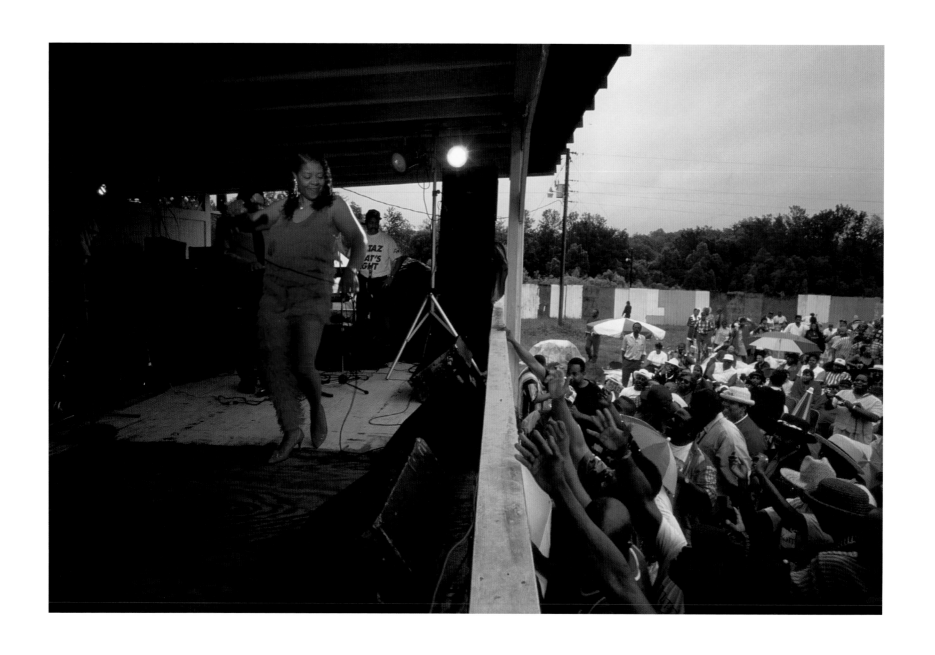

*Lynn White, Pickens, Mississippi*

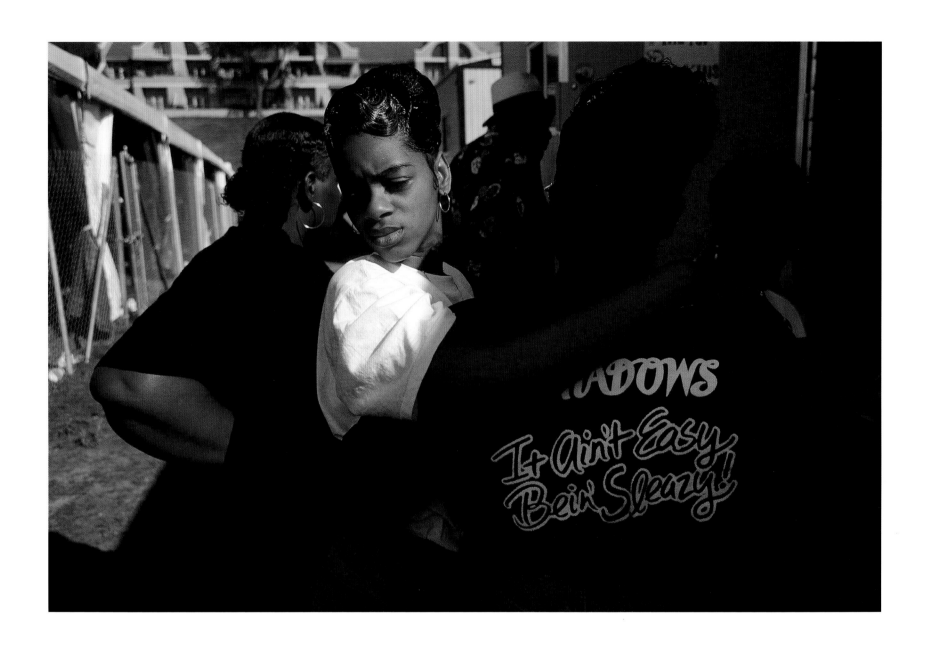

*Family of Big Jack Johnson, Memphis in May Festival*

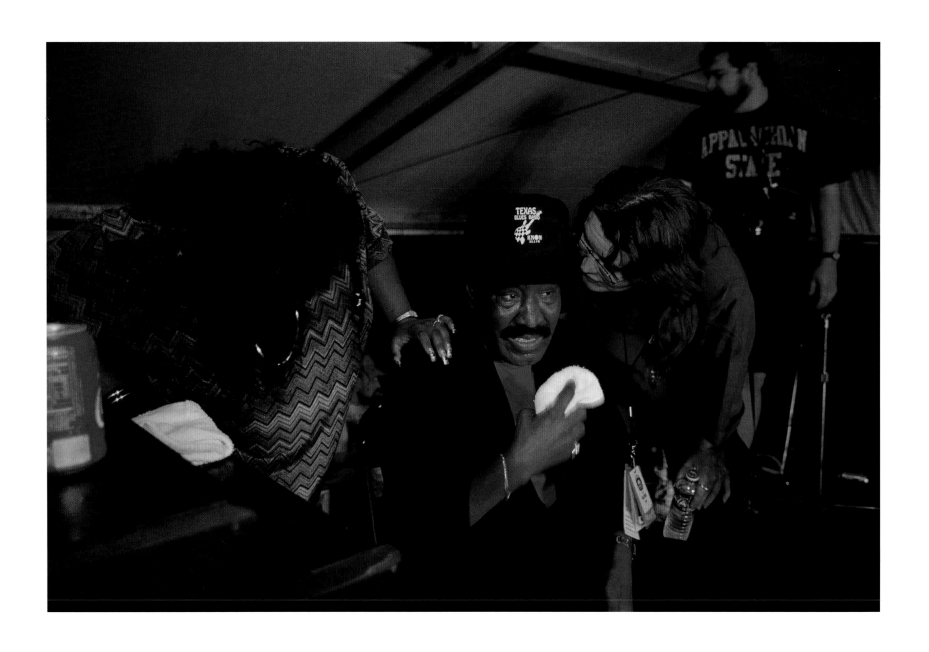

*Johnny Clyde Copeland, Memphis in May Festival*

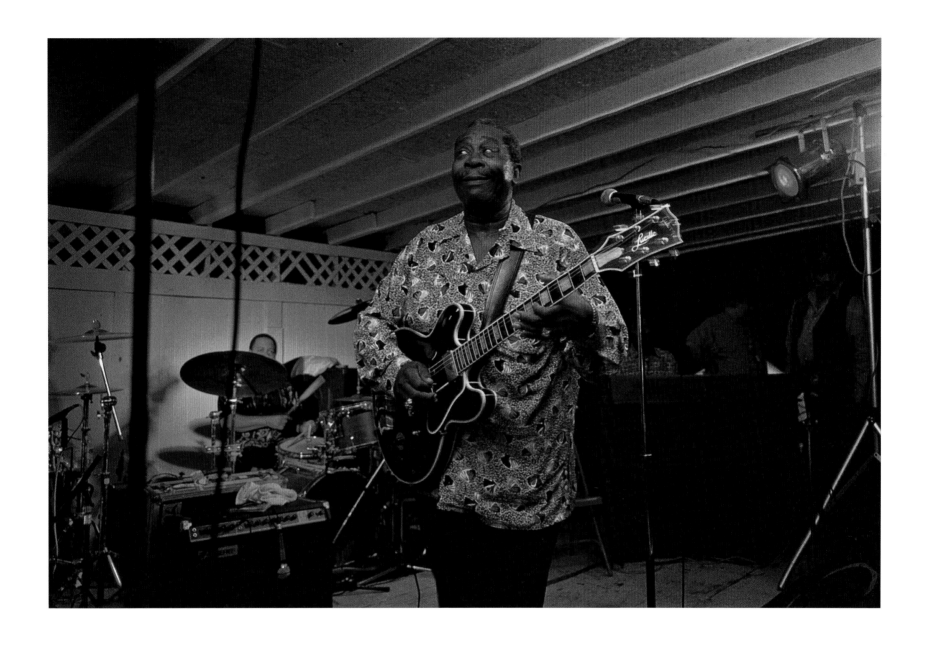

*B.B. King, Pickens, Mississippi*

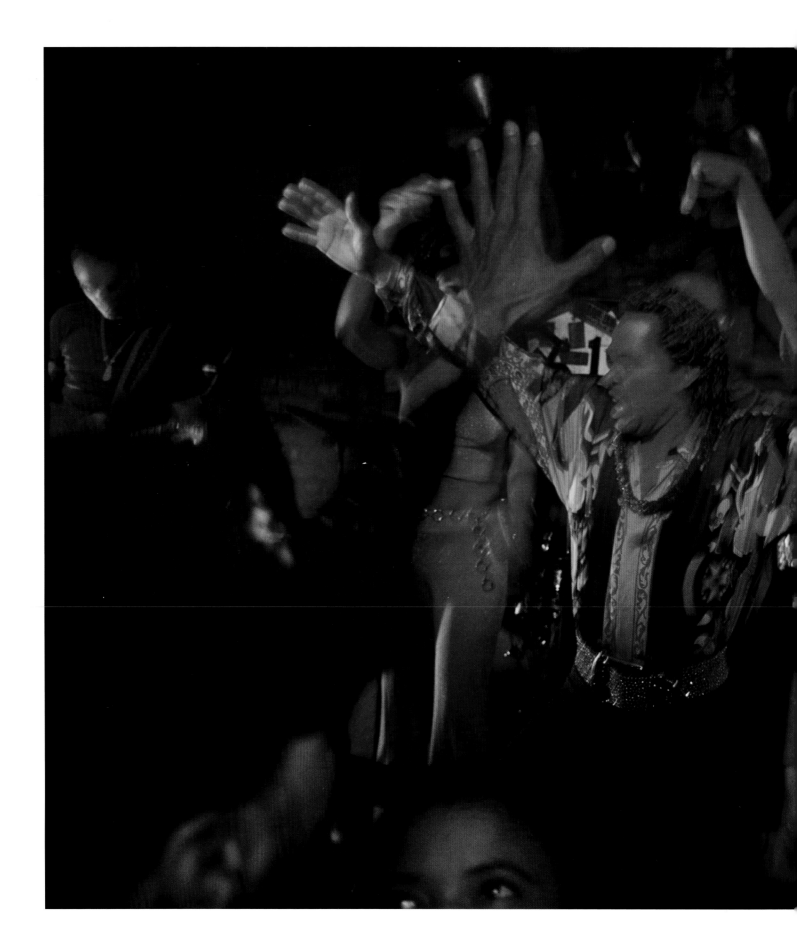

*Bobby Rush, Rum Boogie Cafe, Beale Street, Memphis*

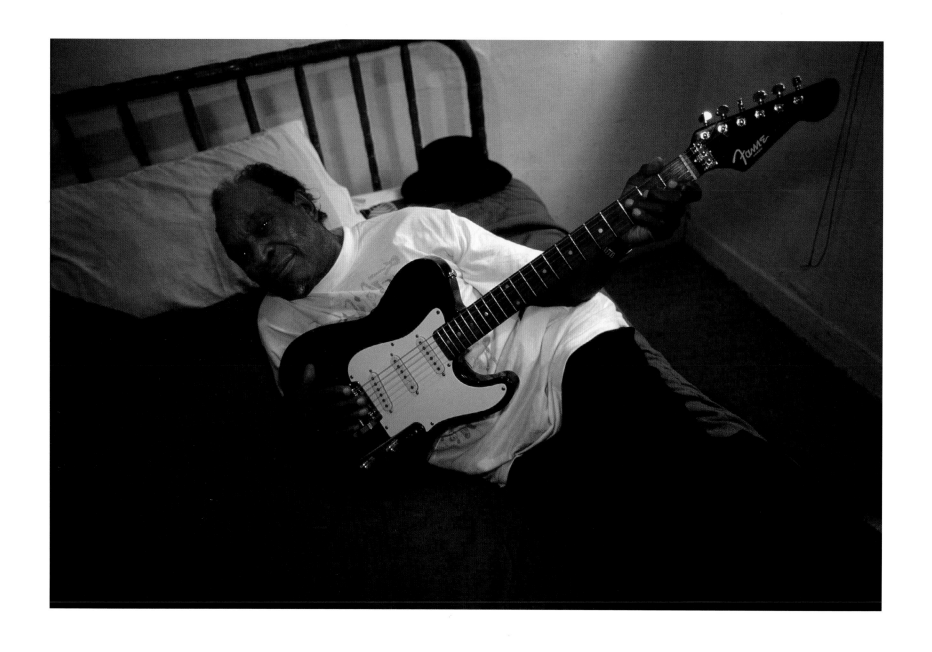

*David "Honeyboy" Edwards, Chicago*

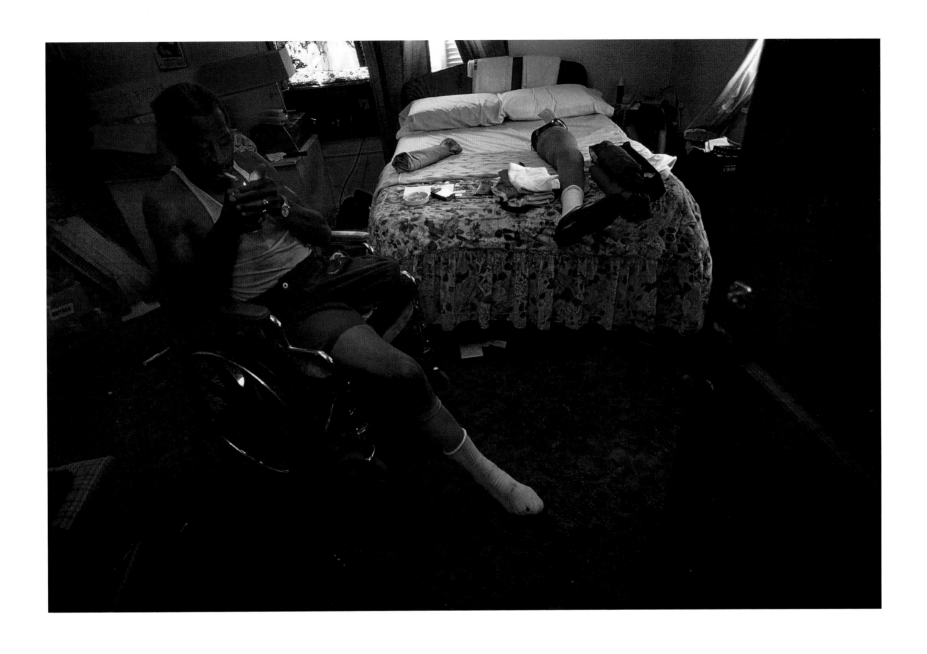

*Harp player Willie Foster, Greenville, Mississippi*

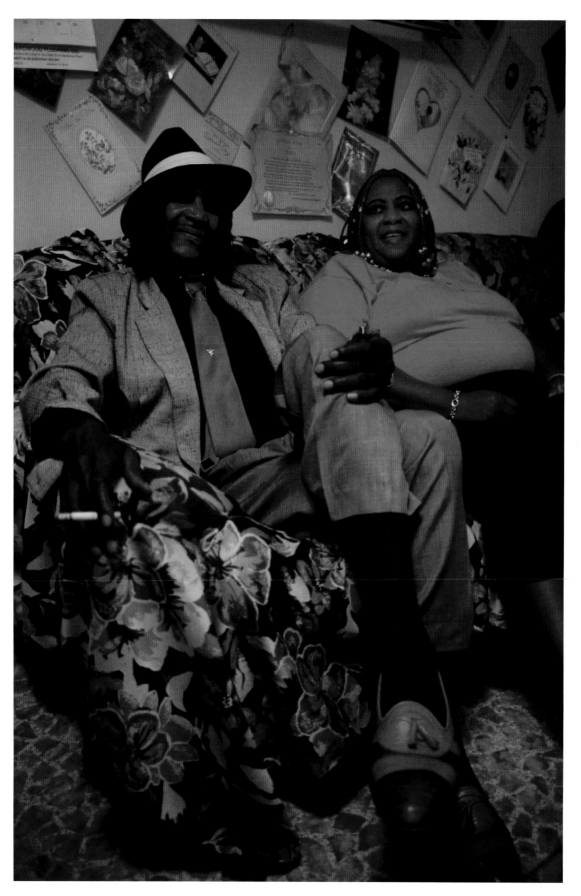

*Juke house, Easter Sunday, Bentonia, Mississippi*

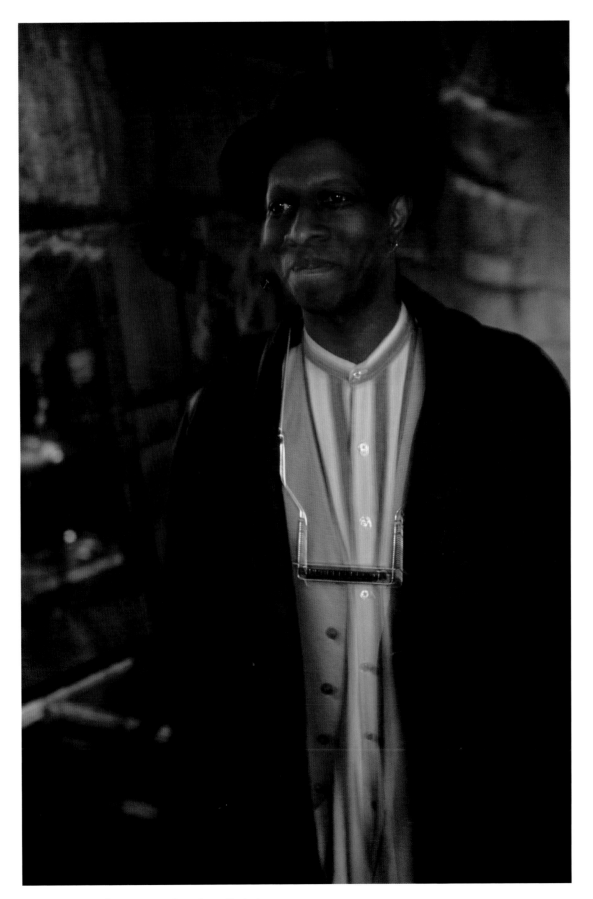

*Keb' Mo', New Orleans Jazz and Heritage Festival*

*Jessie Tolbert, Lee's Unleaded Blues, Chicago*

*Jimmy Lee Robinson (foreground), Smokedaddy, Chicago*

*Ollie Nightingale, Paradise Club, Memphis*

*Junior Wells, Checkerboard Lounge, Chicago*

227

*Junior Wells's funeral, Chicago* JANUARY 1998

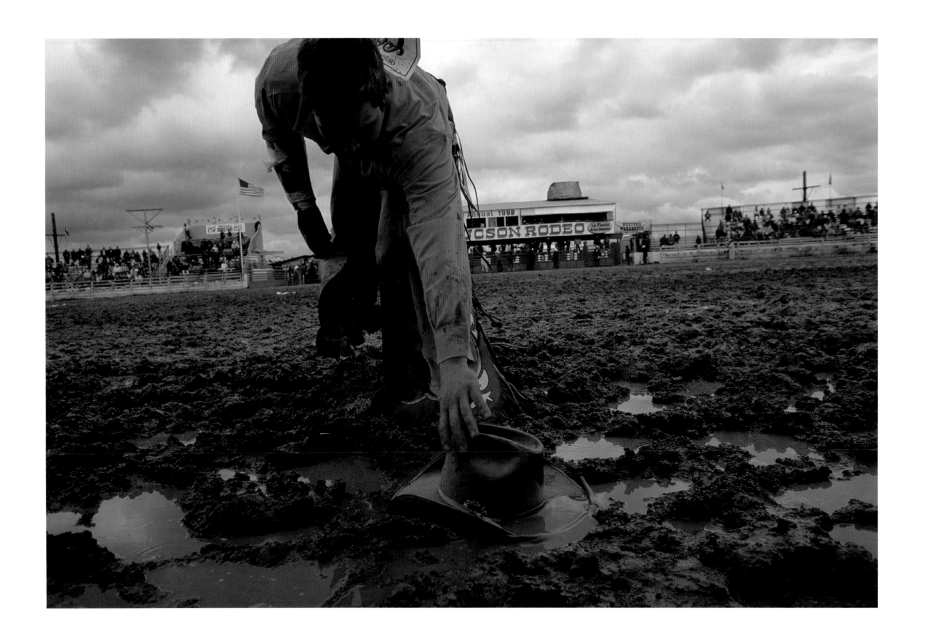

*Tucson, Arizona*

# RODEO

## [ 1998 ]

I HAD COME TO ARIZONA FOR THE GOLDEN LIGHT AND WARMTH, FLEEING THE February doldrums back East where it was gray, wet, and cold, spring still a distant hope. Inside the Tucson bar and restaurant it was warm and inviting.

"If you want to eat out in the lounge, I'll turn on the big-screen TV," she offered before taking my drink order, laying a menu on the bar as she spoke. I guessed the bartender to be in her early 50s, and although her sun-weathered face bore evidence that the years may not have been easy, she had a trim figure in well-shaped black jeans. She sauntered over to a corner of the lounge, where a pair of red velvet drapes descended ceiling to floor. I followed her shape and movements across the room, which was filled with small red rectangular tables, red chairs, and red vinyl banquettes. The whole place seemed to be bleeding.

The bartender parted the drapes, but the television was still out of sight, sitting up on a stagelike platform, the immense screen covered by what appeared to be a wide, black-cloth shade. Rising on tiptoes and extending her arms up and out, she grabbed each end of the shade and began rolling it up with sharp twists of her wrists. Being up on tiptoes and all, the effort got her bottom moving, and as the shade went up, her bottom went to shaking. Rolling and shaking, rolling and shaking. When she finished, she made a quick stab with the remote, and the big Japanese TV soon brightened and flushed with a college basketball game. I glanced back at the menu. In the upper corner in a little bold-lined box the restaurant featured "The world's second best martini."

"Who's got the best?" I asked her when she came back to me at the bar.

"Those are the ones you make at home," she said. "Would you like one of ours?"

"No," I replied. "I'm not a martini drinker. What I'd really like is to watch you roll up that TV shade one more time."

She smiled. "Right. You ready to order?"

It was the best thing I'd seen all day. Certainly the brightest, and maybe the warmest, too.

I had come to Tucson to photograph the first big-time outdoor rodeo of the year on the Professional Rodeo Cowboys of America (PRCA) circuit. I had chosen Tucson for that dependable Southwest light so typical of Arizona and New Mexico and Texas: warm, lustrous, and golden. The light of gods. Light to properly burnish Tucson's Fiesta de los Vaqueros, a four-day rodeo held each February.

So it rained like hell for most of the first three days. Cold rain, wind-driven, coming at you sideways. That afternoon the Tucson rodeo arena had been almost beyond description. The rain-soaked dirt was churned to a thick soup that sucked at the boots and hooves of contestants and rodeo stock, making the simple act of crossing the arena a slow and sloppy trek. A horse passing at a walk could throw enough mud to splatter anyone within five feet. In three days of mucky footing, there were no mishaps. In some respects the conditions might have been a blessing, at least for those who were bucked off hard, because the landing would be soft. Riders emerged from their spills as though they had been suddenly cast in bronze. Sometimes only their eyes stood out from the coating of mud.

It wouldn't have been so bad if it hadn't been so cold. But that didn't stop the diehards in the stands with umbrellas and blankets, who stayed for the duration. They had come to see a

rodeo and, by God, they were gonna see one. I had come for the good Arizona light and, by God, where was it? It finally came out a little on Saturday and then was glorious for the finale on Sunday.

It wouldn't be the last time weather played a major role in rodeos I went to over the course of the 1998 PRCA season. Not much stops a rodeo from going on other than maybe lightning or hailstones the size of golf balls, both of which can come at most any time in some of the western states. There was boot-sucking mud in June at the once-a-year rodeo in Belt, a tiny central Montana community just up the road from my friends at the Surprise Creek Hutterite Colony. And at the Fourth of July rodeo in Pecos, Texas, temperatures were well over a hundred every day. It was 116°F the afternoon I arrived in Pecos after driving from El Paso, wondering all the way why the air-conditioning in my rented car hadn't seemed to be doing much.

One hundred and sixteen. Cruising to Pecos, the heat quivered up in waves off the flat and endless west Texas Highway 10. I passed a picnic area with a conrete slab table sheltered by a concrete roof supported by concrete posts. Further along there was a rest area with concrete tepees. Then a huge sign that said "Live Tiger." For miles between El Paso and Pecos the radio gave up searching for stations, the seek button giving back a relentless digital flutter, ripping on through the numbers and back again, and again, never stopping in this country where in summer you can't do hardly anything from midday until almost dark for fear of frying your brains and all options. But I had tapes of Neil Young and Leonard Cohen, Willis Alan Ramsey and J.J. Cale. Stainless steel tanker trucks swept by in a blinding glare, and I sang along to the plaintive, raspy wail of Neil Young's harp.

I checked in at the Pecos Quality Inn. In the lobby a large glass case held seven diamondback rattlesnakes interwoven on a sand floor. Two of them were abuzz over some unknown violation. I guess you'd expect a rattlesnake to be a nasty creature having to live in such contrary country.

Speaking of contrary, it sometimes occurs to me that rodeo events can run opposite to what I would expect to be a normal person's common sense. Throwing oneself off a galloping horse to jump onto a 450-pound runaway steer in hopes of wrestling it to the ground is one example. Lying back on a saddleless bucking bronc that wants to throw you

to the moon while you hang on with one hand to what is basically a suitcase handle, would be another. I saw and photographed a lot of that and it gave me an appreciation for a rodeo cowboy's courage. His common sense? Well, that's another thing.

As I followed parts of the PRCA circuit in 1998, I kept notes of observations and things I'd heard in a couple of battered and coffee-stained notebooks filled with rapidly scrawled lines that sometimes defied decipherment.

STANFORD, MONTANA: Entry fees are $42 for broncs, another $10 for bulls. The arena is littered with clods of dirt and lumps that look like dirt but reflect too much light to be dirt, and reveal themselves to be rocks of various angular shapes; triangles and wedges waiting to crack the skull of a hard-thrown bronc or bull rider.

In Stanford I watched a young cowboy leaning against the weathered boards of the holding pens behind the bucking chutes. His pale blue shirtsleeves were fluttering as if caught by a breeze, but there wasn't one. He was trembling. I watched him later, as he gingerly eased himself down upon a brindle-colored, short-horned bull. With the braided bull rope wrapped around his leather-gloved hand, the cowboy clenched his jaw and nodded for them to open the chute gate. When it opened the bull came out to the left, then threw his hind quarters the opposite way and seemed to rise in the air at the same time, and the cowboy flew off as if an ejection button had been pushed.

The ultimate in contrariness has to be bull riding. Why would any young man of sound mind and body of 150 pounds lower himself down onto the back of a bucking bull that weighs close to 2,000 pounds? That bull can step on the head of a downed rider and kill him by accident, something that I guess has happened in the past. Or he can gore him on purpose and accomplish the same lethal end. While photographing rodeos, I never saw a cowboy killed, but I saw some I thought were going to be. And more often than not they were bull riders.

A bull that became infamous for almost ending the career, if not the life, of one of the all-time great bull riders was named Bodacious. According to my dictionary that's the blending of the words "bold" and "audacious." He must have been all of that, although I never saw him.

A Charlolais-Brahman cross, Bodacious weighed around 1,900 pounds when he started his career as a three-year-old. He had a hell of a start, winning the title of Bucking Bull of the Year at the PRCA National Finals Rodeo (NFR) in Las Vegas in 1992. The NFR brings together the top 15 rodeo contestants in each event as well as the top stock in bucking horses and bulls. Being selected as the best bucking bull in his first year, Bodacious was like a baseball player being named the Most Valuable Player in his league in his rookie year. That tends not to happen. Bodacious went on to be named Bucking Bull of the Year again in 1994 and 1995, the year he was retired. Three of his four years in competition he was selected as the best.

Tuff Hedeman, three-time world's champion bull rider, is considered among the best ever and is one of only six cowboys to have ridden Bodacious during the bull's short career. Hedeman, a young, good-looking cowboy from Texas, rode him to the buzzer once out of the first four times he got on the bull. The fifth time, Bodacious almost killed Hedeman.

When Hedeman drew Bodacious at a rodeo in Las Vegas in October 1995, many in attendance thought they had a ticket to the dream match: the top rider and the top bull, the best in the game. For Hedeman it was a disaster. As he tried for his second successful ride on the big cream-colored bull, his head came down while the flat, massive head of Bodacious was coming up and the two slammed together. It was all over. They say Bodacious broke close to every bone in Hedeman's face. At the end of that year, Bodacious was retired. Tuff Hedeman came back to successfully continue his career, his face different than it once was, but his name even more of a legend.

TUCSON: Two women—somewhere in their late 60s, early 70s, I'd guess—had small silver diamonds sewn on their denim shirts. Both wore large sunglasses and one's hair was white, the other a very unnatural red. With their large glasses they looked like elderly owls. Many of the gray-haired older women of the Southwest frame themselves, their faces, and their ages, in silver. It's on their ears, around their necks, on their prairie skirts and concho belts. They are like photographs of once beautiful matriarchs displayed in antique silver frames.

TEXAS: At the Pecos rodeo one old cowboy, a steer roper, rode up next to another. "How you doin'? I like your horse," he said, in a simple but sincere greeting.

"Oh, thanks," replied the other man. "I'm still kickin', but not very high."

A middle-aged steer roper riding past another contestant pointed at the man's entry number pinned to the back of his shirt. "Is that your IQ or your number of legal parents?" he said with a smart-assed grin.

RED BLUFF, CALIFORNIA: Bronc riders seem to have a way of walking—like seven-time All-Around Cowboy Ty Murray— with their toes pointed out, as if they were going to spur their way through the door, setting their feet down hard on their heels as they stride forward, their arms held out wide. A lot of nonrodeo cowboys hold their arms out wide but it seems to be a style more common among rodeo rough-stock riders. Some of them have belt buckles the size of Rhode Island.

WOLF POINT, MONTANA: In the blue crepuscular light, they started the wild horse race. Six broncs turned out of the chutes at the same moment, none wanting to be even touched, let alone haltered, saddled, and ridden. As the three-man teams went about trying to do that, horses were rearing and bucking and lunging and kicking around the arena in a fog of dust. For me, it's the most dangerous event in rodeo because I'm out there trying to make a good picture and not get my head kicked in or run over.

LAS VEGAS: In the bronc and bull riders' dressing rooms at the PRCA finals, cowboys talk a lot about a video sold on TV that shows terrible violence in car accidents and police incidents. It seems especially popular with bull riders. They talk about getting "snot-slingin' drunk" and doing all kinds of things when not at a rodeo. "You know what I found last night when I got back to my room?" says a bareback bronc rider. "There was ____ ____ in bed with two girls. I was so proud of him."

"I bet you could tell some wild stories, huh?" a reporter asks one of the riders.

"Yeah, but the best ones are from times I probably can't remember," the cowboy replies.

PENDLETON, OREGON: There seems to be a preponderance of blonds in rodeo bars and among rodeo queen contestants. There is definitely a rodeo queen smile and a rodeo queen wave, flashing white teeth and a sharp, two-fingered salute or a wrist-snapping, side-to-side fanning of the hand as she circles the arena on her galloping steed. A blond in a cowboy bar once walked close by me and her perfume smelled like some kind of movie theater candy; I couldn't quite recall if it were Dots or Jujubes but it was like an edible sweetness that wafted by as she passed. I could almost feel it in my teeth.

LAS VEGAS: On a December night a pretty flag bearer sits astride a big palomino in the cold tunnel leading to the arena at the NFR. A stocky Vegas cop stands close to the horse's shoulder and the girl's leg. "My horse is warm," the girl says, embracing its neck against her chest . "I know," says the cop. "I put my hand on her flank, and it was nice."

CHEYENNE, WYOMING: Older men hang around the concession stands and rodeo bars like gray wolves, eyeing the younger, tight-jeaned women. A tall middle-aged man in western garb is close up with a woman half his age. She sits at the bar and he stands by her side and he talks about going to a "picture show." I can't remember the last time I'd heard that term used for going to a movie unless it was in an old movie.

LAS VEGAS: On an elevator in my hotel I rode down with a man and a woman, both young and attractive, probably rodeo fans, not contestants. "Oh, we had a great time up there," she said to him, quietly. "And nobody's gotta know about that when we get back downstairs." The woman was a bit flushed in the face and hugged herself nervously. She had a strawberry red splotch on her neck, in the hollow just below where her jawline curved up to her bespangled ear.

"Well, I don't know about that, girl," the handsome man said. "You've got a hickey the size of a poker chip there on your neck. You think nobody's gonna notice that?"

The woman's face drained pale. Her mouth slowly opened in an expression between surprise and utter dismay.

"Oh, Christ," she said, softly. "Oh, Jesus Christ."

THERE IS ALWAYS MUSIC BEFORE A RODEO BEGINS, MUSIC that accompanies the calf and steer ropers, the bull doggers and the barrel racers who circle the arena, often riding in pairs, visiting and warming up their horses. The music that plays for them and the early arrivals in the grandstand tends to be mostly rodeo songs about being on the road, living on coffee and doughnuts, going to Cheyenne, and losing your love because of your lust for rodeo. Ian Tyson is popular, especially in the Northwest. Chris Ledoux and Garth Brooks are also. And George Strait. His "All My Ex's Live in Texas," is a favorite. After Roy Rogers died in 1998, "Happy Trails to You" was played just about everywhere along the circuit at the end of each rodeo performance.

And, of course, before the start of any rodeo, large or small, there is the presenting of the American flag, brought into the arena at a gallop, the Stars and Stripes streaming out in glory. Then the national anthem is played. At the finals in Las Vegas, before one evening's performance, a bareback bronc rider standing next to me behind the chutes held his hat over his heart and sang the national anthem in a soft and earnestly off-key voice, the blue shafts of light falling upon the flag in the center of the darkened arena, bleeding off to cast his face as if in a dream. □

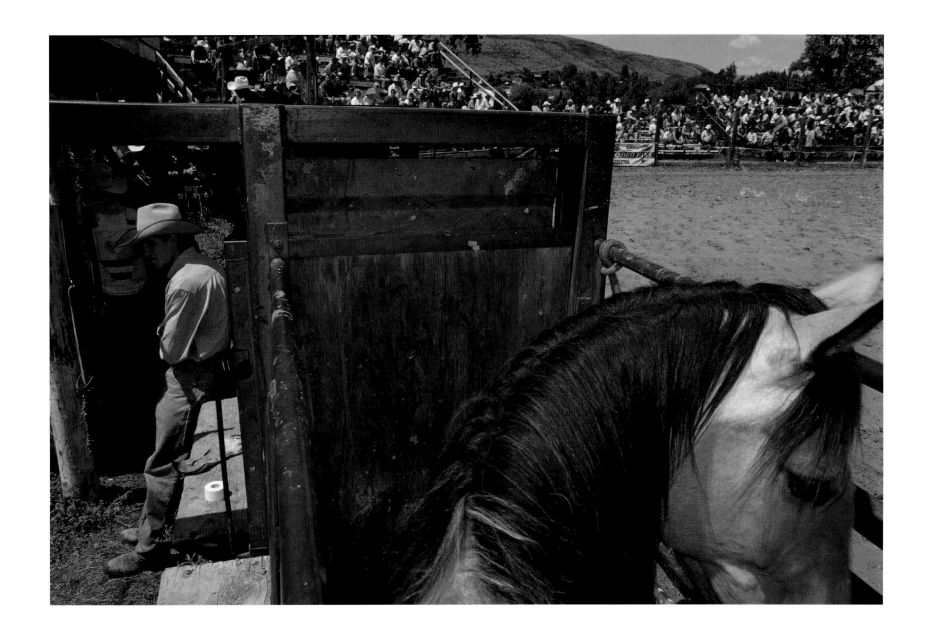

*Belt, Montana*

235

*Tucson, Arizona*

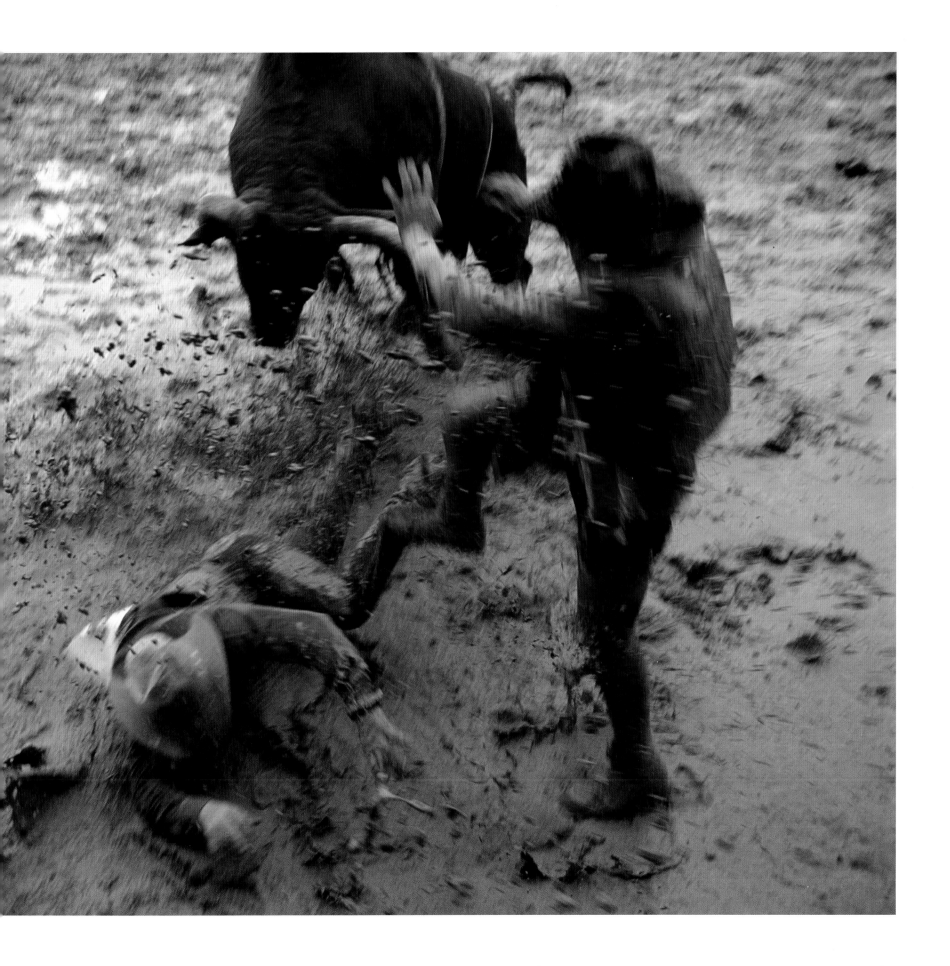

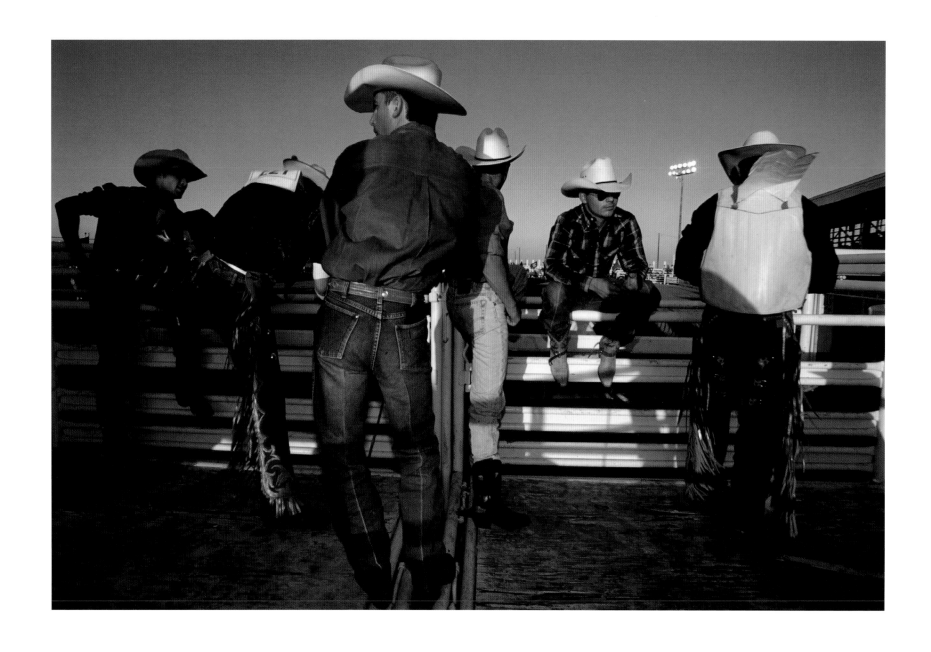

*Pecos, Texas*

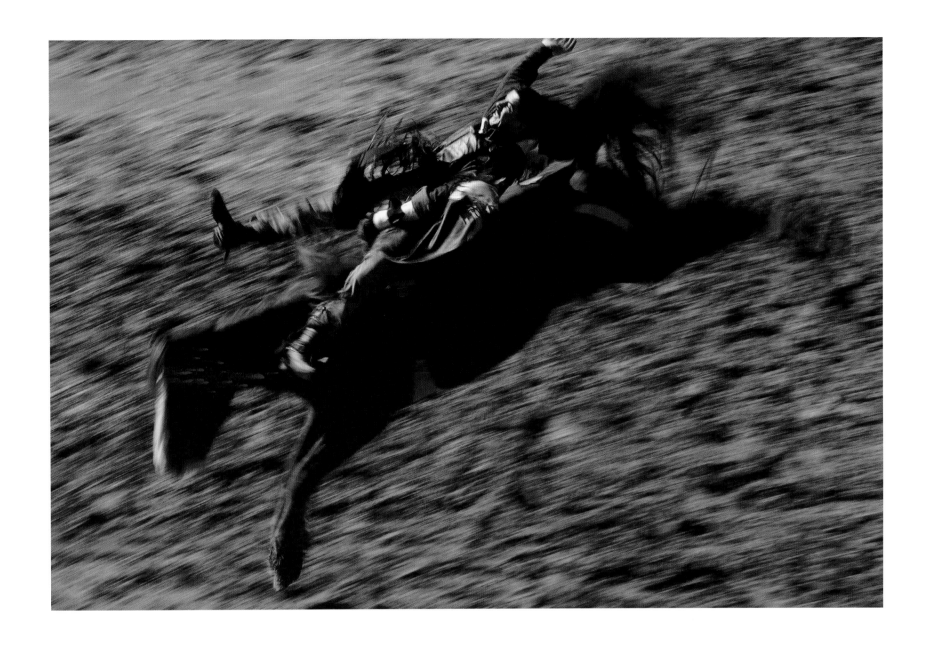

*Eric Mouton, world champion bareback rider, Tucson, Arizona*

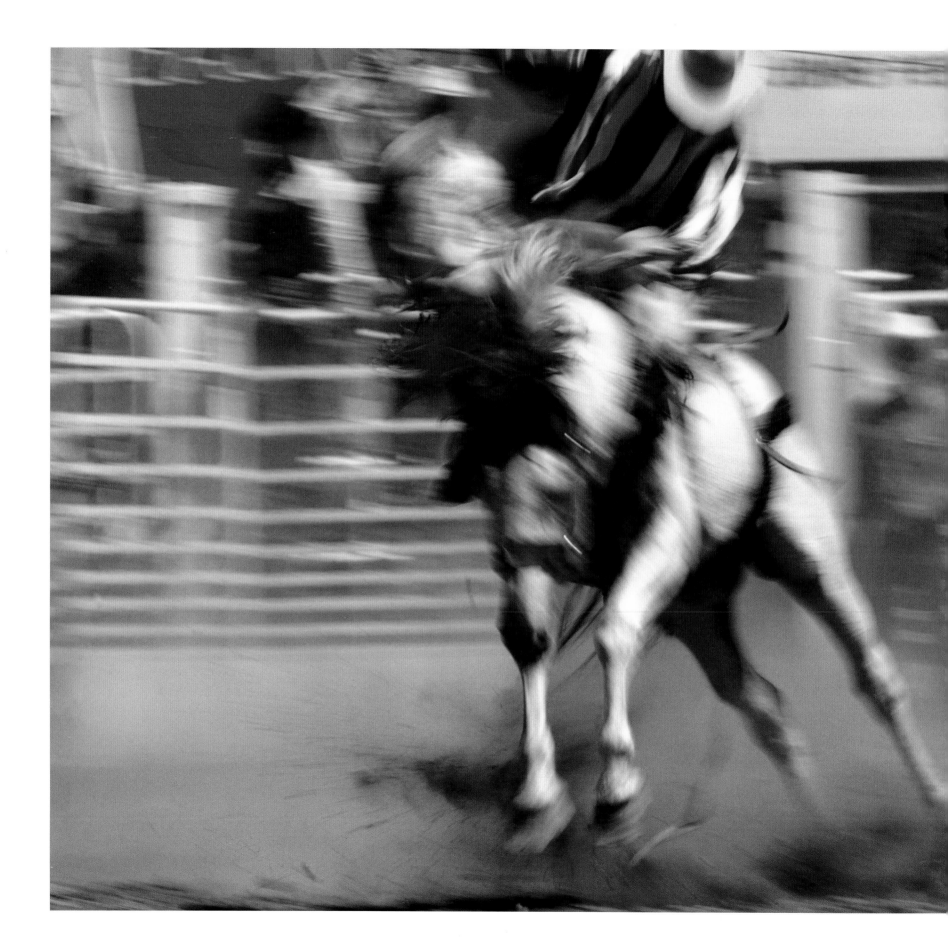

*Stanford, Montana*

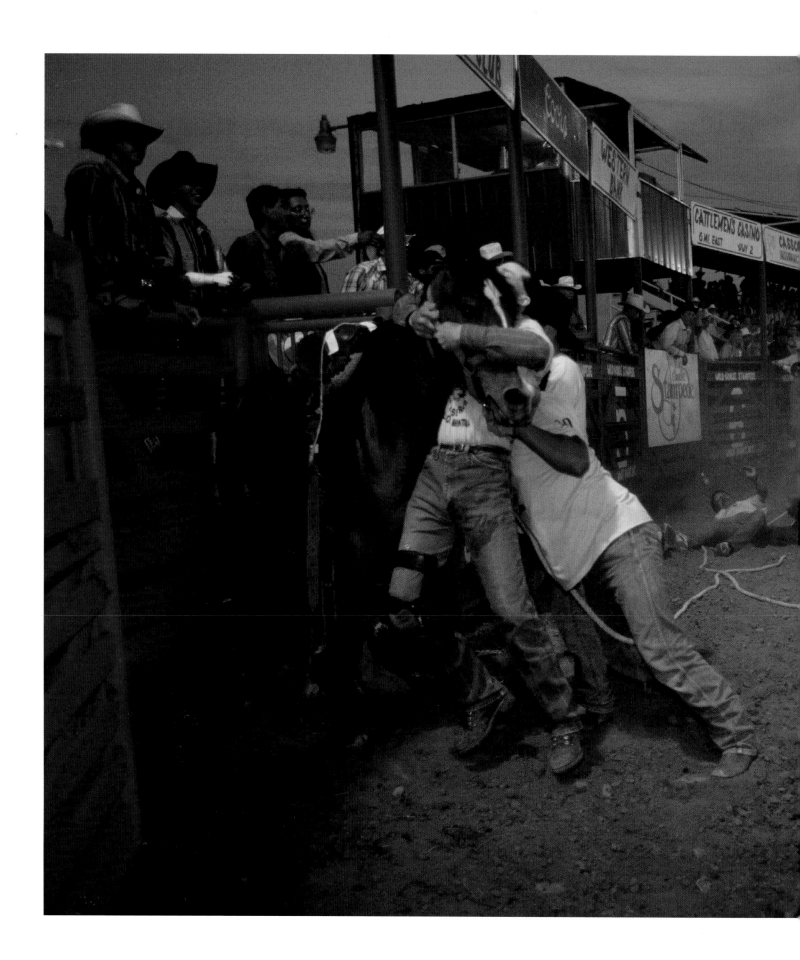

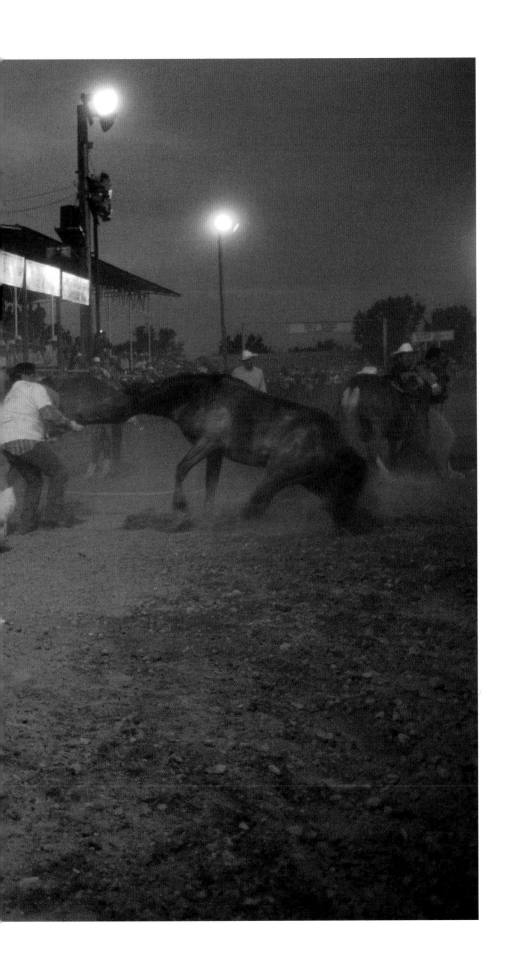

*Wild horse race, Wolf Point, Montana*

Chad Klein, bareback and bull rider, Red Bluff, California

RIGHT: *Three-time world champion bull rider Tuff Hedeman, Red Bluff, California*

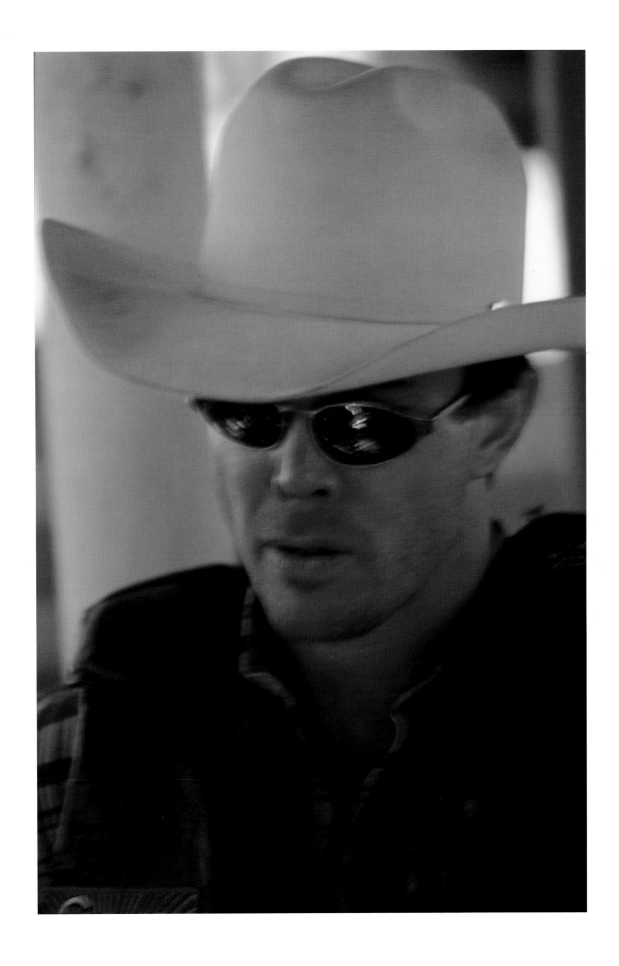

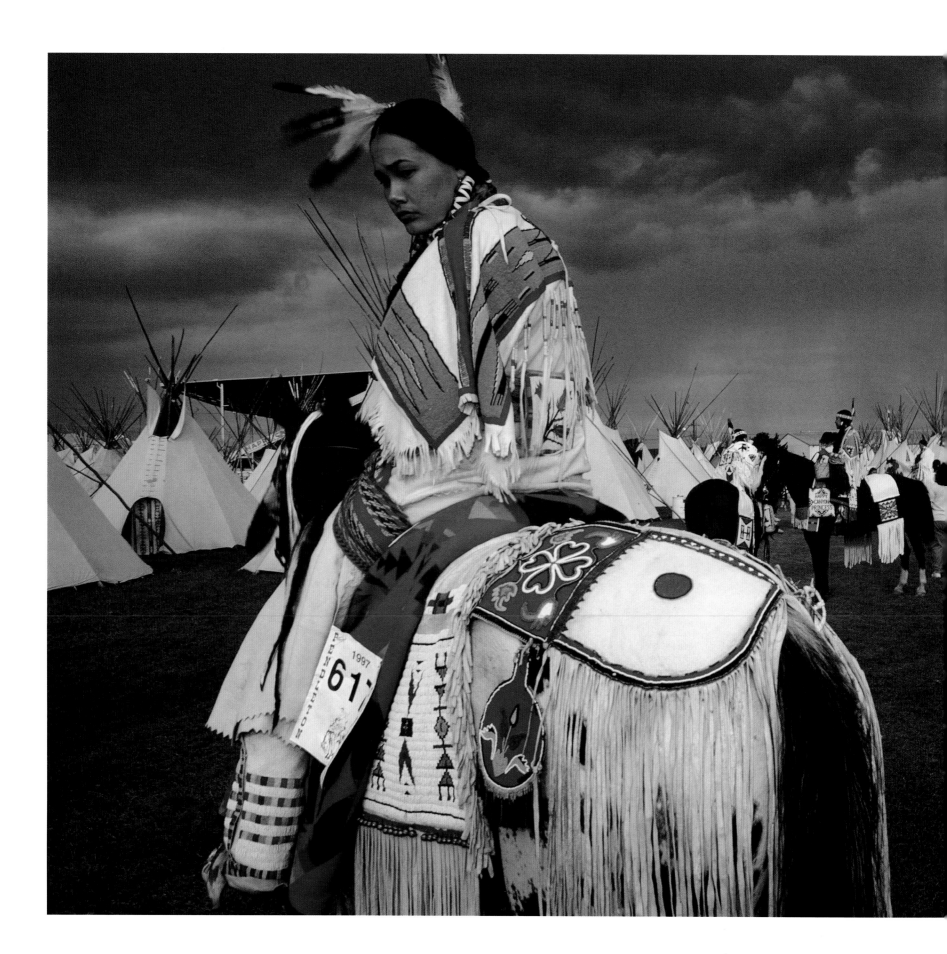

*Acosia Red Elk, Indian Princess, at rodeo, Pendleton, Oregon*

*Bullfighting clown Rob Smets, Tucson, Arizona*

*Rodeo queen, Pecos, Texas*

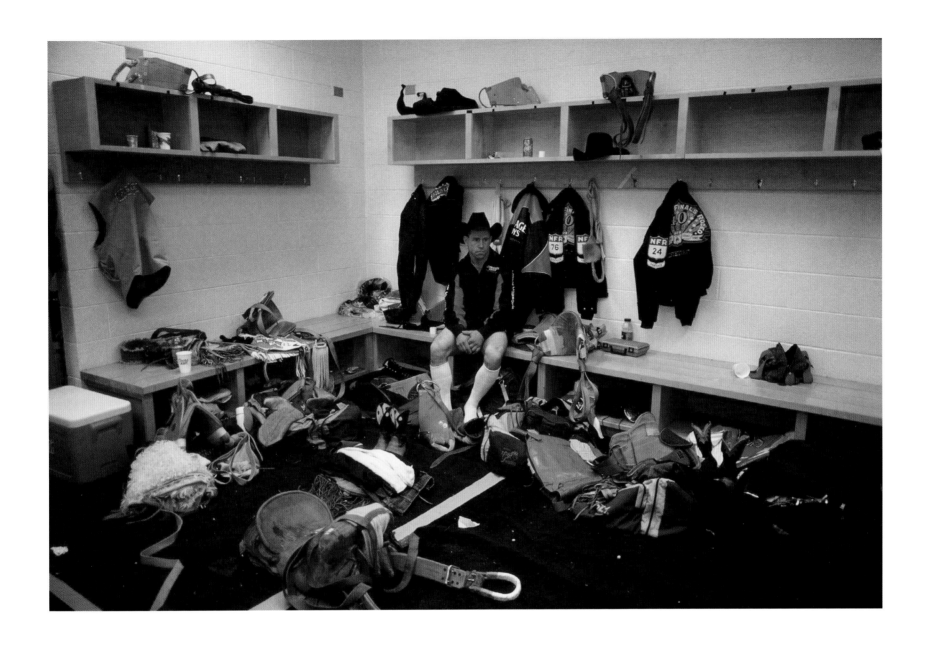

*Bareback rider Deb Greenough, NFR dressing room, Las Vegas*

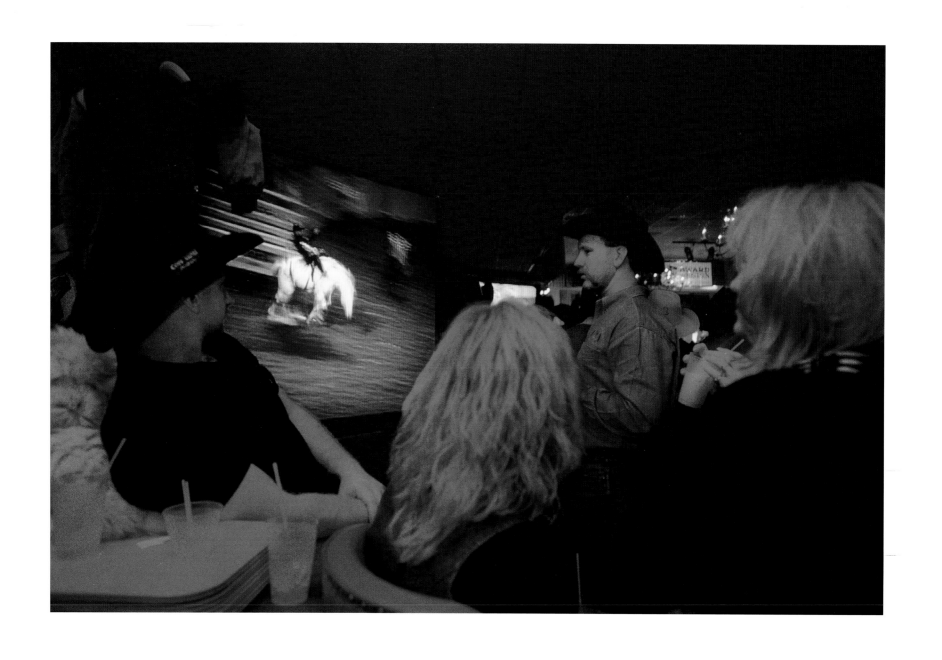

*Watching NFR reruns in the Gold Coast Casino, Las Vegas*

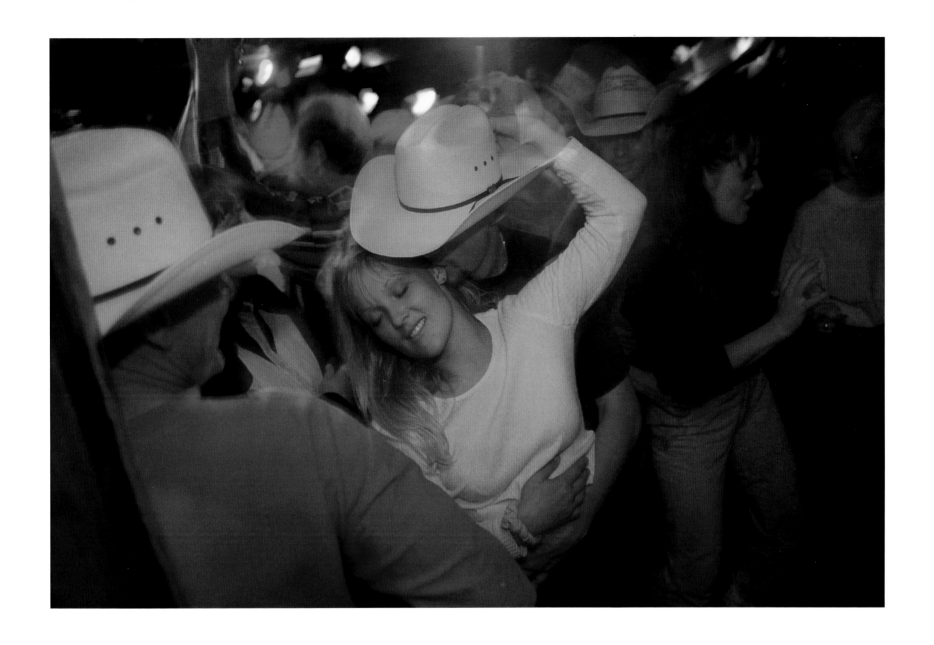

*After the rodeo, Pendleton, Oregon*

*National anthem, NFR, Las Vegas*